HUMAN
ANATOMY
& FIGURE
DRAWING

BERN·SIEG·ALBINI
TABVLAE·ANATOMICAE
MVSCVLORVM
HOMINIS

HUMAN ANATOMY & FIGURE DRAWING

THE INTEGRATION OF STRUCTURE AND FORM

JACK KRAMER

VAN NOSTRAND REINHOLD COMPANY
New York / Cincinnati / Toronto / London / Melbourne

To my Mother

COPYRIGHT © 1972 BY JACK KRAMER
LIBRARY OF CONGRESS CATALOG CARD NUMBER
73-162680
ISBN 0-442-20822-7

PRINTED IN THE UNITED STATES OF AMERICA
DESIGNED BY JEAN CALLAN KING

PUBLISHED BY VAN NOSTRAND REINHOLD COMPANY
A DIVISION OF LITTON EDUCATION PUBLISHING, INC.
135 WEST 50th STREET, NEW YORK, NY 10020

VAN NOSTRAND REINHOLD LIMITED
1410 BIRCHMOUNT ROAD, SCARBOROUGH, ONTARIO
M1P 2E7, CANADA

VAN NOSTRAND REINHOLD AUSTRALIA PTY. LIMITED
17 QUEEN STREET, MITCHAM, VICTORIA 3132,
AUSTRALIA

VAN NOSTRAND REINHOLD COMPANY LIMITED
MOLLY MILLARS LANE, WOKINGHAM, BERKSHIRE,
ENGLAND

16 15 14 13 12 11 10 9 8 7 6 5

CONTENTS

PREFACE

Drawing the human form is difficult and puzzling to many art students. Fluent figure drawing is usually frustrated by a lack of understanding in two important areas: (1) an insufficient knowledge of human anatomy (i.e., as it affects external forms, bones, and muscles) and (2) an inadequate understanding of spatial concepts in drawing. Information on human anatomy is widespread and readily available. In my view, the major difficulty in figure drawing stems from a deficient theory of figure structure. Most books on figure drawing deal with simplified concepts of form that fail to integrate the complexities of anatomy into a coherent scheme of the human figure as a form in space. Similarly, most books on artistic anatomy provide anatomic information with diagrammatic clarity but ignore altogether the problem of spatial order in forms.

This book attempts to resolve the unclear relationship between the anatomy of the human figure and the figure as a form in space. It deals with aspects of three-dimensional space largely ignored in drawing theory but crucially important to the difficult task of integrating a great deal of anatomic information into a dimensionally coherent form. The nature and function of each of the three dimensions are carefully examined and displayed.

The extensive use of drawings by old and modern masters illustrates this relationship of anatomy and space. Researching the illustrations provided me with the personally rewarding discovery of unfamiliar masterworks. It is my sincere wish that these illustrations may enhance the reader's pleasure in drawing and his understanding of anatomy.

I wish to express my sincere appreciation to the following individuals for their help in the preparation of this text: to Professors Reed Kay and Joseph Ablow for a number of valuable suggestions on Part I of the text; to Mr. Jonathan Goell and Mr. Kalman Zabarsky for their effective, special photography; to Mr. Richard J. Wolfe, Rare Books Librarian at the Francis A. Countway Library of Medicine, for his interest and generous help, and to his proficient, attentive staff; to Miss Linn Orear, Reproductions Secretary, Fogg Art Museum, Harvard University, for her consideration and help; to Mrs. Irving M. Sobin and Mr. R. M. Light for the special use of works from their collections; to Mr. Joseph Gropper and Prof. Sidney Hurwitz for particular help and interest; to the various museums and collections for permission to reproduce drawings and paintings; to the University Advisory Research Council of Boston University, for encouragement and support by a grant-in-aid for the preparation of the text; to Dori Watson Boynton for her patient, careful, thorough editorial work; and to Miss Elizabeth J. Knight for her tireless, patient work in typing the manuscript and extensive related material.

The following titles have been shortened in the captions with the permission of the Rare Books Department of the Boston Medical Library in the Francis A. Countway Library of Medicine: Bernhard Siegfried Albinus, *Tables of the Skeleton and Muscles of the Human Body*; Antonio Cattani, *From twenty plates representing the Osteology and Myology of the Human Hand, Feet, and Head*; Jules Cloquet, *Anatomie de L'homme ou descriptions et figures lithographiees des toutes parties du corps humain*; Jean Cousin, *L'Art du Dessin*; Julian Fau, *Anatomie of the External Forms of Man Intended for the Use of Artists, Painters, and Sculptors*; Jean Galbert Salvage, *Anatomie du Gladiator Combattant Applicable aux Beaux Arts ou Traite des Os, des Muscles, du Mechanisme des movements, des Proportions et des Caracteres du Corps*; Hercules Lelli, *Engraving on copper of the Muscles of the Human Body*.

INTRODUCTION

Of necessity, the visual-intellectual relationship of drawing to reality requires demonstration. This book is essentially a practical studio guide. While it is not exhaustive, this study can be the starting point for intensive individual investigation by anyone for whom a sensuously experienced reality is a necessary part of personal creative development and the basis of a language of expression.

Observational drawing is the principal means for developing a visual language, but this drawing process can be accelerated and supplemented by the study of accomplished masters. Compiled in the portfolios of the masters of Western pictorial space are drawings dealing with every aspect of human form and anatomy. With the vast collections of master drawings available through reproduction, it is surprising how infrequently they have been spatially and anatomically analyzed and organized for purposes of drawing instruction. Here the works of old and contemporary masters are systematically offered to demonstrate space in the anatomy of all parts of the human figure. The student can extend this book's usefulness by examining catalogs and books of collected drawings as well as by the study of original works at exhibitions and museum study rooms.

The focus in this text is on the essential objective visual clues to points in space which define the structure of the human form, and how they are employed by the artist in drawing. They can best reveal their full usefulness in the continuous, intensive exercise of drawing before the model.

The visually oriented artist—the artist deriving his expressive language from a directly perceived reality—may be more intensively motivated if his drawing activity is related to a larger aim within the context of painting, sculpture or the graphic arts. Drawing, then, becomes a means to feed information into a more comprehensive pictorial idea. It provides direction and purpose to his drawing effort.

The wide selection of illustrations from varied artists and periods indicates structure and spatial relationships to be a common foundation to many different personal expressive aims within the broad post-Gothic Western tradition.

The study and analysis of space order inherent in forms does not interefere with artistic expressive intent or the integrity of personal style. Indeed, the appearance of a coherent three-dimensional spatial system coincides historically with the period remarkable for the development of individuality (the Renaissance). Structure developed as a tool to serve visual investigation and the extension of visual knowledge. It was not a barrier to expressive vision. "The theory of art developed in the Renaissance was intended to aid the artist in coming to terms with reality on an observational basis; medieval treatises on art, conversely, were largely limited to codes of rules which could save the artist the trouble of direct observation of reality..."[1] When mastered, structure can be integrated into the fabric of expressive or stylized form.

Structure, discovered in visual reality and objectified in drawing, can become part of a formal, remembered visual language stylistically reshaped by content and meaning. It supplies an orderly underpinning of measured space to give support and conviction to artistic purpose. The lengthened, ethereal forms of El Greco, the substantial, earthy forms of Rubens, the afflicted, obsessed figures of Schiele, the formal poetry of Villon reflect an exclusive originality of stylistic expression, sustained and integrated by a consistent space structure.

[1] Erwin Panofsky, *Meaning in the Visual Arts* (New York: Doubleday and Company, Inc., Anchor Books, 1955), p. 278, footnote 114.

PART ONE: STRUCTURE & FIGURE DRAWING

CHAPTER 1
VISION & ABSTRACTION IN DRAWING

An artist may eventually choose the human form as a vehicle for creative expression. The decision is not lightly made, for accomplished figure draftsmanship involves long, persistent study and practice. In freehand observational drawing, the human figure is generally viewed as the ultimate challenge. It is not necessarily the final test of the draftsman's ability, but few will disagree that it is a demanding exercise in skill and vision.

THE PROBLEM OF ANATOMY AND VOLUME

Examining the nude model, the inexperienced observer sees an apparent confusion of subtly merging surfaces, muscular tensions, prominent veins and linear creases, textural changes, and broken shadow patterns that make selective organization seem all but impossible. Armed with some drawing experience, even the young art student with a special interest in figure drawing is often profoundly frustrated by the complexity of the human form. The slightest movement—a turn of the wrist—can completely alter the surface development of an arm. The study of anatomy has not conspicuously improved the student's work. The study of figure drawings by distinguished draftsmen, past and present, has failed to reveal to the immature artist some inspired secret that might contribute to his development. He continues to work with the uneasy feeling that some vital knowledge is missing. Practice, though essential, has not supplied the insight he needs.

To describe the student's dilemma more precisely, he has some experience and theoretical understanding of formal perspective and form projection based on simple geometric solids (i.e., sphere, cube, cylinder, etc.) and their relationship to the human form (the cylindrical characteristics of an arm, for example). He also acquires some functional knowledge of human anatomy—primarily of those bones and muscles that influence surface form. Here, the young artist is faced with a problem. He must integrate a considerable amount of complex anatomic information into a coherent three-dimensional scheme within the human figure. Frequently, at this point, there is confusion and an ensuing integrative breakdown. The student cannot achieve a successful union of space and anatomy to create a spatially convincing drawing of the figure.

Not surprisingly, most literature on this subject echoes the same dilemma. Books on artistic anatomy generally present complex anatomic information with diagrammatic clarity but neglect to indicate its implementation spatially (i.e., three-dimensionally) in drawing. Books on figure drawing often illustrate spatial concepts by the use of simple geometric volumes but invariably fail to relate these convincingly to complex organic anatomy.

Forms are a fundamental part of the language of spatial relationships employed by the artist. Viewed as an introduction to the explanation and understanding of spatial concepts, simple geometric solids (cone, cube, sphere, etc.) have a real and obvious utility. Unfortunately, these same geometric forms are frequently translated into simplified stereotypes of head and body, and such stereotypes are inadequate to describe the living form. A simplified physiognomy is too remote from the true aspects of anatomic structure. The too-insistent visual effort to impose the simple geometric solid on a complex human form may discourage and frustrate visual investigation and inhibit the growth of knowledge and understanding of the figure. The simple geometric solid (cylinder, as an arm), while it may seem to be a reduction to the essentials of a form, is, in fact, a complex and complete concept in itself. It has its own intact, finished character and therefore is of limited adaptability.

The human figure is an intricate interrelationship of organic units. To reflect precisely its significant spatial characteristics requires a very basic structural symbol—one that will mirror the figure selectively, but on a unit-for-unit relationship within a form. To fit varied situations such a symbol has to be simple, neutral, and adaptable. It is a curious paradox that the space in the very complicated human form can best be explained by the most primary spatial abstractions—the bare essentials of space measurement (and its symbols).

THE REPRESENTATION OF THREE-DIMENSIONAL STRUCTURE

Perceptual judgment, to be useful in drawing, must move to a level of visual abstraction more fundamental and adaptable than the geometric form, to an abstracted base that is common to both complex and simple forms. All forms are composed of lengths in various relationships. Understanding a complex form like the arm, for example, does not ultimately consist in visualizing the arm as a simple cylinder, but in reducing both the arm and the cylinder concept to their common dimensional components.

Dimensions are measurements of lengths of space. In figure drawing they mark an inner coherence of measured distance in three directions taken from surfaces and forms. The dimensional attributes of height, width, and depth represent, within a form, its space-filling capacity—its spatial quantity. An understanding of this abstracted characteristic of forms is important. Quantity (from one dictionary) can be described as that which has magnitude, size, volume, area, or length. Recognizing quantities of length in three directions within volumes is fundamental to an appreciation of the space of a figure. It is a function of intellect, distinct from, but based on a visual sense response.

Quantity (dimension) as such has no actual, separate, concrete existence. It cannot be isolated from its identity with material substance (and its attendant qualities: color, texture, etc.) "Quantity considered in itself, apart from the sensible qualities with which it is always found, is seen to be a constituent of all material bodies. There is no actual quantity which is not the quantity of something."[1] But it can be understood and abstracted as a concept. The idea of the space of a form can be intellectually divorced from all its visible attributes, that is, from material substance, surface texture, color shape, and value (light and shade). Identifying the figure's space involves the abstraction, from a form, of the dimensions of height, width, and depth as distinct, isolable factors. Spatial quantity (i.e., dimension) can then be given a separate, "symbolic" existence as measurement (like a ruler, a yardstick, or an eight-ounce measuring cup).

[1]Francis J. Collingwood, *Philosophy of Nature* (New York: Prentice-Hall, 1961), p. 72.

The measurements of a form, its dimensions, thus give autonomous identity to its space-occupying capacity. For example, a tailor's measurements for a custom-made suit provide spatial data separate from the figure—in effect, a symbolic, non-sensuous construct that equals the volume of the human form.

To isolate, in a form, the primary aspect of the purely spatial (the abstracted quantity of a form) from its sensuous apprehension by color and light, it may help to think of an object in a dark room. By physical contact its space-filling dimensions of height, width, and depth can be grasped as clearly distinct from optically perceived qualities (color, light, and texture). One can remove one's hands from an object and, by the distance between them, retain a measured space (an inch or a foot, etc.) independent of a given form (like the frustrated fisherman, indicating the size of the one that got away). In a similar fashion, a length of line, in drawing, can function as a symbol for a "length of space." (Each hand in the above demonstration independently indicates a spatial position correspondingly, a point in drawing can specify a spatial location, a specific place, that is the origin of a length of space.)

The nature of space and the discovery, within forms, of its main spatial attributes—location, direction, and dimension—provide the basis of a rationally consistent visual language in drawing. These spatial attributes can be observed and abstracted as a unified construct, free of sensible qualities (color, texture, light, and shade) and can thus be symbolically understood. Dimensions in drawing can be given a separate graphic identity by line and point; but dimensions in themselves remain conceptual attributes apparent to the eye, as sensed experience, only in the context of color, shape, and value. (Quantity has no separate identity.)

The primary function of line in drawing has been overshadowed by an undue emphasis on the "quality" of line in graphic description. Line "quality"—the capacity for implied textural description (i.e., hardness, softness, roughness, etc.), or value emphasis (light and dark line)—in both a general and specific sense is not the only purpose of line in drawing. Line has a very comprehensive function that has been largely obscured by an almost total and exclusive consideration of its "qualitative" possibilities.

The distinction between the immediate visual perception of "qualities" (i.e., color, texture, shape, substance) and the "secondarily" deduced factor of visual spatial "quantity" as an independent abstraction represented in drawing by location and length (graphically stated as point and line) is not apparent in the immediate act of drawing. The seeming directness with which one can describe a form with line can be deceptive of what a line represents. Line is not a representation of a sense impression in the direct sense that color is. (One can record on paper or canvas a directly seen color-value; but a line drawn on paper is not a reproduction of another line seen on a form.) Line, in observational drawing, is not a record of direct visual sensation.

What, then, does a line represent? It depicts something deduced from sensations. Since the defining characteristic of a line is length, a line represents an abstraction of length taken from directly sensed phenomena. The full meaning of that old truism, "There are no lines in nature," becomes evident when line is understood as a symbol for quantity (i.e., length measurement). Line is a means to give identity to space (length) separate from the direct visible sensation of qualities (color, value, texture, shape). (The point, as a symbol for position or location in space, will be discussed in detail later. As a symbol, it is less obvious, generally an implied but critically essential factor in drawing. The point establishes position; line defines length.)

Length and position are the basis of an intelligible space representation in drawing forms. All else is embellishment. The embellishments are important. They are

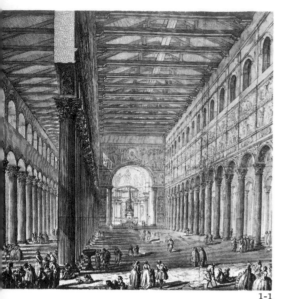

1-1

1-1 Detail from Interior of St. Paul Outside the Walls (engraving) by G. B. Piranesi. (Collection: the author. Photograph by Jonathan Goell.)

The columns and figures are seen in perspective. The forms visually are reduced in size in a receding space. The major converging perspective lines meet at the column supporting the left side of the arch.

the specifics of sense experience, qualities that amplify and give meaning to forms. But without a secure abstract underpinning of spatial order, forms may be dissipated into meaningless, unrelated superficialities—an incoherent pattern of light, shade, shape, and texture.

Line is often viewed as an edge, but line is not the simple equivalent of the margin of a form. To consider line merely as an edge is to leave unidentified its major significant function as measurement (as a container of quantity). Furthermore, to equate line with an edge is to substitute one abstraction for another. Edges cannot, in themselves, be detached from the surfaces of which they are a part. When they are mentally identified as "detached edges," they have, indeed, become an abstraction.

In observational drawing, a "seen" three-dimensional quantity, as an abstraction, undergoes a perceptual modification. Perspective is a factor. Obviously, in observed forms, visual extent—length as it relates to the dimension of depth (i.e., distance)—is perspectively altered by vision. It is not an "actual" measured length. Columns (or telephone poles) each of the same length are perspectively diminished in size as they recede in space from the viewer [1-1]. Or, an arm projecting toward the observer might have a visually foreshortened length of ten inches when its actual measurement is thirty inches. What should be distinguished, however, is the attribute being abstracted, a length of space that equals the observed extent of a form.

Space, in observed forms, is an abstraction of visually measured dimensions removed from perceived reality and held in mind as a relationship. These momentarily separated spatial attributes (height, width, and depth) when identified can then be viewed as an open transparent framework of the essential spatial aspects of simple or complex material bodies. In figure drawing, quantitative extension (i.e., length), as an abstraction from human form, may be measured from the significant limits of major organic anatomic structures (i.e., the length of the leg, from knee to ankle).

By viewing forms as visually measurable quantities (dimensions), those immediately perceived and insistent sensuous qualities (color, value, shape, and texture) are set on a second, more manageable level. The concept of a separate and independent three-dimensional spatial quantity then becomes the first aspect of form to consider.

In actual drawing practice, one reverses the order of direct perception. What is seen (sensed) first is set down second, and what is deduced secondarily is the first thing drawn. For example, the guidelines in a drawing are the first things drawn (but are not the first things observed) [1-2]. This may not seem directly apparent in a completed drawing. The fact that a sketch by Rembrandt may contain, in a few pen strokes, a synthesis of spatial measure and sensuously (texturally) embellished line does not alter the order in which these are thought out: line as space (i.e., length) comes first; line "quality" comes second. (Line, primarily a symbol of length, may be adorned with implied qualities, usually value and texture.) The fact that so much discussion of drawing revolves around line "quality" should not obscure the underlying essential function of line as a symbol for quantitative measurement.

Line as quantity (length) and line as quality (texture, value, etc.) are generally combined in the drawing experience by veteran draftsmen and expressed as a synthesis in drawing. There are, however, drawings in which a severe limitation is made—preparatory sketches restricted almost exclusively to quantitative relationships (the guidelines in a drawing). In figure drawing, a graphic illustration of nearly unencumbered observed dimensional measurement is the pen study *Le Joueur de Flageolet* by Jacques Villon. It is conceived as a "spatial" construct rather than a volumetric (solid) one. The distinction is important. As a functional, preparatory drawing it contains the bare minimum of sensuous description, a spatial statement unadorned by the sentient

12

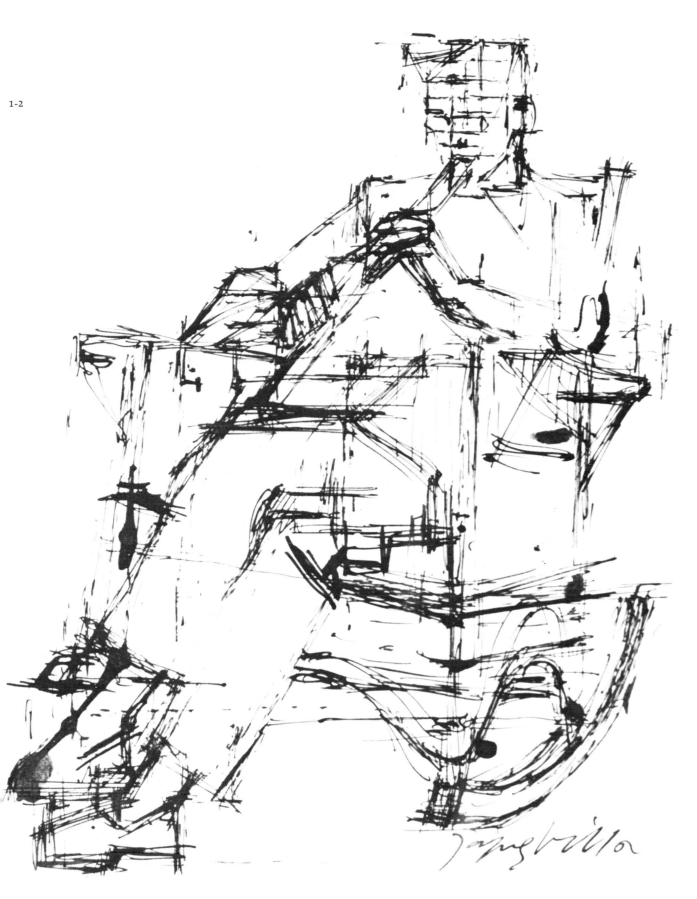

1-2 <u>Le Joueur de Flageolet</u> (pen and ink, c. 1938—39) by Jacques Villon. (Collection: Mr. and Mrs. Irving M. Sobin, Boston. Photograph by Kalman Zabarsky.)

In this spatial study, line measures the space of a form but does not describe the inner surface of a volume—an important distinction in drawing. Transparent alignments of vertical, horizontal, and diagonal directions limit the area of space to be filled by forms. This is a function of guidelines in a drawing.

appeal of modeling, tone, or texture. A "transparent" construct in which line functions within a firm scheme of verticals, horizontals, and diagonals, this drawing measures size, direction, and position. Its active penmanship has no specific textural focus (i.e., cloth, wood, etc.). It graphically illustrates the primacy of space (measured space) as that which precedes the development of a more substantial volumetric modeling. As a preliminary drawing, it offers a diagrammed plan, a visible scaffold of open, measured structure, eventually developed into an elaborate and finished etching.

Observational drawing in its visual-spatial aspects is essentially a process of freehand space measurement. In this respect, it has a clear relation to geometry and perspective.

PERSPECTIVE AND SPACE

Quantity (i.e., length) as a visually abstractable spatial concept is related to perception in depth. In the visual arts, it has been given diagrammatic identity by the science of linear perspective. Artificial linear perspective presents the possibility of representing depth on a two-dimensional surface in a simplified schematic fashion, employing lines and (vanishing) points. It deals with forms in space as perceived by the eye (forms reduced in size, the greater the distance from the observer).

Perspective, as a pure theoretical construct, does not concern itself with qualities. A pure outline drawing of a house in linear perspective offers no evidence of its material substance, color, texture, value—in a word, no evidence of its visible, sensible qualities.

Formal perspective theory, as an aid to drawing, has dealt adequately only with very regular geometric forms and form relationships. It is related to freehand drawing, but it has not been convincingly linked to figure drawing and complex anatomy in a way that is functionally useful. (See the reference to Jean Cousin in Chapter 2, page 33.) Yet the symbols of geometric perspective—the plane, the line, and the point—have a bearing on freehand form structure that is of vital consequence if vision in drawing is to develop any degree of sophistication.

The principle of space structure as the visually measured location of height, width, and depth (within a form), while easily grasped in theory, is widely ignored in practice, carelessly confused with light and shade, and lamentably misunderstood in the context of intricate human anatomy. Since it can be masked in an infinite variety of ways by complex anatomic and visual phenomena, its discovery within forms requires close examination.

Historically, the principle of three-dimensional structure derived from descriptive geometry (i.e., perspective) is the cornerstone of early Renaissance pictorial space. Vasari, in his life of Masaccio (c. 1401-1428), observes how this artist was the first (through foreshortening) to draw figures standing flat on their feet, correcting the old medieval manner in which figures seem to stand on the tips of their toes. Masaccio's ability to foreshorten forms coincided with his learning in formal perspective, discovered and communicated to him by his architect friend, Brunelleschi. (Apparently, Brunelleschi did not present his ideas in a written text, but in the form of drawn and painted diagrams. Alberti developed the first text based on the ideas of Brunelleschi.)

Masaccio was the first to shake off completely all medieval limitations in figure drawing. Following the instructive lead of Brunelleschi and Alberti, early Renaissance draftsmen like Uccello and later Mantegna, fascinated with the new science of perspective, gave an obvious perspective emphasis to figure structure. Their forms, while

1-3 Detail from The Rout of San Romano by Paolo Uccello. (Courtesy: The National Gallery, London.)

This early Renaissance example of foreshortening in the human figure shows the influence of perspective.

1-4 The Dead Christ (oil) by Andrea Mantegna. (Pinacoteca di Brera, Milan.)

This well-known painting may be studied as a moving and dramatic exercise in foreshortening by a master of Renaissance perspective.

14

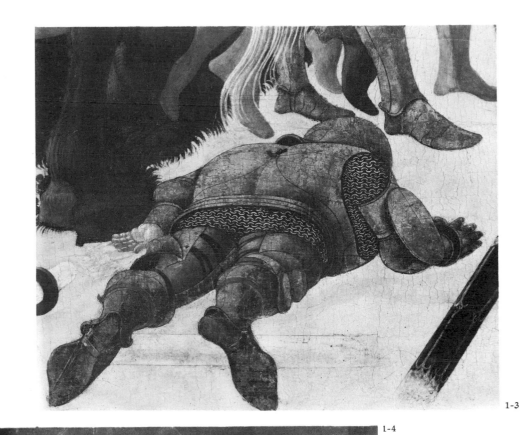

1-3

1-4

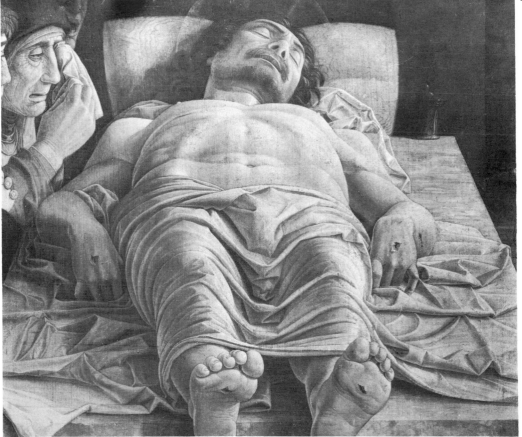

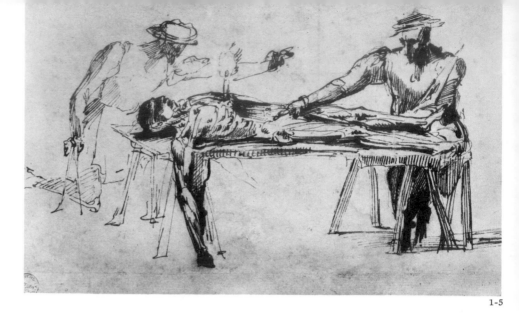

1-5

1-5 <u>Study for Anatomy Dissection</u> by Bartolomeo Manfredi. (Courtesy: Ashmolean Museum.)

The science of human anatomy developed rapidly during the Renaissance, encouraged by youthful and original investigators like Andreas Vesalius. The Renaissance artist was an eager student and participant in this study of the human figure.

convincing, are dependent on an invented space carefully directed to vanishing points [1-3, 1-4]. With the rapid and extended investigation by Renaissance artists into anatomy and drawing, it was discovered that the intricacy of human forms required a correspondingly suitable and adaptable framework for figure space more related to direct observation, and capable of spatial consistency [1-5].

How was spatial order in the figure to be maintained without confusion, while accommodating the growing complexity of anatomic information observed in the human form? The genius of the Renaissance artist found the answer with apparent ease and expressed it in drawing as a spatial construct, an informal perspective, freely adapted to observation. This concept has continued to be an underlying (often tacit) influence in Western pictorial vision.

A clue to the solution of the problem of structure is offered by Leonardo da Vinci in his *Paragone,* where he defined the nature of the artist's space: "The science of painting begins with the point, then comes the line, the plane comes third, and fourth the body in its vesture of planes. This is as far as the representation of objects goes. For painting does not, as a matter of fact, extend beyond the surface and it is by these surfaces that it represents the shapes of all visible things."[2] The geometric derivation is from Euclid's *Elements:*

1. A point is that which has no parts. (A point has position but no dimension.)
2. A line is breadthless length.
3. The extremities of a line are points.
4. A straight line is a line which lies evenly with the points on itself.
5. A surface is that which has length and breadth only.
6. The extremities of a surface are lines.

The translation of these geometric concepts into the sensuous experience of freehand observational figure drawing has not been, to my knowledge, clearly or extensively developed in a drawing text. Leonardo, in his book on painting, did not outline the procedural implementation of his definition in the *Paragone.* Although he made many references to mass and volume and to the perspective of whole bodies diminishing in size in a common space, he did not clarify or develop the use of space measurement and locational relationships in detailed freehand drawing of the specific parts of the figure form. Yet, in practice, it has been part of a visual language of enormous significance in dealing with complex irregular forms and the basis of what may be termed space structure in Western European (post-Gothic) spatial drawing.

Forms, to be fully understood, must be reduced to their constituent planes. Conceptually, in a geometric sense, there is a further reduction of the plane to its limiting edges (lines—the equivalent of length) and connecting corners (points—the equivalent of position).

[2]Irma A. Richter, introduction and English translation, *Paragone, a Comparison of the Arts,* by Leonardo da Vinci (Oxford University Press, 1949), p. 24.

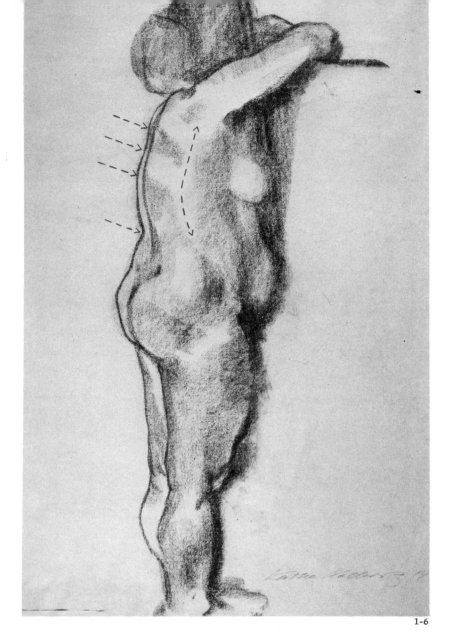

1-6 <u>Standing Nude</u> (charcoal) by Käthe Kollwitz. (Collection: Mr. and Mrs. Irving M. Sobin, Boston. Photograph by Barney Burstein.)

1-6

Accurately conceived tonal drawing is a means of defining structure. Contour changes of direction (in the silhouette) are carefully related to changes of planes within the form. These are expressed by carefully observed tones (values) extending into the inner surface. The vertical highlight on the inner torso follows the larger contour curve of the back, showing a surface change from the back, to the side, to the front of the body.

The geometrician's concept of line and point is a pure non-material abstraction. A line as pure length has no thickness. A pure point has no dimension (but it can be understood as location). Piero della Francesca in his treatise, *De Prospectiva Pingendi*, translates the geometrically conceived abstract nature of line and point to the practical needs of the draftsman: "A point is that which has no parts, and according to what the geometricians say, is only in the imagination. A line, they say, has length without breadth and because of this is apparent only to the intellect. But I say that in order to discuss perspective with demonstrations, which I wish to be comprehended by the eye, it is necessary to give another definition. Therefore I say, a point is a thing as small as it is possible for the eye to comprehend. A line, I say, is an extension from one point to another whose breadth is of the same quality as the point. Surface, I say, is width and length enclosed by lines...."[3] In graphic representation, the conventions of line and point (implied or drawn) are necessary to give objective identity to surface limits in drawn forms.

Tonal drawings such as those by Seurat, Prud'hon, Menzel, and Kollwitz seemingly depend on a broad expanse of modulated value only. But their spatial strength rests on a point location structure inherent in angular changes in the silhouette and identifiable related lengths running into the form through a tone. A field of value gradation or shadow tone (carefully observed) has a structurally functional limit [1-6].

[3]Elizabeth G. Holt, *Literary Sources of Art History: An Anthology of Texts from Theophilus to Goethe* (Princeton University Press, 1947), p. 156.

1-7 The Symbols of Space.

In an abstract sense, the symbols of perspective (lines and points) identify important aspects of space. Lines identify direction and length; points identify location. Graphically, the breakdown of a simple form to its geometric constituents is: plane—to line—to point. In drawing, the point (the unit that has position in space) is the essentail useful resource. Terminal locations (points) abstracted from more complex forms (i.e., the human figure at its bony articulations) are a means of understanding its spatial order. In a simple block, the corners can be abstracted and symbolically located as points. Their position is important in conveying the idea of a block.

1-8 Allegory of Fidelity (oil on canvas, 1570-80) by Tintoretto. (Fogg Art Museum, Harvard University; Gift of Mrs. Samuel Sachs in memory of Mr. Samuel Sachs.)

In this unfinished canvas by Tintoretto, selectively precise brush drawing is revealed in the underpainting of the legs, setting up large plane relationships. (For details, see illustrations 1-9, 1-23, and 6-23.)

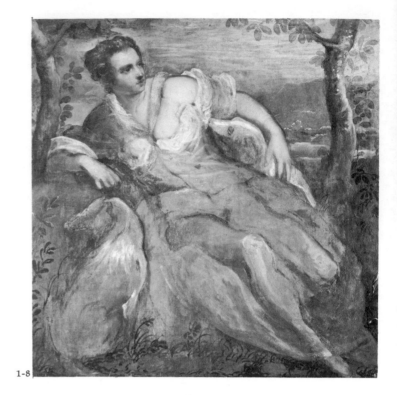

1-8

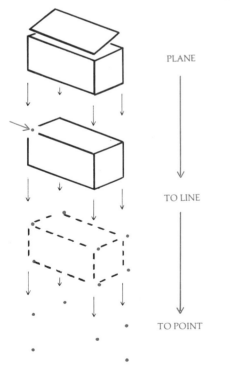

1-7

PLANE

TO LINE

TO POINT

The space structure within volumes is here understood to be the visually measured relationship at the juncture of two or more plane surfaces. Since connecting planes are limited by corner points common to both planes, the elimination of connecting lines (i.e., edges) leaves the points in an established position in space [1-7].

In drawing, the point (the unit that has position) is clearly the most fundamental space symbol. In establishing drawn spatial relationships, it is the essential resource. Structure is stated primarily by relationships of location, not by linear or modeled connections. It is the measurement of that portion of space occupied by the form rather than the form itself (quantity stripped of substance). Its function is to establish with precision the positions of height, width, and foreshortened depth within a volume. As part of a fundamental freehand geometric perspective, it deals largely (though not exclusively) with foreshortened forms.

Structure as an order of positioned relationships may be graphically represented by the point, but in practice, as a symbol for location, the point is rarely stated directly. It is generally held in mind and functions as a concealed, implied element in drawing.

Position or location within a form is important in communicating a visual idea. A simple block is identified by a relationship of its corner limits (represented by points) carefully calculated by observation [1-7]. If this relationship is not attentively observed (or is deliberately altered), another quite different visual idea (form) will result [1-10].

In drawing the human form, the very same locational considerations are important. In the leg a similar blocklike structure, but organically more complex relationship, exists. Complexity can distract attention away from a fundamental spatial order. As a result, the positions of limits in an intricate human form—at the knee joint, for example—are often carelessly noted. Consequently, even though the leg may be carefully and persuasively modeled, the drawing will seem spatially flat. The difference may be illustrated by the detail from the Tintoretto figure [1-9], and altered in the accompanying drawing [1-10].

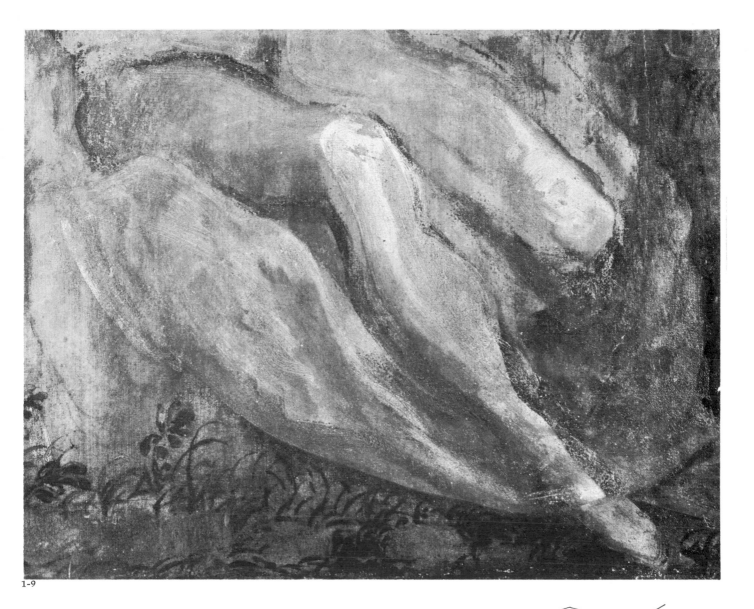

1-9

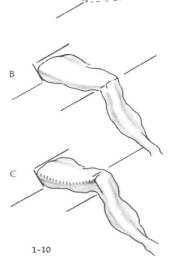

1-10

1-9 Detail from <u>Allegory of Fidelity</u> by Tintoretto.

The locational limits in the knee articulation are strong and spatially convincing, like the corners of the block in illustration 1-7. A frequent error in drawing is illustrated in the diagrammed sequence [1-10] based on this detail.

1-10 Distortion of Space.

A frequent error in drawing is illustrated based on the leg detail [1-9] from the painting by Tintoretto. In figure *A*, the inaccurate location of corners flattens two right-angled planes. This is obvious in a simple block. The same distortion is frequently overlooked in drawing from the human figure. Though convincingly modeled, figure *B* contains the above spatial contradiction. In figure *C*, the right angles at each end of the form explain the planes that make up the volume. The position of the kneecap above the lower contour contains the full dimension and direction of the side plane in relation to the top plane of the leg.

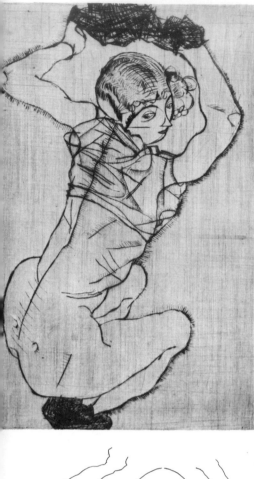

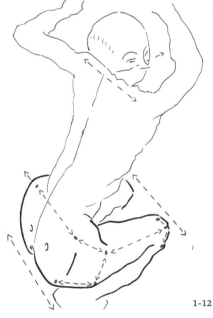

1-11 <u>Squatting Woman</u> **(etching, 1914) by Egon Schiele. (Courtesy: Galerie St. Etienne, New York.)**

Perspective, space, and volume are skillfully conveyed in this line drawing. Selectively consistent location is the key to spatial order. (See the analysis, 1-12.)

1-12 Diagram of Space.

Carefully compare this analysis of related locations within the figure with the etching by Egon Schiele. Locational structure is clear and conveys a consistent perspective.

When location is noted carefully, the modeling is reinforced, and space and modeling are consistent. With experience, when forms are fully understood, often little or no modeling is required. A great deal of information is compressed within a few related lines and cogently, convincingly implied [1-11]. It should be stressed that a drawing of this latter kind is the result of close study and long experience.

If one considers spatial ideas in terms of locational relationships, a more precise synthesis of anatomy and form is possible [1-13]. Positions are observed with care and can be identified with specific skeletal or muscular units. The problem is still a difficult one. Planes in the figure are not limited to simple or obvious right-angle relationships as in the above examples. They are varied and complex, set at many subtle angles, and fluidly merging, one with another within a form unit.

Intricate anatomic structures can easily obscure significant fundamental relationships. For purposes of space explanation in freehand drawing, the nature of point-location must be broadly interpreted. In the figure, smaller anatomic entities (a round bone or muscular eminence) can serve as a structural limit (i.e., a geometric point).

The point is a convention and a convenience, a mental symbol for the location of visual positions within a relationship. In a drawing it is embodied in the order of parts which make up a plane and which relate plane to connecting plane in a representation of the full three-dimensional volume. In figure drawing, the point may be used as an abstract symbol for the precise position of a part of human anatomy—in effect, a temporary mental (or graphic) stand-in.

Ideally, space within a volume may thus be conceived as an abstracted scaffold of associated locations (height, width, and depth) which may be represented by the geometric concept of a point. Whether graphically stated or held in mind, the point identifies a single factor only: one positioned limit of a visually measured extension of surface. It is an element clearly distinct from patterns of light and shade on a form. This should be emphasized. While light is an obvious necessity to vision, the interpretation of significant clues on a lighted form aims to identify surface areas beneath tonal modulations.

By its abstract and neutral character, the located point can define spatial limits in any and all forms without influencing expression, style, or technique. It can be uniquely useful in giving spatial order to complex anatomic relationships in figure drawing. Structure provides support for expression. The function of this geometric symbol (the point) is to aid the artist to hold in mind a framework of locational limits; first in their widest order and distribution within an overall form, and then proceeding to smaller related parts.

The initial selective isolation of important locational limits in the human form is abetted by a knowledge of important bone relationships at the extremity of a form. The Raphael study [1-13] is a good example. In the drawing of the bent elbow, three points of location are inherent—in the two epicondyles of the humerus and the olecranon process of the ulna. They set the order of planes which end at the wrist in a related spatial sequence [1-14]. While this space structure is more obvious where skeletal limits come directly to the surface of a form, the same analysis can be made in the more muscular and fleshy parts of the torso.

The choice of which prominences to use as a basis for significant surface structure can be determined by their utility in containing and explaining the broadest extent of surface. Thus, a wrinkle or vein on the skin occurring midway between wrist and elbow would not contribute to an understanding of the largest or broadest organic structure of surface in the forearm. It would be an unfortunate choice as a structural

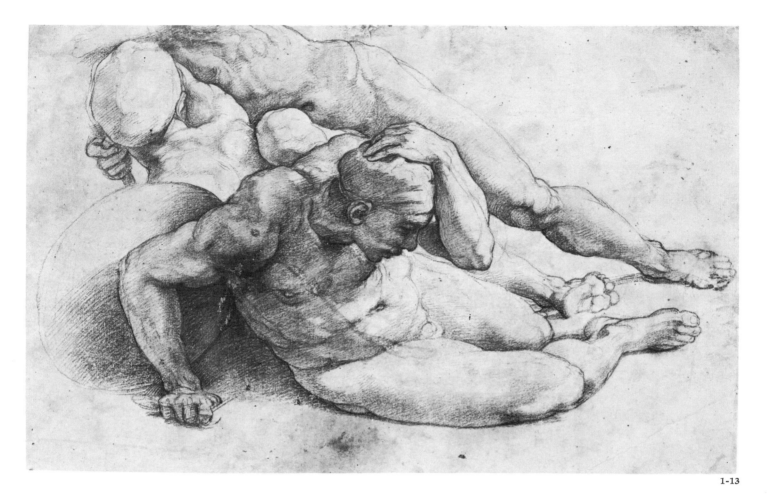

1-13 <u>Three Nude Men in Attitudes of Terror</u> (black chalk) by Raphael. (Devonshire Collection, Chatsworth. Reproduced by permission of the Trustees of the Chatsworth Settlement.)

The relationship of planes in the raised forearms is dependent on its bone structure. The light and dark planes join along an axis running from elbow to wrist. For an analysis of surface order and its dependence on skeletal anatomy, see the accompanying diagram [1-14].

1-14 Analysis of Skeletal and Plane Structure.

The diagram is based on the chalk drawing [1-13] by Raphael. Figure *A*: Within a long form, the position of bony prominences at the end of the volume determines the surface development within the overall length of the form. The triangular arrangement of bones at the elbow sets the direction of major opposing planes that end at the wrist. Figure *B*: A simplified diagram indicates the surface relationships from elbow to wrist. Within this broad order of two planes, smaller form units have been integrated while this basic structure is preserved.

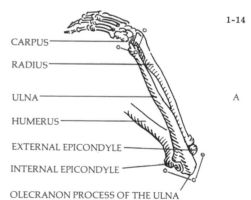

1-14

CARPUS

RADIUS

ULNA

HUMERUS

EXTERNAL EPICONDYLE

INTERNAL EPICONDYLE

OLECRANON PROCESS OF THE ULNA

A

B

21

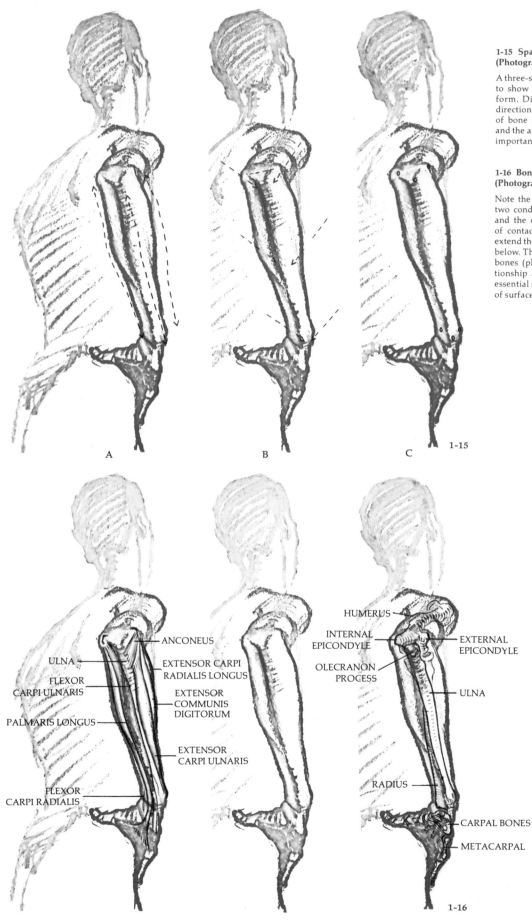

1-15 Space Analysis of an Arm by the author. (Photograph by Jonathan Goell.)

A three-stage visual analysis of an arm is reproduced to show significant relationships at each end of a form. Directions of length (*A*) intersecting with directions of width (*B*) identify the locational limits of bone at each articulation (*C*). (This illustration and the accompanying text explanation represent an important key to the analysis of space.)

1-16 Bone Structure: Key to Space in the Figure. (Photograph by Jonathan Goell.)

Note the triangular relationship at the elbow. The two condyles of the humerus bone are the origin and the olecranon process (of the ulna) the point of contact for the two long diagonal planes that extend the full length of the forearm to related angles below. The styloid processes of the ulna and radius bones (plus muscle tendon) create a similar relationship at the wrist. These positions provide the essential structure for the modeling and refinements of surface.

A B C 1-15

ANCONEUS
ULNA
FLEXOR CARPI ULNARIS
PALMARIS LONGUS
FLEXOR CARPI RADIALIS

EXTENSOR CARPI RADIALIS LONGUS
EXTENSOR COMMUNIS DIGITORUM
EXTENSOR CARPI ULNARIS

HUMERUS
INTERNAL EPICONDYLE
OLECRANON PROCESS
EXTERNAL EPICONDYLE
ULNA
RADIUS
CARPAL BONES
METACARPAL

1-16

22

limit. Prominent veins on the back of the hand, for example, if copied solely as shadow pattern, destroy the sense of continuous unified surface.

Understood as an abstracted relationship, space structure permits a wide variety of form and textural development from the simple line sketch to the heavily modeled or patterned drawing. In perceptual practice, it is the discernment of an abstracted arrangement of dimensions; a framework briefly lifted from its context, visually measured, then restored to its specific location in a form. Its identification does not require the elimination of complexity but demands instead a technique of initial selective visual isolation. Since numerous small curving plane surfaces can obscure the overall surface order in the figure, the uncovering of significant points of structure requires focused perception, experience, and some understanding of important surface anatomy. Difficult to discover in complex reality and generally concealed by artistic or expressive intent in drawing and painting, structure may be called the hidden language.

The following example illustrates the observational procedure involved in analyzing the space in a drawing. Of course, it must be clearly recognized that the drawing [1-15] represents the completed thought of the artist, and important selective emphasis has already been distilled from reality. Reading the space in the drawing is not the same as facing the myriad complexities of the living, moving model. But the means of identifying fundamental structure is essentially the same. To "uncover" the explanatory spatial structure in this detail of an arm (in this case, a long form): (A) related directions of length are identified running parallel or nearly parallel through the length of the form (as in the contours and the direction of shadow from elbow to wrist); (B) related directions of width moving in from both long contours at the elbow and wrist are noted (which may be parallels or near-parallels running into the center of the volume from the contours); (C) where directions of length intersect directions of width at the end of the form (the articulations), the limiting angles (points) of surface are identified and located as a basis for the description of surface and volume.

This indicates an essential order. With practice, it may be held in mind as an abstracted construct on which the forms are drawn. Explanation of complicated, overlapping forms is dependent on the specific anatomy of muscles, related to bones [1-16]. Part two of this text develops this relationship.

DIRECTION IN DRAWING

Direction in drawing is closely tied to location and length. Simply understood as the movement between two locations, it may be vertical, diagonal or horizontal. (The degrees of diagonal are countless.)

Direction, as the major action or gesture of the figure, is an initial important concern in drawing. As a primary spatial factor it seldom receives the full consideration it deserves and is open to easy misrepresentation. It can only be successfully established in the first stages of a drawing. Therefore, ample time should be allowed to make careful, accurate judgments of the chief actions. Precise comparison of the figure with an adjacent vertical—a door frame or the vertical corner of a room—is a convenient, useful aid in discovering the main axis of a form [1-17]. When there is no neighboring vertical, a pencil (or other drawing implement) can be held firmly at arm's length on the line of sight with the figure, and will perform this same function.

Quick gesture drawing may help the student grasp large actions and relationships, and it does stimulate an alert frame of mind. But gesture drawing also opens the possibility of self-deception. The spontaneous but imprecise, inaccurate movements of

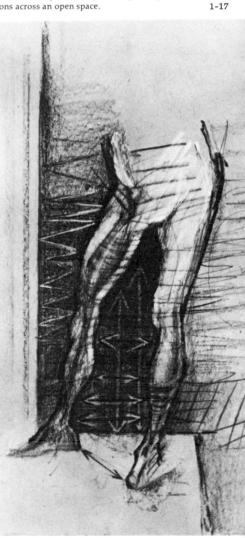

1-17 Direction and Figure Gesture. (Photograph by Kalman Zabarsky.)

The gesture of the figure may be accurately observed by comparing the directions in the figure with a nearby vertical (or horizontal) direction. Arrows and zigzag white lines illustrate graphically the movement of the eye carefully viewing divergent directions across an open space.

1-17

1-18 Study of a Man Standing, Seen from the Back (charcoal) by Edgar Degas. (The National Gallery of Canada, Ottawa.)

In this study the figure is seen from the back; the left leg is raised and the left elbow rests on the knee. A too-narrow focus on small individual irregularities of contour frequently obscures long directions and major changes along the edge of a form. In this early study by Degas, significant contour changes have been precisely observed. Smaller irregularities have been compressed, but not lost, within the sequence of longer movements (i.e., angular changes at the ankle, calf, and hip in the extended leg.)

1-19 Lucretia (black and white ink) by Albrecht Dürer. (Graphische Sammlung Albertina, Vienna.)

Rounded volumes with subtly continuous curved surfaces can reveal structural clues through an understanding of the articular connections of the skeleton. The bony projection at the hip (great trochanter of the femur) unites two opposing directions above and below. (See the accompanying diagram [1-20].)

1-20 Diagram from Lucretia.

The identification of a structural limit in subtly curving forms. The "peak" of the curve in the rounded hip is determined by the projecting great trochanter of the femur bone. This prominence affords a structural limit.

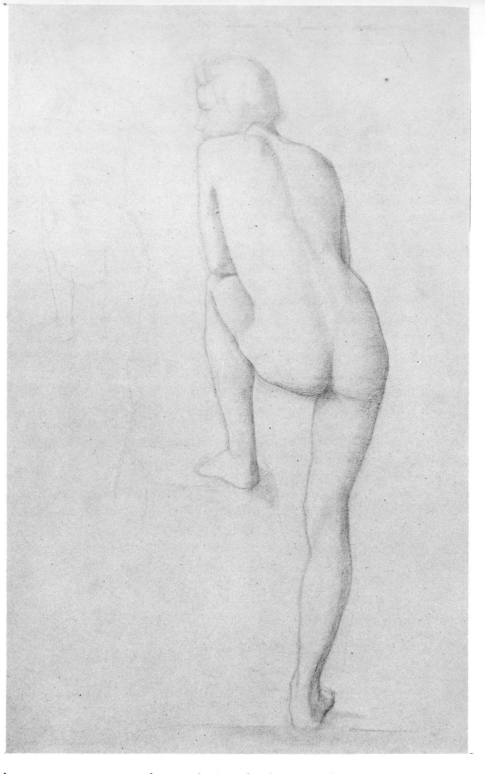

1-18

the crayon on paper are often a substitute for the true and convincing action of the figure. The rapid crayon marks may have a superficially attractive sense of movement but no relation to the actual gesture. With careful observation, however, gesture studies may help to focus attention on the larger actions and dimensions of the figure.

Students who have experienced the alert attention inspired by quick poses should remember that this same alertness can and should be sustained in longer studies of the figure. Drawing is not a passive, mindless activity of mechanically recording the shadow-shapes on a form or a series of meaningless linear bulges on a contour.

Direction in drawing is paramount in planning the large disposition of related forms. It also is an important consideration in the refinement of surface relationships within forms—that is, the direction along the margin between adjoining surfaces. These occur, often with great subtlety, throughout the figure. An easy-to-see example is the

exposed shaft of the shinbone (tibia) which follows a continuous direction from the knee to the inner ankle. Two planes of the front of the lower leg join along this curved direction. (See illustration 1-22.)

Structure in relation to the subtlety of curved forms and contours requires special comment. Curves and angular changes in contour should be noted with great care in the figure. All curves are not the same, though in drawing they are often carelessly assumed to be. They vary enormously from long, open crescents to short, hooklike arcs. A sharply constricted contour curve may serve functionally as an angle (point limit) in describing a change of plane. Directional changes in a contour, which at first glance may seem easy and fluid, can be compressed to an almost angular opposition of direction. The early, largely linear, study by Degas [1-18] accounts for numerous small variations kept subordinate to larger, precise contour "breaks." The contour of one side of a form is carefully related to the contour of the other side of the form.

Long contour lines and precise angular changes may be camouflaged by small irregularities. Care should be taken to keep these smaller contour irregularities from overpowering and obscuring major breaks in direction. The Degas drawing presents a good, disciplined example of small irregularities compressed to emphasize main contour movements.

The relation of point location as an internal structural element in rounded volumes has also to be considered. In this instance, complexity and asymmetry aid the draftsman. The organic irregularity of forms or, more accurately, the interplay in the figure between curved and angular relationships prevents an absolute perfection of geometric volume. Rounded forms in the figure are not purely round, and, in addition, they intersect with adjacent forms. The intersecting connection between two form units creates an angle of different directions and thus provides the location of a structural limit.

In the female form, in which rounded volumes generally dominate, angular connections occur between round forms as well as between flat planes. In the drawing by Dürer [1-19], the almost pure conical form of the thigh intersects at the hip with a long vertical angle [1-20]. Again, the connecting relationship at the end of the form (usually a bone) clarifies the surface definition through the length and mass of volume.

In continuous irregular surfaces which, in many parts of the figure, extend from one bony limit to another, there are angular changes. These often are subtle in curvature, and may encompass subordinate points within their surface areas. These subordinate softer, muscular surface transitions, while they should be observed carefully with respect to structure, can generally be emphasized less than the articular limits of form, which more often are hard and skeletal. A strict flattening of rounded surfaces can result in excessive geometricising in a rigidly mechanical fashion. A qualification is in order here.

Though there may be a temporary danger of fragmentation and disunity, it is helpful to identify changes in the direction of a curve by reducing it to faceted sections along its curved length. This sharpens observation. When this has been accomplished in the context of other relationships, and the character of the curve is understood, faceted units can be reintegrated into a fluid and unified curved plane and contour.

In drawing, visual sensitivity to hard bony surface in relation to softer fleshy form should help to avoid the danger of making repetitious and mechanically meaningless facets. Proceeding, say, from the elbow to the wrist, the rounder egglike fleshy part on the upper forearm develops into the blocklike bony and tendinous form of the lower forearm (just above the wrist). The transition from bony surface to fleshy form should be carefully noted in dimension and direction.

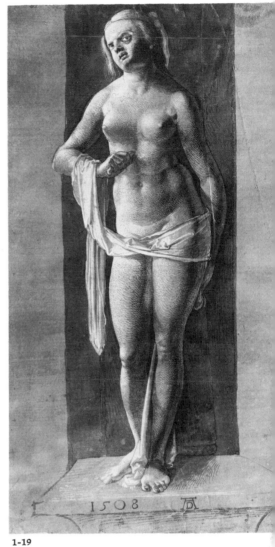

1-19

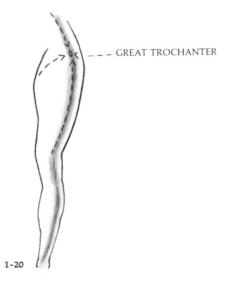

 — — — GREAT TROCHANTER

1-20

25

LIGHT AND STRUCTURE

Although structure has its own clear primary abstract identity, it requires the indispensable condition of light to be visually revealed and drawn. But, as indicated earlier, whereas light can reveal, it can also confuse. Misunderstood as a tracery of meandering tonal pattern, light and shade can camouflage and destroy all semblance of spatial order in forms. It must be understood selectively and apart from the relationship of the connected surfaces of a form.

While the artist, as observer, is dependent on light and shade, these are not inherent qualities of form. If a form could be evenly lit from all sides by many sources of equally intense light, the form would then reveal its allover tonal value minus shadow (value) changes. Shadow then would be cancelled out as a distorting factor and as a component influencing visual sensation.

Light and shade are, undeniably, a part of an immediately sensed phenomenon, but they are variable effects, not permanences of the form. For instance, shadows change when the source of light is altered in relation to a stationary form. The fact that illumination is from outside the form may be understood intellectually but quickly forgotten in the hurried, involved activity of drawing. Then, cut-out shapes of light and dark or vague, meaningless smudges become a substitute for the underlying surface of the volume.

In the act of drawing, many inexperienced artists are too readily attracted to patterns of light and shade on the figure before they have understood the underlying structure of surface. Even after the full intellectual awareness that the effect of light and shade is a secondary consideration to surface, the habit of "copying light" is not easily overcome and results in weak and chaotic drawing. Numerous small lights and shadows on an intricate bony, muscular form seem to have no apparent order. Many unwary draftsmen treat highlights as solid shape and shadow as substance, but both are equally transient effects and should be clearly understood as such. When this is fully realized (and it cannot be stressed enough), highlight and shadow can be viewed as useful and functional in drawing, for both offer essential clues to surface development within a form.

Light and shade, or, more precisely, highlights and lengths of shadow, can act as "pointer-indicators" to space structure. Seen in relation to contour, they often bear a parallel or nearly parallel relationship and can direct the eye to surface changes at significant limits. The ability to observe and identify these alignments when they occur is exceedingly useful in drawing. (Refer to illustrations 1-26 and 1-27.)

Surface limits, the edges of planes within a form, frequently duplicate the direction of one of the enclosing contours. Identifying and tracing parallels can direct the eye quickly to important structural relationships at each end of a form unit. The clues are revealed by the direction of lights and shadows. Contour limits and long highlights are often parallels, enclosing planes. This is not always recognized, particularly in such a varied and confused mass as the hair or through the complicated length of the torso. The parallel between a length of shadow and a contour is often obvious and more easily identified.

Parallel relationships in a form occur with frequency: (1) between a contour and a shadow; (2) between a shadow and a highlight; (3) between a highlight and a contour; (4) between related contours; (5) parallels across the form. It will be useful to illustrate each of these conditions.

Contour and Shadow. In *The Carmelina* [1-21], a strongly lit early painting by Matisse, the precision of parallel relationships between a contour and a shadow are clearly set

1-21 <u>Carmelina</u> (oil) by Henri Matisse. (Courtesy: Museum of Fine Arts, Boston; Arthur Gordon Tomkins Residuary Fund, Tomkins Collection.)

The parallel relationship between a contour and an edge of shadow within the length of a form is clearly defined in the legs. In the right leg, the shadow from knee to ankle repeats both contours of the calf. At the knee, the rectangular plane of shadow and its adjacent plane of light enclose the end of the foreshortened thigh. In this way, light and dark planes create a convincing volume from one contour to the other, supported by vigorous, accurate brushwork.

26

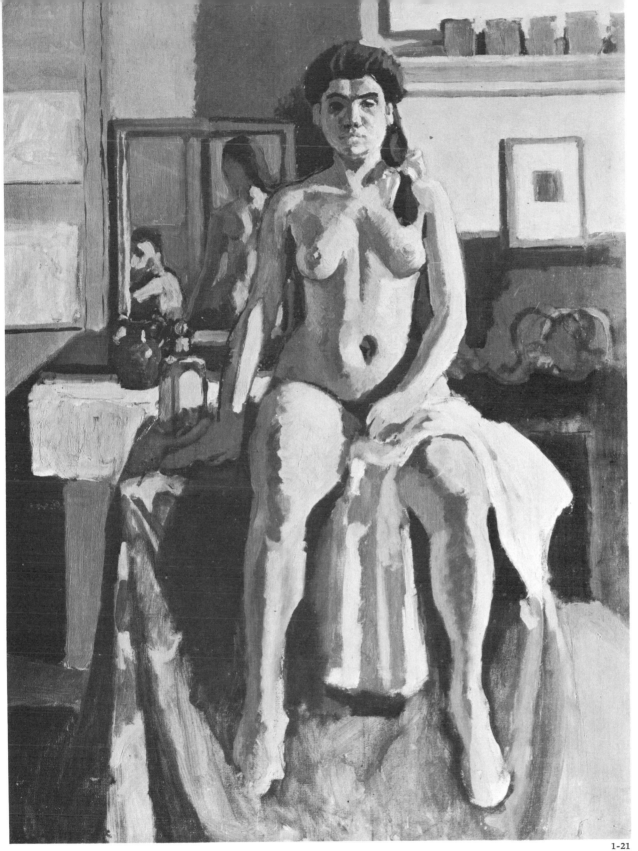

out in the legs. The limits of the plane of dark shadow in the right leg repeat both enclosing outer contours from knee to ankle. This surface becomes the transitional connecting plane across the form. The outer edge of this shadow follows the crest of the tibia (shinbone), the sharp angled connection between the two front planes of the lower leg.

1-22

1-22 Seated Nude Woman by Jean Baptiste Greuze. (Fogg Art Museum, Harvard University; Bequest of Meta and Paul J. Sachs.)

The foreshortened volumes of the thighs from knee to hip contain strong modeling across the surface of each plane, emphasizing surface direction.

Shadow and Highlight. Parallel relationships between a shadow and a highlight occur habitually on the front plane of the nose and identify the three planes (two sides and front) that make up the larger part of this form. This close relationship between a highlight and a shadow may also be observed in the drawing by Greuze [1-22]. The highlight in the right forearm from elbow to wrist and the shadow below it from elbow to wrist enclose a long horizontal plane (directed upward from the lower contour). The receding planes above and below are coordinated in tone and contour with this inner relationship. The inner surface edge dividing the upper arm and forearm is also coordinated, and ends at the highlights. The shadow below relates also to the lower contour and perspectively carries the plane away from the spectator.

28

1-23

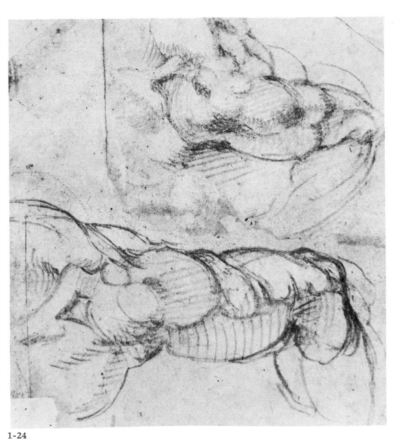

1-24

Highlight and Contour. Parallel relationships between a highlight and a contour are seen in the detail [1-23] from Tintoretto's technically revealing work, *Allegory of Fidelity* [1-8]. This is an unfinished canvas showing clearly the first stages of drawing in large areas (the underpainting). The fluid but precise brush drawing in the underpainting of the leg explains clearly the two major long planes. Closer analysis is valuable. Within the large unit of the knee, the highlight follows the inner contour in a sequence some degrees lower but still parallel with it. The lower position of the highlight implies a series of diagonals that give a forward thrust to the inner plane of the knee. It should also be noted that this highlight follows the surface prominence of the patella, the ligamentum patellae, and the long crest of the tibia (shinbone) from knee to ankle.

Related Contours. Parallels between contours enclosing a form are most difficult to identify in the larger and more complex forms in the figure. The torso in certain views and positions presents a distinct problem. Parallel or near-parallel relationships may exist between two enclosing contours in their longest overall direction and dimension (the full length of the torso). Taken singly, however, an individual contour may be widely different in each of its particular, smaller characteristics. This is the case in views of the torso and the profile of the head and neck. This may be seen clearly in the contours of the back in the drawing by Degas [1-18].

Parallels Across the Form. Parallels are important in related units of overlapping forms usually indicated by contour lines, breaking into a form at right angles to its length and running crosswise to the length of the form. A clear example is the arm study [1-24] by Michelangelo. The contour overlapping the back of the deltoid is part of a parallel sequence ending at the elbow.

1-23 Detail from Allegory of Fidelity by Tintoretto. (Fogg Art Museum, Harvard University; Gift of Mrs. Samuel Sachs in memory of Mr. Samuel Sachs.)

The relationship between a length of highlight and a parallel contour from the knee to the ankle is a first, precise observation in this unfinished work by Tintoretto. It is a revealing study of essentials in developing a form. (The entire painting is reproduced in illustration 1-8.)

1-24 Detail from Study of an Arm by Michelangelo. (Teylers Stitchting, Haarlem.)

Linear parallels extending across the back (top) plane of the arm from the shoulder to the elbow. The curve of the deltoid, the diagonal triceps, and the direction of the condyles of the humerus establish a related parallel sequence cutting in from the long contour and support the perspective of this plane.

29

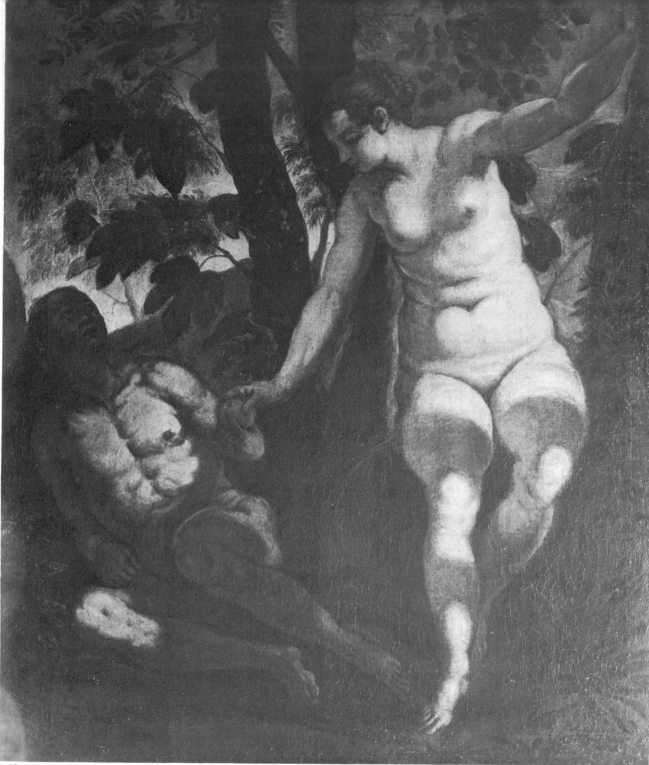

1-25

CAST SHADOWS, HIGHLIGHTS, AND MODELING

1-25 <u>Adam and Eve</u> **(oil on canvas) by Tintoretto. (The National Gallery of Canada, Ottawa.)**

Cast shadows, encircling the legs, emphasize their conical volumes. Perpendicular directions running through the length of the thighs may be picked up within the encircling shadows. The inner edge of reflected light is tied to surface changes ending at the knee and hip in the right leg. (Study the shadow side of the torso for parallel directions from hip to breast.)

Cast shadows present a perplexing problem to the draftsman. Clearly the product of an influence from outside the form, they are nonetheless a part of the visual phenomena with which he may have to contend. A ribbon of shadow cutting across the middle of a form can be revealing if intelligently understood, or result in disaster, if not.

In the Tintoretto *Adam and Eve* [1-25], the figure of Eve presents a typical baroque compositional device—the dramatic use of the cast shadow. Both thighs are encircled by broad bands of shadow (cast from a nearby tree) and create a dramatic

pattern. They give immediate emphasis to the modified conical volume of the form. At first glance these shadows have the appearance of easy fluid curves. On closer examination, a more precise change from the vertical to the horizontal curve can be identified. A glance at the perpendicular movements from knee to hip will reveal connections of an important kind. Vertical and horizontal curves at the hip are repeated at the upper shadow edge and precisely where the vertical plane of reflected light on the inner thigh meets the darker horizontal shadow plane on top of this form.

A knowledge of bone structure, particularly as it affects an articulation (i.e., wrist, elbow, knee, etc.) or the extremity of a form, can offer a means of identifying related directions of shadows indicating major broad surface connections within a form. Sharp points of highlight are also helpful as clues to a coming together of related planes. Again caution is in order not to abuse the planes in favor of the clues.

In seeking structural limits within a form, the direction of thin linear highlights is as useful as directions through shadows. Connected directions of interrupted linear lights on undulating surfaces are, however, more difficult to recognize. A pattern of sharp highlights can form a direction. Their identity, through their length to the end of a form, can often pinpoint a major structural surface change [1-26, 1-27].

1-26 <u>Study of a Nude Male Figure, Seated</u> (red chalk) by Michelangelo. (Graphische Sammlung Albertina, Vienna.)

A number of apparently independent small highlights discovered on curved and undulating surfaces may form a connected sequence pointing to a structural limit at each end of a form. In this study, the highlights are directed to the greater tuberosity (shoulder) and the external epicondyle of the humerus bone, indicating the relationship between the planes of the back and side of the upper arm.

1-27 Analysis of an Arm.

This analysis is based on the study by Michelangelo [1-26]. The sequence of highlights points to each end of the humerus, the external epicondyle (A) at the elbow and the greater tuberosity (B) at the shoulder. This alignment is the connection for broad planes on the back and side of the arm. The muscles, as smaller form units, fit into this broader scheme.

1-26

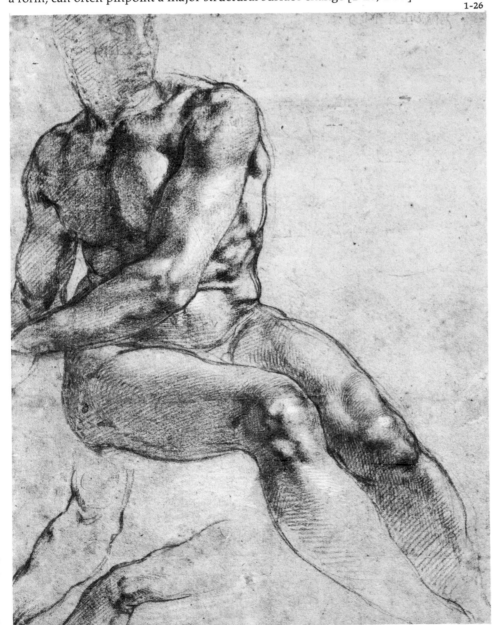

1-27

DELTOID
BRACHIALIS ANTICUS
BICEPS
BRACHIORADIALIS
(SUPINATOR LONGUS)
TRICEPS
EXTENSOR COMMUNIS
DIGITORUM
EXTENSOR CARPI ULNARIS
EXTENSOR CARPI
RADIALIS LONGUS
FLEXOR CARPI ULNARIS

Location is the key and guide to the modeling of a form in light and dark. Carefully organized relationships at each end of a form, once established, cannot be ignored. A haphazard scratching in of a tone can violate space and volume structure and distort surface relationships within a volume.

There are a variety of approaches to modeling. One is the classic method in which modeling lines are curved into the form at right angles to its length. Another is modeling by means of lines running parallel to the length of a form (that is, parallel with the contour). To preserve spatial order, modeling should be consistent with all other factors in the drawing.

The completeness of a mental, abstracted structural image may vary from drawing to drawing, depending on the scope of the individual work. Technically, a wide range of modeling (or no modeling) is opened up. Many of Degas' pastels, for instance, contain all vertical (or slightly diagonal) modeling but remain three-dimensionally convincing due to an underlying structural order.

With skill born of much drawing experience, structure can become part of a fundamental identity kept in mind rather than directly expressed. This structural image held in mind just above the drawing paper then permits an enormous range and uniqueness of expression without loss of order.

The complexity of the human form may require a part of the anatomy to be understood within a hierarchical structure of two levels. This is the case, first, where a small form unit has its own internal structural identity. Also, the same unit, by its location over a larger form, expresses the dimension of the hidden or partially concealed volume beneath. One level is large and fundamental; the other is small and complex. The first is held in mind; the second is drawn and, by its representation, reveals the first. Like H. G. Wells' invisible man, it can only be seen when clothed. For example, the structure of the shoulder blade is often visible as a complete triangular framework in the back. It has its own internal structure. But, by its angle and position over the major curving dimension of the rib cage, it functions also to limit the larger form of the torso at the upper back and shoulder, thus serving a dual function in drawing [see 5-10].

The selective abstraction of significant locational relationships within a complex form, to reveal precisely the form's broad spatial order, is a disciplined activity of eye and mind. In practice, the approach to drawing is one in which the visual sense experience of reality is subjected to intellectual analysis. It is important to bear in mind that observational drawing is not simply a retinal response to visual sensation. This results in shadow "copying." The significant preliminary groundwork in drawing is the spatial information (measurement or dimensions) deduced from observation and separately identified (symbolized by line and point).

CHAPTER 2
FORESHORTENING &
VISUAL RELATIONSHIPS

In contemporary art theory, perhaps the most current and widely held assumption is that idea of the clear and distinct autonomy of various art elements (color, line, shape, texture, etc.). Each is conceived as sovereign and independent of the larger context of visual reality, and each is often understood for its own theoretical quality and pertaining only to drawn or painted relationships within the frame of paper or canvas. The dissociation of the abstracted elements of a visual language from the direct visual perception of reality has obscured the value these elements possess in the education of the eye to observe and understand tangible, physical bodies in space.

Of these elements, flat shape is viewed as a freely manipulable factor that may be utilized for its decorative or expressive function. Art students, educated to think of shape as pattern or design detached from observed reality, are frequently unaware of the useful relational function that a carefully observed silhouette shape and its surrounding contiguous space can perform in organizing forms into a coherent, structured, three-dimensional space in drawing the figure and in foreshortening forms.

OBSERVATION AND PERSPECTIVE

One of the abiding difficulties in observational drawing is the perplexing problem of foreshortened forms. These are invariably drawn too long. Inexperienced students frequently impose an idea of the actual "known" length on the visually reduced length of a foreshortened volume or plane in perspective. As a result, part of a drawing will appear out of scale to the general representation of forms (for example, the inadequately reduced dimension of a projecting arm in relation to the torso). Here, knowledge and perception can create a conflict of visual understanding that requires adjustment to a uniform perspective (that is, to the station point of the observer). Few individuals are fully aware of, or take the time to check foreshortened measurements.

Attempts to apply formal perspective principles in a mechanically schematic fashion to the problem of foreshortening in figure drawing have not been notably successful. Jean Cousin the Younger published a curious work in 1671 in which groundplan projection was applied to foreshortening in figure drawing [2-1]. This scheme probably evolved from original and more complicated concepts of Piero della Francesca or Albrecht Dürer. The procedure is extravagantly cumbersome, requiring the artist to make two additional drawings (a top and a side view) for each foreshortened view he wishes to project. A further weakness in the system rests with the original top and side views, since the foreshortened view can be only as good as these. Implicit in the use of this method is the assumption that the practitioner already has the skill to project these views convincingly in a drawing. If this is true, anyone capable of handling the figure convincingly from top and side would probably have no need of the scheme in the first place. It cannot function as a substitute for observation and direct visual understanding.

2-1

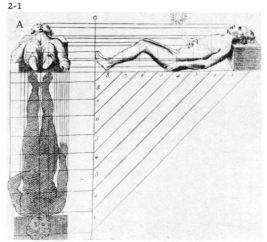

2-1 A Foreshortened Figure from L'Art du Dessin (1671) by Jean Cousin. (Courtesy: Boston Medical Library in the Francis A. Countway Library of Medicine. Photograph by Kalman Zabarsky.)

This illustration is from a work that attempts to apply formal perspective projection to the problem of foreshortening in figure drawing. Top and side views are disposed at right angles. Vertical and horizontal dimensions are intersected to provide a foreshortened figure at (A). The scheme is limited and cumbersome.

33

Probably the best means to learn and master foreshortening is direct observation—keeping in mind the principles of perspective. (Perspective theory is thus placed in the service of observation.)

The psychology of perceptual disbelief in the sharply compressed dimensions of foreshortened forms is often very difficult to overcome. It results in repeated, unintentional, out-of-context distortions in drawing. For this reason the careful measurement of foreshortened forms is crucially important. While a number of visual techniques are known and used for this purpose, they are all related.

THE SILHOUETTE AND THE VISUAL FIELD

By far the most effective means, in my view, to achieve convincing foreshortening is the measurement of forms and spaces viewed two-dimensionally—that is, measurement of a form by its silhouette and its related contiguous negative spaces. This compels a visual reduction of observed, three-dimensional reality to a two-dimensional field (consisting of height and width). It may be described as a perceived flat transparent plane on which forms have been reduced to flat shadow shapes surrounded by flat spaces (like a window with reality glued two-dimensionally to its outer side). It is directly pertinent to locational structure discussed in Chapter 1 and can ultimately become an integral part of unified structural vision.

To measure an observed, foreshortened form, it is necessary to abstract the spatial attributes of its silhouette (height and width). These two attributes of space, by themselves, "fix" the visual limit of the observed third dimension or depth (i.e., the foreshortened dimension). Observationally, the silhouette of an object is its two-dimensional shape configuration seen from a precise given viewpoint. This brief flattening of the visual field emphasizes not only the silhouette, but the shape relationships between and around forms. No matter how irregular these configurations may be, they provide evidence of the missing foreshortened third dimension, usually in the shape of diagonal edges.

In his etching, *Le Petit Dessinateur* [2-2], Jacques Villon has drawn himself in the act of making a dimensional measurement. The etching offers clear evidence of careful observation. Using the thumb and pencil system, the artist is measuring the span of a horizontal dimension. For Villon, the concept of precise, disciplined visual measurement is more than a symbolic action employed as a subject. It is representative of an attitude and a practice reflected in all of his work. The measurement being taken is of a specific single spatial attribute, a "width." Had he held the pencil vertically, he would be measuring a "height." In both cases the measurement identifies an aspect of form or space that is two-dimensional. The artist is momentarily ignoring depth. He is, in effect, measuring across the visual field as though it were a flat plane.

As an abstraction, the measurement may be the width of a form (or part of a form), a foreshortened form, or the space between forms. Thumb and pencil measurement is a means to make accurate comparisons between lengths of form or space, height with width. The procedure can entail the comparison of a visually undistorted length with a perspectively foreshortened length, to measure the degree of foreshortening.

A less fragmented means to determine foreshortened relationships involves the visual reduction of a three-dimensional field to a visual plane of two dimensions—a visual configuration of silhouettes and open negative spaces. (The term "negative" space is used to describe those contiguous intervals of space between and around

2-2 Le Petit Dessinateur (etching) by Jacques Villon. (Courtesy: Print Department, Boston Public Library. Photograph by Jonathan Goell.)

Thumb and pencil measurement is a guide and an aid to observation for Villon. For this artist, disciplined vision was essential to expression.

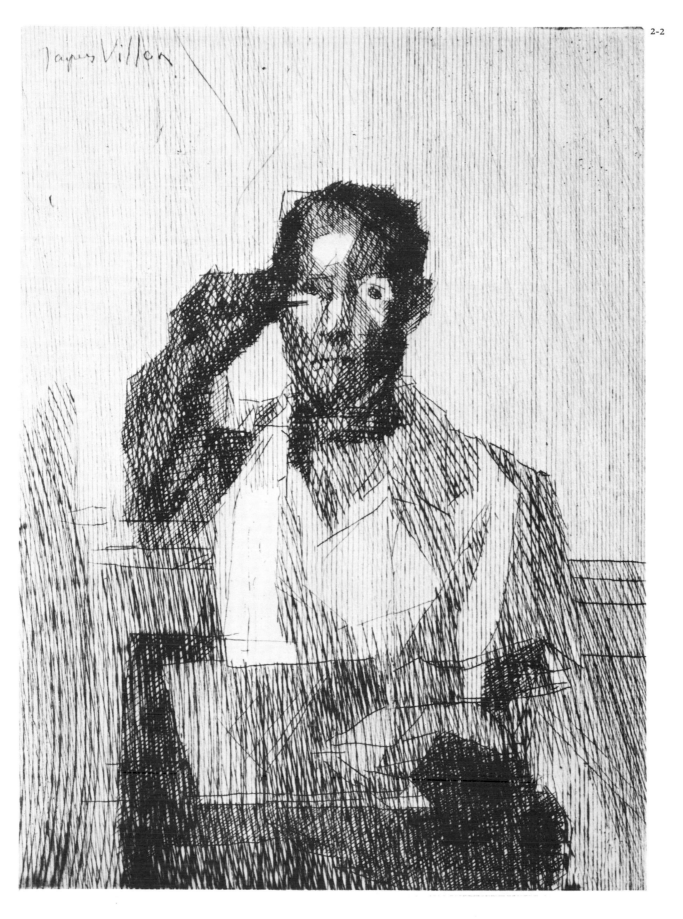

2-3 The Key, the Chair, and "Negative" Space.

Viewing the space along the serrated edge of the key will reveal a familiar profile. This gives meaning to the open negative space. Below is a chair drawn by the spaces between the various parts. A relationship between two legs, a cross support, and the seat is immediately established by carefully and precisely drawing space (A). With the addition of space shapes (B) and (C), the four legs, the seat, and three crosspieces have been related. It is possible to construct the complete chair by this procedure. The perspective of the floor plane is implied by the position of the four legs.

2-3

forms.) The shock of this visual action can be an immediate awareness of a compressed foreshortened dimension. The impact of the silhouette is important in an added sense.

The configuration of a flat shape is dependent not only on the area contained by its contour, but is equally revealed by its immediately adjacent surrounding space. The flat shape emphasizes the relationship and visual alteration of the contiguous negative space. (Villon may be measuring the width of a negative space.) The isolated study of positive silhouette shape (kept perspectively consistent in relation to the third dimension) and the adjacent surrounding space, offers a relatively quick, accurate means to achieve convincing foreshortening in the measurement of visual depth.

As a technique of observation, focusing on the spaces surrounding objects requires the acquisition of a new perceptual habit. Psychologists interested in visual perception have, with numerous experiments, dramatically refocused visual attention into new perceptual patterns. The technique can be easily demonstrated with a familiar and appropriate example. In an initial response, the accompanying drawing [2-3] is seen as a key. But a shift of focus to the space adjacent to its irregular serrated edge will reveal a familiar profile. This represents a momentary reversal of visual emphasis. Once seen, it is hard to ignore.

Extending the transfer of visual attention to more complex visual situations can be equally instructive for an understanding of space and form structure. (It is not, however, to play hide and seek with Dali-like double images). Before moving on to the human figure, it will help to illustrate this procedure with a simple three-dimensional object: a chair [2-3] drawn by the spaces enclosed by its various parts, the interstices of the form. By carefully drawing space *A*, a relationship between two legs, a crosspiece, and the seat is immediately established. With the addition of shapes *B* and *C*, the four legs, the seat, and the extended crosspieces have been indicated. It is possible to construct the chair in perspective from this information alone. The direction of the floor plane is implied by the position of the four legs.

The dramatic simplicity of this means of visual measurement in drawing a foreshortened form can be seen in the Degas study [2-4, 2-5]. The relationship between the legs, in the kneeling figure, has been convincingly drawn by careful study of positive form and the somewhat square space enclosed by both bent legs. The shape of this negative space, seen in relation to the hip and the intersection of the vertical inner contour of the calf with the hip and buttock, set the compressed dimensional limit of the foreshortened thigh. This foreshortening of the thigh is confirmed again by shifting attention to the left outer side of the drawing to the shape and angles of the knee, arm, and shoulder.

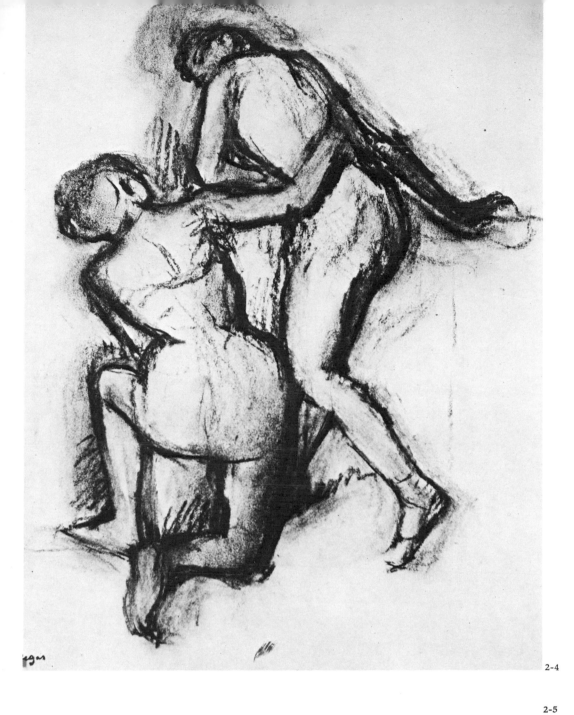

2-4 <u>Deux Danseuses en Maillot</u> (charcoal) by Edgar Degas. (Photograph by Durand-Ruel.)

The space between the legs of the kneeling figure (almost a square) and the space outside, to the left of this figure, have been observed with accuracy and provide the visual measurement for the foreshortened thigh.

2-5 Analysis of Foreshortening.

In the Degas drawing [2-4], the silhouette and the negative spaces (dark areas) have been carefully observed. The two horizontal arrows represent the dimension of the flat silhouette of the thigh. The diagonal arrow represents the axis of the form in perspective (i.e., the foreshortening).

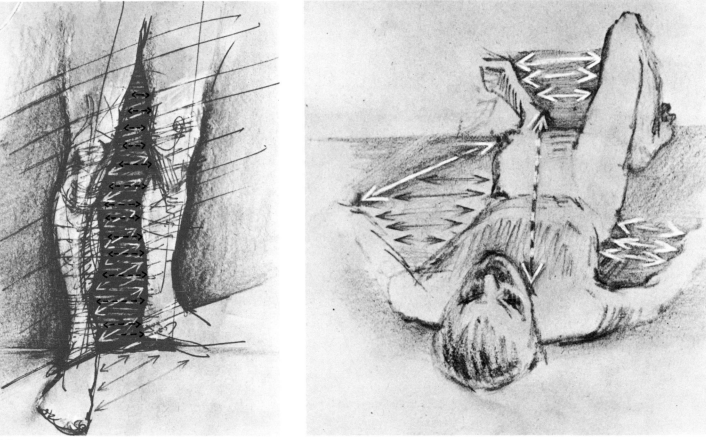

2-7

2-8

To return for a moment to Villon's *Le Petit Dessinateur* [2-2] and an examination of the space enclosed by the face, shoulder, arm, and hand, we will see that the inner dimension of the forearm (wrist to elbow) has been fixed in its foreshortening by this enclosed space (i.e., where the inner limit of the hand visually overlaps the cheekbone). A few additional examples [2-6, 2-7, 2-8] may illuminate the value and utility of precise "positive" and "negative" silhouette space study.

Observations made on both sides of the contour of a form seen alternately as in a three-dimensional and two-dimensional space avoids the danger of drawing forms that are floating and unsubstantial or that are inadequately foreshortened. This also avoids the softening of surface limits (contours) and of contour changes in direction.

The study of the silhouette offers a clearer view of major changes in the direction of the contour of a form. (See the back of the head in Toulouse Lautrec's *Portrait of Louis Bougle* [2-6].) Angular changes in the contour of the cranial form are identified by the brushstrokes of the light-painted areas outside the head.

2-7 Leg Study (pen and chalk) by the author. (Photograph by Kalman Zabarsky.)

Carefully "drawing" the space between two form units is a means to relate the forms. The light diagonal arrows represent the observation of perspective back into space from the near leg to the far leg. Dark horizontal arrows represent the visual measurement of the narrowness of space. The result is a cohesive relationship between the two forms.

2-8 Foreshortened Figure (pencil) by the author. (Photograph by Kalman Zabarsky.)

This foreshortened figure has been defined by carefully drawing the "negative" space. This is a simple, accurate means to control foreshortened dimensions. A related procedure was mentioned by Benvenuto Cellini. A lamp was carefully placed near the model to cast a shadow on a whitewashed wall. By drawing the cast shadow on paper, foreshortened lengths were quickly measured. A few added details completed the inner form. Viewing the figure "flat" against its surrounding space is a valuable aid to measurement.

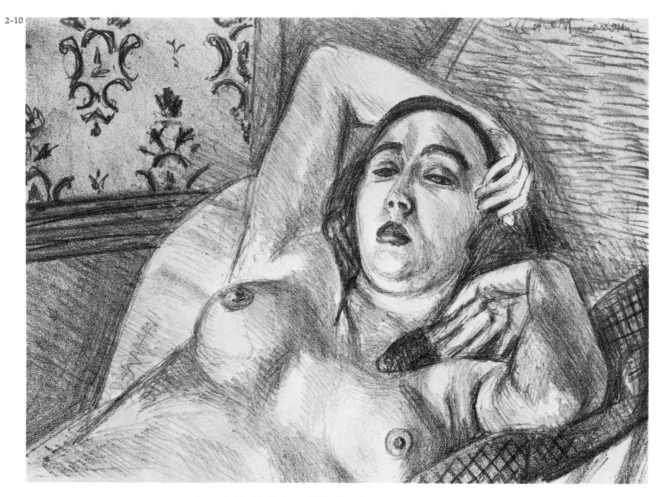

2-10

2-9

2-10 <u>Repos du Modèle</u> (lithograph) by Henri Matisse. (Museum of Art, Rhode Island School of Design, Providence.)
In this lithograph, foreshortening is admirably demonstrated. Note especially the convincing thrust of the compressed planes in the sharply foreshortened arm.

2-9 <u>Figure Study: Contour and Structure</u> (pencil) by the author. (Photograph by Jonathan Goell.)
Angular changes in the contour were carefully observed by drawing "outside" the figure. Each arrow indicates a change of direction along the edge of the form. These contour angles are carefully coordinated with the structure of planes within the form. In the left leg, the vertical line at the hip is parallel to the verticals at the knee. Coordinated with parallel foreshortened lengths, vertical and horizontal planes are enclosed.

Focusing on the spaces around forms is a perceptually deliberate act of visual attention. It has to be learned. Often the inexperienced student forgets to consider this problem of relationships when he is faced with a complex form or a group of closely associated forms. Practice can make this easier. For the student, it is advisable to carry out a series of drawings dealing precisely and carefully with the silhouette and "negative" (interstitial) space. He can then integrate this exercise with the observation and analysis of three-dimensional relationships. The coherence this provides among the various parts of the figure is almost immediately apparent. A number of analyzed and diagrammed drawings [2-9 through 2-12] are included for additional study. The study of such illustrations should be supported by repeated concentrated drawing from the figure. (Though not directly related to the problem of foreshortening in figure drawing, it is worth noting that the careful drawing of "negative" spaces is very useful in establishing scale and distance between near and far forms, as in a large interior space or in a landscape, or the scale between two figures in the line of sight, one near, the other distant.)

2-11

2-11 **Provincial** **Dance** (brush and brown wash) by Francisco de Goya. (The Metropolitan Museum of Art; Harry Brisbane Dick Fund, 1935.)

In drawing the figure, it is important to establish its relation to a supporting plane. In this brush drawing, the feet help describe the perspective of the ground plane. The two planes in the supporting foot of the young girl form a pivot for two intersecting directions within the cast shadows beneath the dancing figures.

2-12 **Ground Plane Analysis.**

In the sketch by Goya [2-11], the middle foot is the point of intersection for the brush work describing the perspective of the ground plane.

2-12

PART TWO: ANATOMY & STRUCTURE

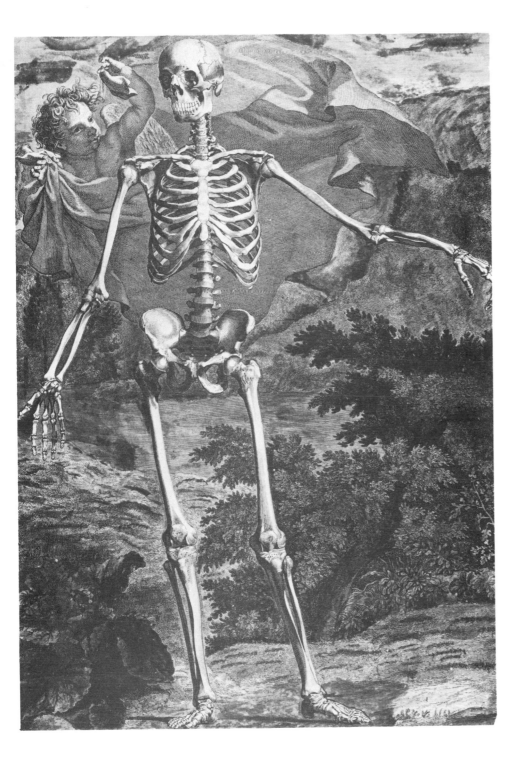

ANATOMICAL PLATES FOR REFERENCE

The six plates on the following pages are from *The Tables of the Skeleton and Muscles of the Human Body* by Bernhard Albinus. They are reproduced through the courtesy of the Boston Medical Library in the Francis A. Countway Library of Medicine.

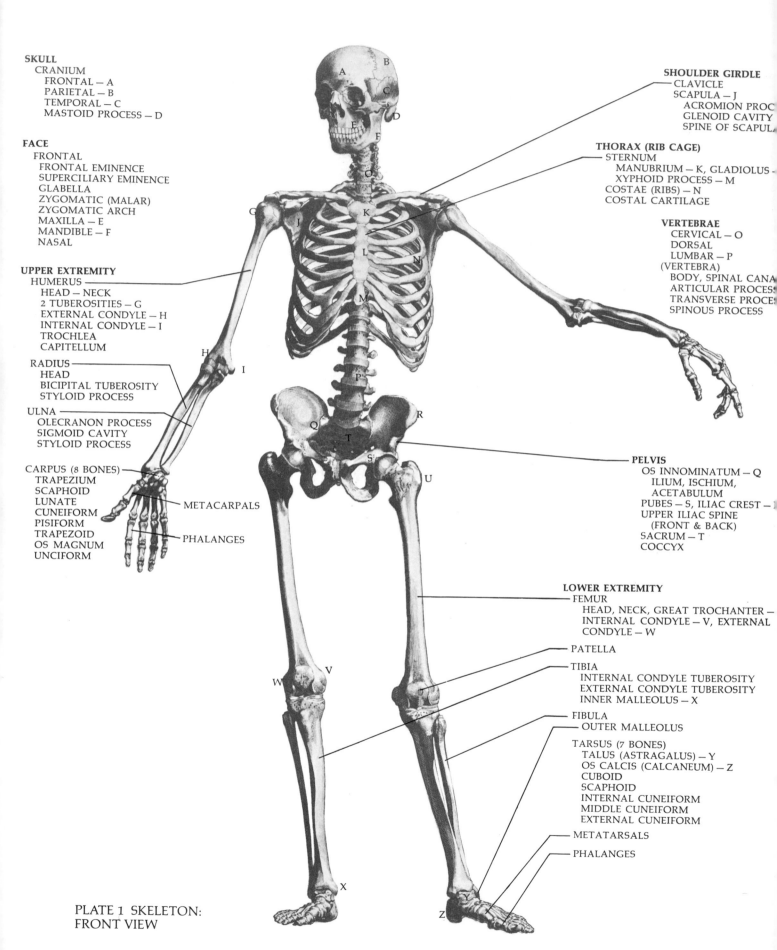

SKULL
 CRANIUM
 FRONTAL — A
 PARIETAL — B
 TEMPORAL — C
 MASTOID PROCESS — D

FACE
 FRONTAL
 FRONTAL EMINENCE
 SUPERCILIARY EMINENCE
 GLABELLA
 ZYGOMATIC (MALAR)
 ZYGOMATIC ARCH
 MAXILLA — E
 MANDIBLE — F
 NASAL

UPPER EXTREMITY
 HUMERUS
 HEAD — NECK
 2 TUBEROSITIES — G
 EXTERNAL CONDYLE — H
 INTERNAL CONDYLE — I
 TROCHLEA
 CAPITELLUM

 RADIUS
 HEAD
 BICIPITAL TUBEROSITY
 STYLOID PROCESS
 ULNA
 OLECRANON PROCESS
 SIGMOID CAVITY
 STYLOID PROCESS

 CARPUS (8 BONES)
 TRAPEZIUM
 SCAPHOID
 LUNATE
 CUNEIFORM
 PISIFORM
 TRAPEZOID
 OS MAGNUM
 UNCIFORM

METACARPALS

PHALANGES

SHOULDER GIRDLE
 CLAVICLE
 SCAPULA — J
 ACROMION PROC
 GLENOID CAVITY
 SPINE OF SCAPUL

THORAX (RIB CAGE)
 STERNUM
 MANUBRIUM — K, GLADIOLUS
 XYPHOID PROCESS — M
 COSTAE (RIBS) — N
 COSTAL CARTILAGE

VERTEBRAE
 CERVICAL — O
 DORSAL
 LUMBAR — P
 (VERTEBRA)
 BODY, SPINAL CANA
 ARTICULAR PROCES
 TRANSVERSE PROCE
 SPINOUS PROCESS

PELVIS
 OS INNOMINATUM — Q
 ILIUM, ISCHIUM,
 ACETABULUM
 PUBES — S, ILIAC CREST —
 UPPER ILIAC SPINE
 (FRONT & BACK)
 SACRUM — T
 COCCYX

LOWER EXTREMITY
 FEMUR
 HEAD, NECK, GREAT TROCHANTER —
 INTERNAL CONDYLE — V, EXTERNAL
 CONDYLE — W

 PATELLA

 TIBIA
 INTERNAL CONDYLE TUBEROSITY
 EXTERNAL CONDYLE TUBEROSITY
 INNER MALLEOLUS — X

 FIBULA
 OUTER MALLEOLUS

 TARSUS (7 BONES)
 TALUS (ASTRAGALUS) — Y
 OS CALCIS (CALCANEUM) — Z
 CUBOID
 SCAPHOID
 INTERNAL CUNEIFORM
 MIDDLE CUNEIFORM
 EXTERNAL CUNEIFORM

 METATARSALS

 PHALANGES

PLATE 1 SKELETON:
FRONT VIEW

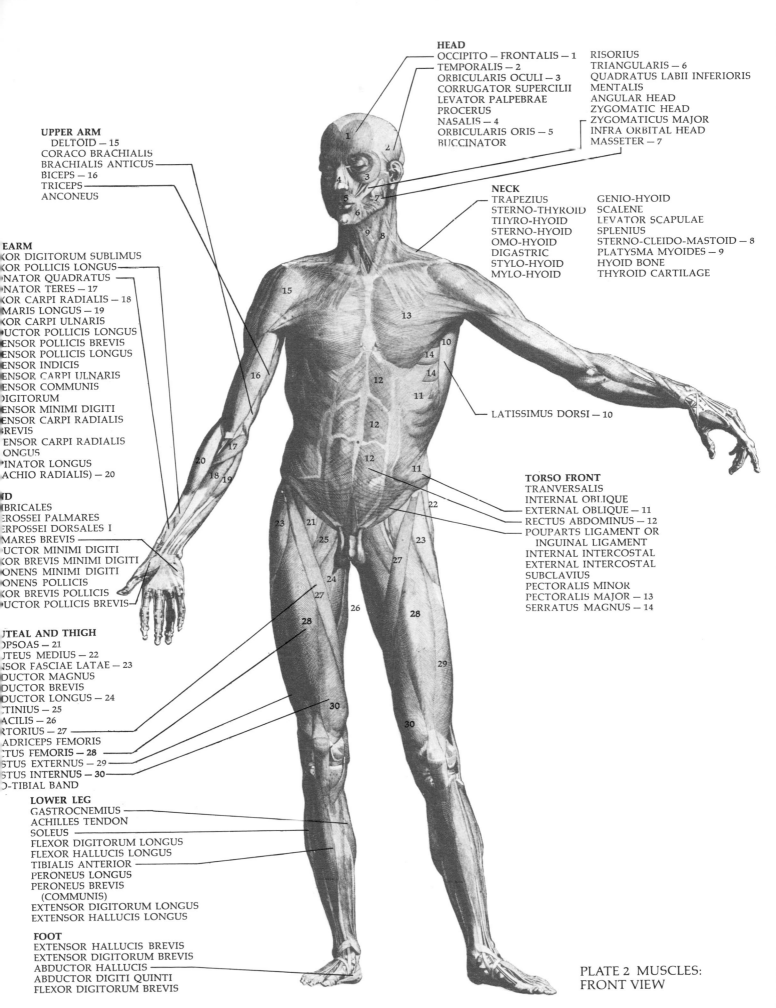

HEAD
OCCIPITO – FRONTALIS – 1
TEMPORALIS – 2
ORBICULARIS OCULI – 3
CORRUGATOR SUPERCILII
LEVATOR PALPEBRAE
PROCERUS
NASALIS – 4
ORBICULARIS ORIS – 5
BUCCINATOR
RISORIUS
TRIANGULARIS – 6
QUADRATUS LABII INFERIORIS
MENTALIS
ANGULAR HEAD
ZYGOMATIC HEAD
ZYGOMATICUS MAJOR
INFRA ORBITAL HEAD
MASSETER – 7

UPPER ARM
DELTOID – 15
CORACO BRACHIALIS
BRACHIALIS ANTICUS
BICEPS – 16
TRICEPS
ANCONEUS

NECK
TRAPEZIUS
STERNO-THYROID
THYRO-HYOID
STERNO-HYOID
OMO-HYOID
DIGASTRIC
STYLO-HYOID
MYLO-HYOID
GENIO-HYOID
SCALENE
LEVATOR SCAPULAE
SPLENIUS
STERNO-CLEIDO-MASTOID – 8
PLATYSMA MYOIDES – 9
HYOID BONE
THYROID CARTILAGE

EARM
KOR DIGITORUM SUBLIMUS
KOR POLLICIS LONGUS
NATOR QUADRATUS
NATOR TERES – 17
KOR CARPI RADIALIS – 18
MARIS LONGUS – 19
KOR CARPI ULNARIS
UCTOR POLLICIS LONGUS
ENSOR POLLICIS BREVIS
ENSOR POLLICIS LONGUS
ENSOR INDICIS
ENSOR CARPI ULNARIS
ENSOR COMMUNIS
DIGITORUM
ENSOR MINIMI DIGITI
ENSOR CARPI RADIALIS
BREVIS
ENSOR CARPI RADIALIS
LONGUS
INATOR LONGUS
ACHIO RADIALIS) – 20

ND
BRICALES
EROSSEI PALMARES
ERPOSSEI DORSALES I
MARES BREVIS
UCTOR MINIMI DIGITI
KOR BREVIS MINIMI DIGITI
ONENS MINIMI DIGITI
ONENS POLLICIS
KOR BREVIS POLLICIS
UCTOR POLLICIS BREVIS

TEAL AND THIGH
OPSOAS – 21
UTEUS MEDIUS – 22
NSOR FASCIAE LATAE – 23
DUCTOR MAGNUS
DUCTOR BREVIS
DUCTOR LONGUS – 24
TINIUS – 25
ACILIS – 26
RTORIUS – 27
ADRICEPS FEMORIS
CTUS FEMORIS – **28**
STUS EXTERNUS – 29
STUS INTERNUS – **30**
O-TIBIAL BAND

LOWER LEG
GASTROCNEMIUS
ACHILLES TENDON
SOLEUS
FLEXOR DIGITORUM LONGUS
FLEXOR HALLUCIS LONGUS
TIBIALIS ANTERIOR
PERONEUS LONGUS
PERONEUS BREVIS
(COMMUNIS)
EXTENSOR DIGITORUM LONGUS
EXTENSOR HALLUCIS LONGUS

FOOT
EXTENSOR HALLUCIS BREVIS
EXTENSOR DIGITORUM BREVIS
ABDUCTOR HALLUCIS
ABDUCTOR DIGITI QUINTI
FLEXOR DIGITORUM BREVIS

LATISSIMUS DORSI – 10

TORSO FRONT
TRANVERSALIS
INTERNAL OBLIQUE
EXTERNAL OBLIQUE – 11
RECTUS ABDOMINUS – 12
POUPARTS LIGAMENT OR
INGUINAL LIGAMENT
INTERNAL INTERCOSTAL
EXTERNAL INTERCOSTAL
SUBCLAVIUS
PECTORALIS MINOR
PECTORALIS MAJOR – 13
SERRATUS MAGNUS – 14

PLATE 2 MUSCLES:
FRONT VIEW

45

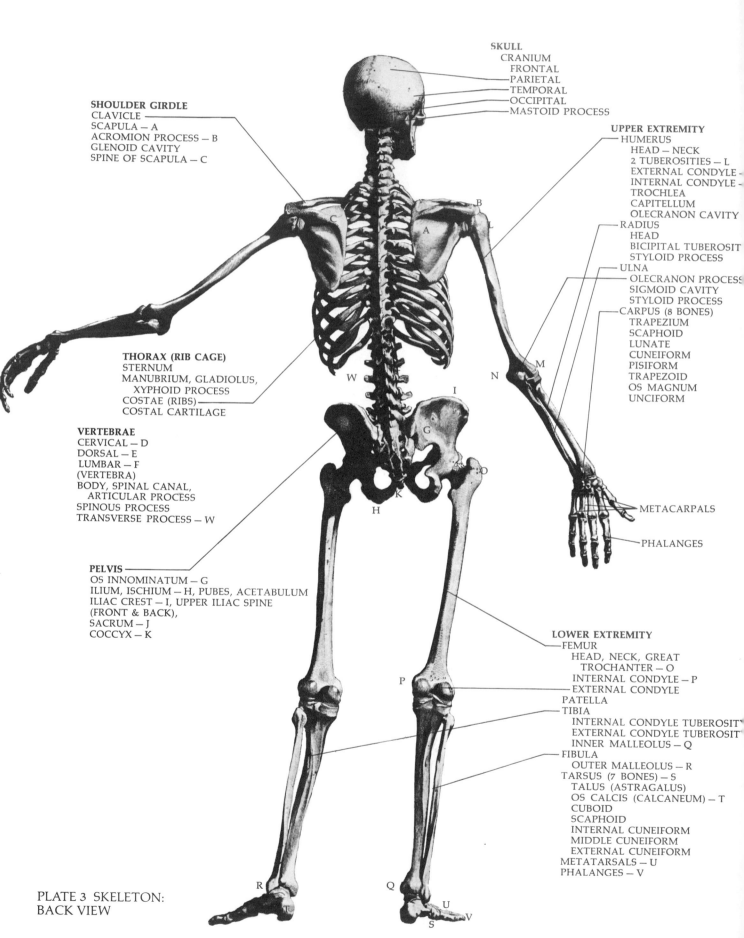

SKULL
CRANIUM
FRONTAL
PARIETAL
TEMPORAL
OCCIPITAL
MASTOID PROCESS

SHOULDER GIRDLE
CLAVICLE
SCAPULA — A
ACROMION PROCESS — B
GLENOID CAVITY
SPINE OF SCAPULA — C

UPPER EXTREMITY
HUMERUS
HEAD — NECK
2 TUBEROSITIES — L
EXTERNAL CONDYLE
INTERNAL CONDYLE
TROCHLEA
CAPITELLUM
OLECRANON CAVITY
RADIUS
HEAD
BICIPITAL TUBEROSIT
STYLOID PROCESS
ULNA
OLECRANON PROCESS
SIGMOID CAVITY
STYLOID PROCESS
CARPUS (8 BONES)
TRAPEZIUM
SCAPHOID
LUNATE
CUNEIFORM
PISIFORM
TRAPEZOID
OS MAGNUM
UNCIFORM

THORAX (RIB CAGE)
STERNUM
MANUBRIUM, GLADIOLUS,
XYPHOID PROCESS
COSTAE (RIBS)
COSTAL CARTILAGE

VERTEBRAE
CERVICAL — D
DORSAL — E
LUMBAR — F
(VERTEBRA)
BODY, SPINAL CANAL,
ARTICULAR PROCESS
SPINOUS PROCESS
TRANSVERSE PROCESS — W

METACARPALS

PHALANGES

PELVIS
OS INNOMINATUM — G
ILIUM, ISCHIUM — H, PUBES, ACETABULUM
ILIAC CREST — I, UPPER ILIAC SPINE
(FRONT & BACK),
SACRUM — J
COCCYX — K

LOWER EXTREMITY
FEMUR
HEAD, NECK, GREAT
TROCHANTER — O
INTERNAL CONDYLE — P
EXTERNAL CONDYLE
PATELLA
TIBIA
INTERNAL CONDYLE TUBEROSIT
EXTERNAL CONDYLE TUBEROSIT
INNER MALLEOLUS — Q
FIBULA
OUTER MALLEOLUS — R
TARSUS (7 BONES) — S
TALUS (ASTRAGALUS)
OS CALCIS (CALCANEUM) — T
CUBOID
SCAPHOID
INTERNAL CUNEIFORM
MIDDLE CUNEIFORM
EXTERNAL CUNEIFORM
METATARSALS — U
PHALANGES — V

PLATE 3 SKELETON:
BACK VIEW

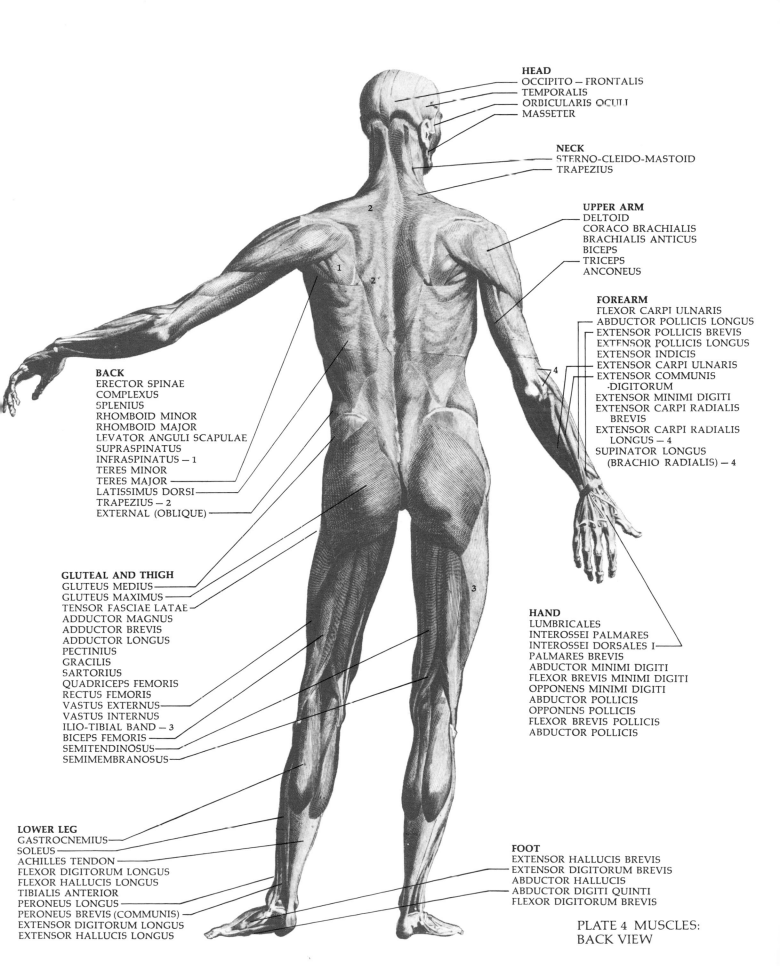

HEAD
OCCIPITO – FRONTALIS
TEMPORALIS
ORBICULARIS OCULI
MASSETER

NECK
STERNO-CLEIDO-MASTOID
TRAPEZIUS

UPPER ARM
DELTOID
CORACO BRACHIALIS
BRACHIALIS ANTICUS
BICEPS
TRICEPS
ANCONEUS

FOREARM
FLEXOR CARPI ULNARIS
ABDUCTOR POLLICIS LONGUS
EXTENSOR POLLICIS BREVIS
EXTENSOR POLLICIS LONGUS
EXTENSOR INDICIS
EXTENSOR CARPI ULNARIS
EXTENSOR COMMUNIS
 ·DIGITORUM
EXTENSOR MINIMI DIGITI
EXTENSOR CARPI RADIALIS
 BREVIS
EXTENSOR CARPI RADIALIS
 LONGUS – 4
SUPINATOR LONGUS
 (BRACHIO RADIALIS) – 4

BACK
ERECTOR SPINAE
COMPLEXUS
SPLENIUS
RHOMBOID MINOR
RHOMBOID MAJOR
LEVATOR ANGULI SCAPULAE
SUPRASPINATUS
INFRASPINATUS – 1
TERES MINOR
TERES MAJOR
LATISSIMUS DORSI
TRAPEZIUS – 2
EXTERNAL (OBLIQUE)

GLUTEAL AND THIGH
GLUTEUS MEDIUS
GLUTEUS MAXIMUS
TENSOR FASCIAE LATAE
ADDUCTOR MAGNUS
ADDUCTOR BREVIS
ADDUCTOR LONGUS
PECTINIUS
GRACILIS
SARTORIUS
QUADRICEPS FEMORIS
RECTUS FEMORIS
VASTUS EXTERNUS
VASTUS INTERNUS
ILIO-TIBIAL BAND – 3
BICEPS FEMORIS
SEMITENDINOSUS
SEMIMEMBRANOSUS

HAND
LUMBRICALES
INTEROSSEI PALMARES
INTEROSSEI DORSALES I
PALMARES BREVIS
ABDUCTOR MINIMI DIGITI
FLEXOR BREVIS MINIMI DIGITI
OPPONENS MINIMI DIGITI
ABDUCTOR POLLICIS
OPPONENS POLLICIS
FLEXOR BREVIS POLLICIS
ABDUCTOR POLLICIS

LOWER LEG
GASTROCNEMIUS
SOLEUS
ACHILLES TENDON
FLEXOR DIGITORUM LONGUS
FLEXOR HALLUCIS LONGUS
TIBIALIS ANTERIOR
PERONEUS LONGUS
PERONEUS BREVIS (COMMUNIS)
EXTENSOR DIGITORUM LONGUS
EXTENSOR HALLUCIS LONGUS

FOOT
EXTENSOR HALLUCIS BREVIS
EXTENSOR DIGITORUM BREVIS
ABDUCTOR HALLUCIS
ABDUCTOR DIGITI QUINTI
FLEXOR DIGITORUM BREVIS

PLATE 4 MUSCLES:
BACK VIEW

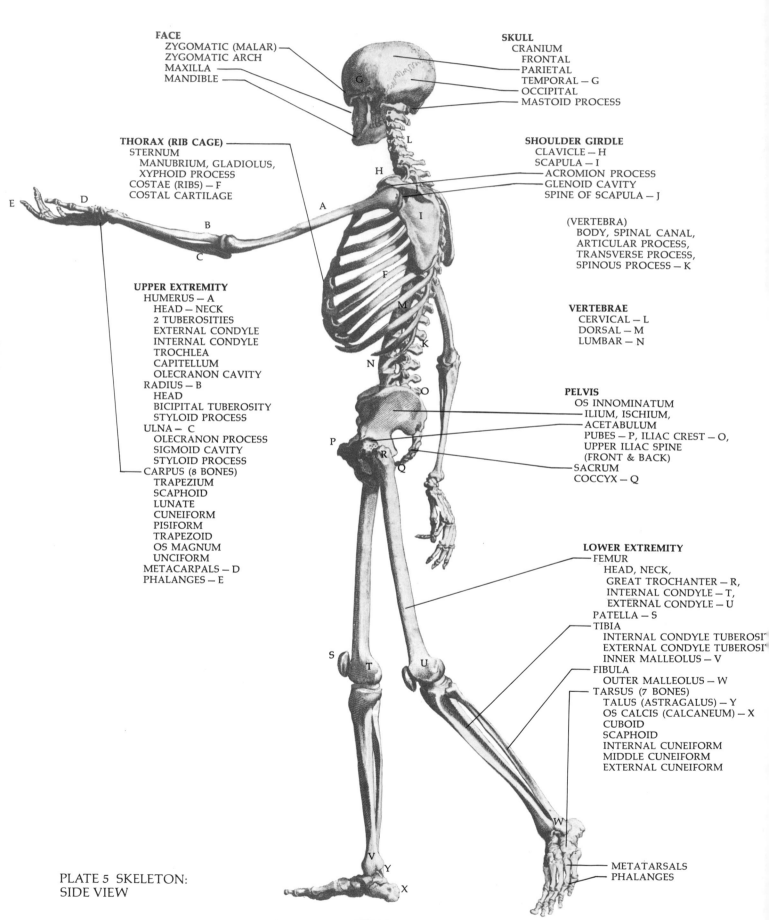

FACE
 ZYGOMATIC (MALAR)
 ZYGOMATIC ARCH
 MAXILLA
 MANDIBLE

SKULL
 CRANIUM
 FRONTAL
 PARIETAL
 TEMPORAL — G
 OCCIPITAL
 MASTOID PROCESS

THORAX (RIB CAGE)
 STERNUM
 MANUBRIUM, GLADIOLUS,
 XYPHOID PROCESS
 COSTAE (RIBS) — F
 COSTAL CARTILAGE

SHOULDER GIRDLE
 CLAVICLE — H
 SCAPULA — I
 ACROMION PROCESS
 GLENOID CAVITY
 SPINE OF SCAPULA — J

 (VERTEBRA)
 BODY, SPINAL CANAL,
 ARTICULAR PROCESS,
 TRANSVERSE PROCESS,
 SPINOUS PROCESS — K

UPPER EXTREMITY
 HUMERUS — A
 HEAD — NECK
 2 TUBEROSITIES
 EXTERNAL CONDYLE
 INTERNAL CONDYLE
 TROCHLEA
 CAPITELLUM
 OLECRANON CAVITY
 RADIUS — B
 HEAD
 BICIPITAL TUBEROSITY
 STYLOID PROCESS
 ULNA — C
 OLECRANON PROCESS
 SIGMOID CAVITY
 STYLOID PROCESS
 CARPUS (8 BONES)
 TRAPEZIUM
 SCAPHOID
 LUNATE
 CUNEIFORM
 PISIFORM
 TRAPEZOID
 OS MAGNUM
 UNCIFORM
 METACARPALS — D
 PHALANGES — E

VERTEBRAE
 CERVICAL — L
 DORSAL — M
 LUMBAR — N

PELVIS
 OS INNOMINATUM
 ILIUM, ISCHIUM,
 ACETABULUM
 PUBES — P, ILIAC CREST — O,
 UPPER ILIAC SPINE
 (FRONT & BACK)
 SACRUM
 COCCYX — Q

LOWER EXTREMITY
 FEMUR
 HEAD, NECK,
 GREAT TROCHANTER — R,
 INTERNAL CONDYLE — T,
 EXTERNAL CONDYLE — U
 PATELLA — S
 TIBIA
 INTERNAL CONDYLE TUBEROSI
 EXTERNAL CONDYLE TUBEROSI
 INNER MALLEOLUS — V
 FIBULA
 OUTER MALLEOLUS — W
 TARSUS (7 BONES)
 TALUS (ASTRAGALUS) — Y
 OS CALCIS (CALCANEUM) — X
 CUBOID
 SCAPHOID
 INTERNAL CUNEIFORM
 MIDDLE CUNEIFORM
 EXTERNAL CUNEIFORM
 METATARSALS
 PHALANGES

PLATE 5 SKELETON:
SIDE VIEW

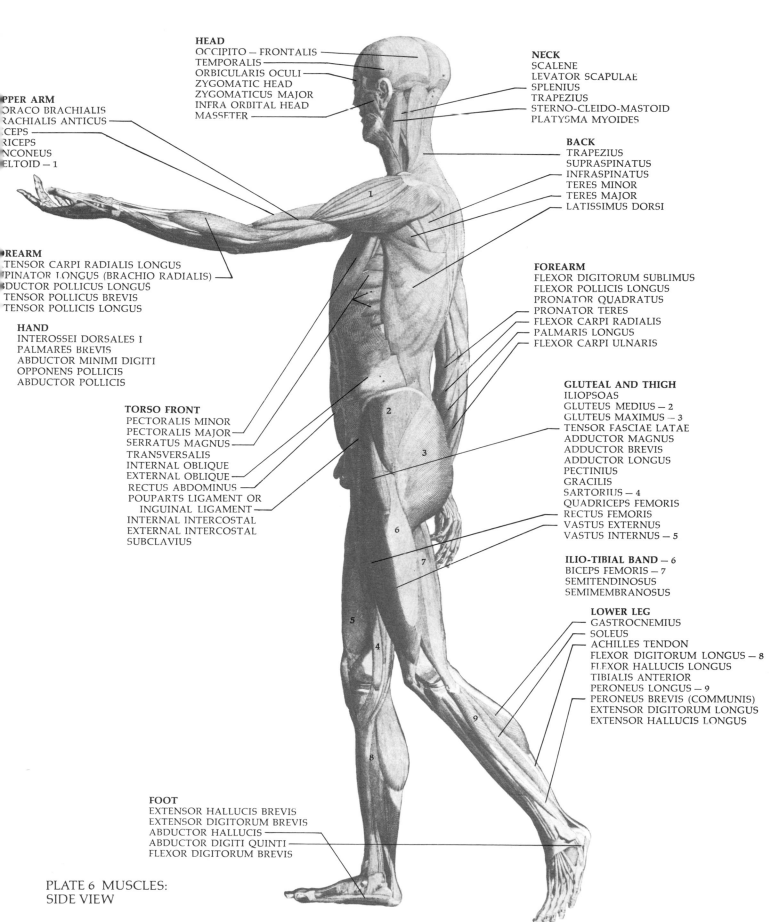

HEAD
OCCIPITO — FRONTALIS
TEMPORALIS
ORBICULARIS OCULI
ZYGOMATIC HEAD
ZYGOMATICUS MAJOR
INFRA ORBITAL HEAD
MASSETER

NECK
SCALENE
LEVATOR SCAPULAE
SPLENIUS
TRAPEZIUS
STERNO-CLEIDO-MASTOID
PLATYSMA MYOIDES

PPER ARM
ORACO BRACHIALIS
RACHIALIS ANTICUS
CEPS
RICEPS
NCONEUS
ELTOID — 1

BACK
TRAPEZIUS
SUPRASPINATUS
INFRASPINATUS
TERES MINOR
TERES MAJOR
LATISSIMUS DORSI

OREARM
TENSOR CARPI RADIALIS LONGUS
PINATOR LONGUS (BRACHIO RADIALIS)
DUCTOR POLLICUS LONGUS
TENSOR POLLICUS BREVIS
TENSOR POLLICIS LONGUS

FOREARM
FLEXOR DIGITORUM SUBLIMUS
FLEXOR POLLICIS LONGUS
PRONATOR QUADRATUS
PRONATOR TERES
FLEXOR CARPI RADIALIS
PALMARIS LONGUS
FLEXOR CARPI ULNARIS

HAND
INTEROSSEI DORSALES I
PALMARES BREVIS
ABDUCTOR MINIMI DIGITI
OPPONENS POLLICIS
ABDUCTOR POLLICIS

GLUTEAL AND THIGH
ILIOPSOAS
GLUTEUS MEDIUS — 2
GLUTEUS MAXIMUS — 3
TENSOR FASCIAE LATAE
ADDUCTOR MAGNUS
ADDUCTOR BREVIS
ADDUCTOR LONGUS
PECTINIUS
GRACILIS
SARTORIUS — 4
QUADRICEPS FEMORIS
RECTUS FEMORIS
VASTUS EXTERNUS
VASTUS INTERNUS — 5

TORSO FRONT
PECTORALIS MINOR
PECTORALIS MAJOR
SERRATUS MAGNUS
TRANSVERSALIS
INTERNAL OBLIQUE
EXTERNAL OBLIQUE
RECTUS ABDOMINUS
POUPARTS LIGAMENT OR
 INGUINAL LIGAMENT
INTERNAL INTERCOSTAL
EXTERNAL INTERCOSTAL
SUBCLAVIUS

ILIO-TIBIAL BAND — 6
BICEPS FEMORIS — 7
SEMITENDINOSUS
SEMIMEMBRANOSUS

LOWER LEG
GASTROCNEMIUS
SOLEUS
ACHILLES TENDON
FLEXOR DIGITORUM LONGUS — 8
FLEXOR HALLUCIS LONGUS
TIBIALIS ANTERIOR
PERONEUS LONGUS — 9
PERONEUS BREVIS (COMMUNIS)
EXTENSOR DIGITORUM LONGUS
EXTENSOR HALLUCIS LONGUS

FOOT
EXTENSOR HALLUCIS BREVIS
EXTENSOR DIGITORUM BREVIS
ABDUCTOR HALLUCIS
ABDUCTOR DIGITI QUINTI
FLEXOR DIGITORUM BREVIS

PLATE 6 MUSCLES:
SIDE VIEW

CHAPTER 3
THE HEAD
& FEATURES

No form exerts a greater fascination than the human countenance. It is the initial point of contact in human communication and the focus of continuous interest, both intellectual and emotional. But, in spite of its familiarity and the generous attention it receives, it can be reckoned a problem to discerning observation in drawing.

Few forms present more misleading clues to space and structure than the head and its many prominent units. "Character" wrinkles, decorative markings like the eyebrows, and the "linearity" of the features tend to camouflage the substantial planes of the face. The unique importance of the features may cause them to be seen separately, in a manner that ignores their interrelationship or obliterates their larger cranial and skeletal context. It is essential to see beyond the individual features—to get behind the veneer of deceptive detail and to discover the substance of significant surface and volume. Awareness of anatomy will help. But it too presents a vast and complex array of individual elements.

The selection of a number of key anatomic limits, organically precise, is a first essential step. This disposition of selective major anatomic relationships, positioned before attention is given to the smaller organic anatomic details, may be graphically identified (by the point)—for instance, the distance between the cheekbones and their relation to the chin and the angle of the jaw. Axes running the length of the form and those extending across, at the forehead and through the features, may be tied into this framework. Over this initially measured abstracted ground plan (carried out to include cranial dimensions), the recognizable units of detail may be superimposed and organically integrated. As a process, these groupings may, with experience, be joined; and broad location and detail may be seen and drawn together in a single synthesized statement [3-1].

A comparison of illustrations 3-2 and 3-3 indicates that there are sizable anatomic relationships in the skull structure. The locational and directional significance of these larger planes is diagrammed to show their influence. The most careful attention should be lavished on these big spatial connections. It is precisely at this early stage of observation, in the abstraction of wide positions, that form and "character" meet at their most significant level. It is at this stage that a true "likeness" is achieved by the tension of lengths, axes, and angles seen beneath and through the features.

3-1 Detail of Provincial Dance by Francisco de Goya. (The Metropolitan Museum of Art; Harry Brisbane Dick Fund, 1935.)

The blocklike side and front planes of the head are echoed in the angle at the shoulder and the broad planes of the upper arm. The features are perspectively consistent within the head and with the upper torso. (See illustration 2-11 for the complete drawing.)

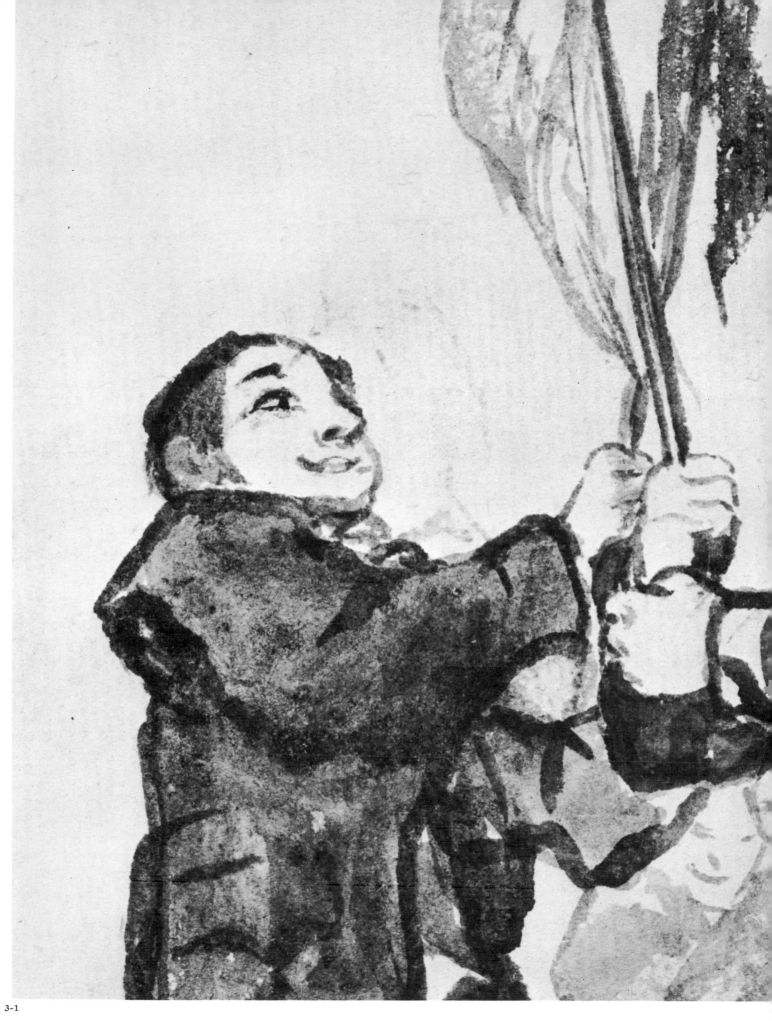

3-1

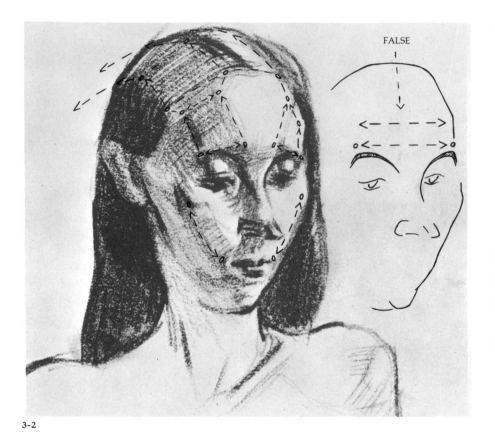

FALSE

3-2

3-2 Head of a Girl (crayon) by the author. (Photograph by Kalman Zabarsky.)

The planes of the forehead (frontal bone) are frequently falsified when the eyebrows are used to define its lower border. A more authentic guide is the direction of the eye cavity. The upper edge of this cavity, running beneath the eyebrow, rarely coincides with it. This less obvious upper margin of the eye cavity marks the true origin of planes in the forehead, continuing over the top of the skull, under the hair mass, to the back of the skull. (Compare this illustration with the skull by Salvage [3-3] and the one by Cloquet [3-11].) Below the eyes, the zygomaticus major muscle extends from the cheekbone to the corner of the mouth and frames the large triangular plane of the front of the face, separate from the vertical side planes.

3-3 Skull: Front View, from <u>Anatomy of Bones and Muscles Applicable to the Fine Arts</u> by Jean Galbert Salvage. (Courtesy: Boston Medical Library in the Francis A. Countway Library of Medicine. Photograph by Kalman Zabarsky.)

The diagonal planes of the cranial structure begin at the upper limit of the eye cavity. These planes continue into the cranium to the back of the skull. The eyebrow usually conceals the direction of this edge and can distort (flatten) the plane above. Identified on the profile of the head are the following: occipito frontalis (F); temporalis (A); zygomatic arch (Z); buccinator (B); triangularis (T); quadratus labii inferioris (Q); mentalis (M); orbicularis oris (O); orbicularis oculi (C).

3-3

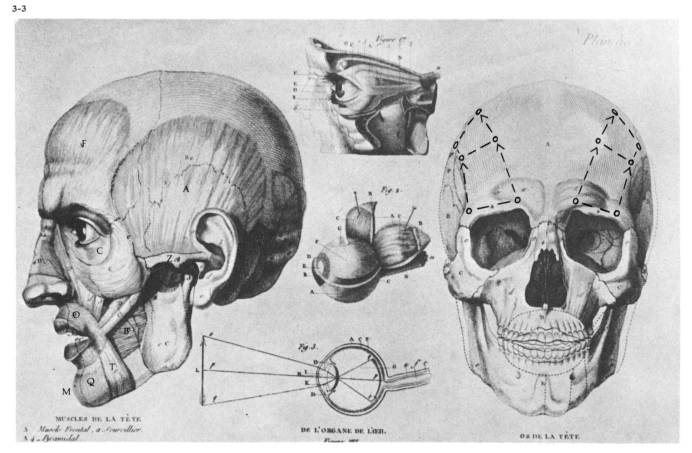

MUSCLES DE LA TÊTE

DE L'ORGANE DE L'ŒIL

OS DE LA TÊTE

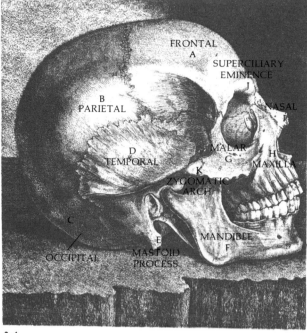

3-4

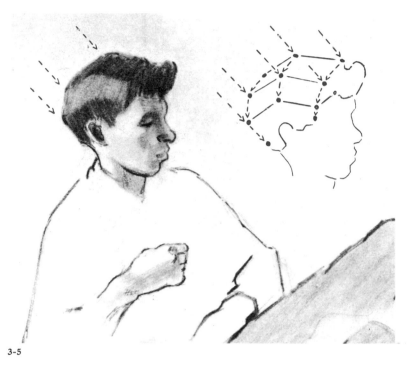

3-5

Yet it is precisely this level of measurement that is so frequently ignored in drawing. The inexperienced eye responds with astonishing relish to an out-of-context detail—the curve of a nostril or an isolated wrinkle. Unfortunately, the premature cataloging of small detail can result in overall spatial chaos. The observer cannot "read" his way into a coherent and selectively ordered form. Therefore, small detail should be set apart in favor of carefully calculated, related, broad spatial positions. Once these inclusive locations have been well observed and are perspectively consistent, "meaningful" accessories can be developed with some confidence.

A complicated, dishevelled hair mass can disguise its own scale and overall unity. Drawn too small, the hair can frame the face with a broken irregular border that has no relation to the planes of the head. The face can appear to be an empty mask without substance or weight. This may result from a lack of careful consideration of the scale of the larger cranial form above and behind the features. In his memoirs, Cellini makes the point in a trenchant comment on a sculpture by Bandinelli: "If the hair of your Hercules were shaved off, there would not remain skull enough to hold his brains."

Study of a side view of the skull compared with the frame of space occupied by the features will quickly reveal the importance of the cranial mass [3-4]. The largeness of this form is less obvious from the front. It should not be ignored, however. The planes can often be clearly seen beneath the hair mass projecting to the back of the skull. The widest part of the skull—the parietal eminences—affect the bend of planes on top, side, and back, in turn influencing the broad form of the hair mass [3-5]. (In studying the skull, the sutures—the saw-tooth connections between the bones—should not be stressed. They have no influence on the form.)

3-4 Skull, from Twenty Plates of the Osteology and Myology of the Hand, Foot, and Head by Antonio Cattani. (Courtesy: Boston Medical Library in the Francis A. Countway Library of Medicine. Photograph by Jonathan Goell.)

The dimension of the large cranial dome should be carefully compared with the small mask of the face. While head proportions vary, the cranial volume is the dominant form. In drawing, small details tend to expand in scale at the expense of large, simple forms. So, individual features, as they are closely examined and drawn, may grow larger and eliminate or minimize simple surfaces and ample volumes. The skull is composed of several bones and processes. As seen in this illustration, they are: frontal (A); parietal (B); occipital (C); temporal (D); mastoid process (E); mandible (F); malar (G); maxilla (H); nasal (I); superciliary eminence (J); zygomatic arch (K).

3-5 Figure Drawing by the author. (Photograph by Ronald Lubin.)

In drawing the hair mass, changes in direction can be tied to important surface changes within the form. This is usually revealed in the parallel movement of highlights and contour within the hair.

THE FOREHEAD

The cranial structure of the head is dominated by the bones. The muscles of the cranium are stretched thinly over the frontal bone, following closely the hard surface of its curved eminences. In the cranium, the bones determine the form and influence the shape of the hair covering. (The temporal, parietal, and occipital bones make up this large, usually enveloped volume [3-4].)

The most visible bone of the cranium, the frontal bone of the forehead, seems deceptively simple. But subtle eminences and the camouflage of skin wrinkles and an irregular hairline can easily mislead even the most alert observer. The rounded frontal eminences and the projecting superciliary ridge, bordering the top of the eye cavity, must be seen in relation to a larger surface development. (See illustration 3-3.)

The planes of the forehead are limited, below, by the angle of the upper borders of the eye cavities. Superficially, the hair of the eyebrow would seem an obvious and logical indication of this boundary. But the direction of the eyebrow and the direction of the eye cavity rarely, if ever, coincide. In fact, the eyebrow usually hides the true direction of the upper limit of the cavities and the angle of the important planes of the forehead. If one is guided by the eyebrow, the forehead will be distorted into one flat, even plane. The truer, but less obvious, limit runs beneath this at the upper margin of the eye cavity, the two diagonal ridges of both cavities meeting above the nasal bone, joining into the glabella (nasal eminence of the frontal bone). This frequently distorted order of large planes is shown in illustrations 3-2 and 3-3.

The glabella is a clearly identifiable triangular wedge of bone surface between the eye cavities just above the two small nasal bones. Like the keystone at the center of an arch, it can function as a visual anchor to hold the eyes in place. It is identified in the illustration here [3-6] and may also clearly be seen in two other illustrations of the skull, one shown from the front [3-3] and the other, from the side [3-4]. Superficially, the glabella may occasionally be divided by frown lines or hidden by heavy eyebrows.

3-6 <u>Skull</u> (crayon and wash) by the author. (Photograph by Kalman Zabarsky.)

The zygomaticus muscle (major and minor) and the masseter muscle have a prominent influence on the planes of the face. From the cheekbone to the corner of the mouth, the zygomaticus (Z) separates the front plane of the face below the eyes from the vertical side plane. The masseter muscle (M) emphasizes the side of the head from the cheekbone to the angle of the jaw. (Compare the delineation of this muscle with its description in the painting by Degas [3-8].) The wedge-shaped glabella (G) is a useful plane to help align the eye cavities and the eyes.

3-6

PLANES OF THE FACE

Relationships between the cheekbone and mouth (and chin) are crucial to an understanding of the planes that make up the front and side of the face. Linear diagonal creases beneath the eye and beside the nose can obscure the more important (but often less obvious) opposing thrust of the zygomaticus muscles running from the cheek to the corner of the mouth [3-6]. It is these two thin muscles that form the margin between the front of the face (below the eyes) and the transitional vertical side plane above the jawbone from the chin to the front edge of the masseter muscle. (In fleshy, full-cheeked individuals, the change is very subtle. In elderly persons, wrinkles and slack muscles may obscure this relationship.)

The cheekbone (malar) is again the pivot for a major surface connection that moves diagonally back to the angle of the jaw. (See illustrations 3-7 through 3-10.) This cheek-to-jaw division is caused by the masseter muscle (padded by the parotid gland), which occupies the area below the zygomatic arch, filling out the form to the rear vertical limit of the jawbone (ramus of the mandible).

54

3-7

3-9

3-8

3-10

3-7 <u>Dancers Preparing for the Ballet</u> (oil on canvas) by Edgar Degas. (Courtesy: Art Institute of Chicago.)

3-8 Detail from <u>Dancers Preparing for the Ballet</u> by Edgar Degas.

In this enlarged detail, one can see clearly the planes of the side of the face formed by the jawbone, the cheekbones, and the masseter muscle. (Compare this with illustrations 3-5 and 3-9.)

3-9 Analysis of Facial Planes.

This analysis of the detail of the painting by Degas [3-8] shows the planes of the side of the face. The planes join along the masseter muscle from the cheek to the angle of the jaw.

3-10 Detail from <u>Figure Study</u> (crayon) by the author. (Photograph by Kalman Zabarsky.)

The jaw structure and the masseter muscle are strongly defined as a side plane on the head. Sharp angular changes may be seen from jaw to chin and in the cheek plane.

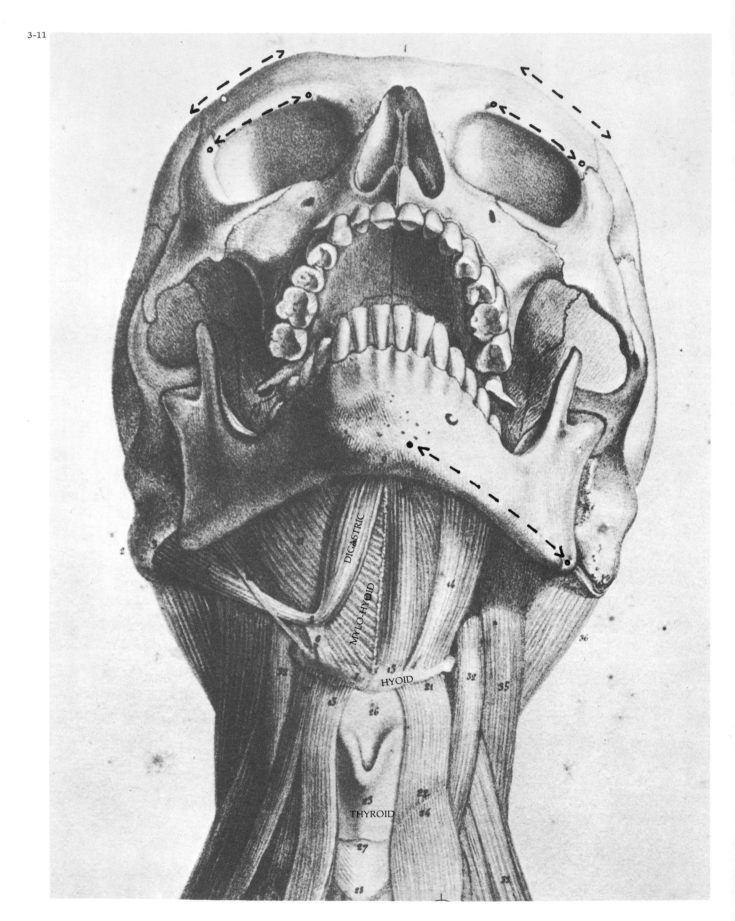

3-11 <u>Foreshortened Skull</u> (lithograph), from <u>Anatomie de L'Homme</u> by Jules Cloquet. (Courtesy: Boston Medical Library in the Francis A. Countway Library of Medicine. Photograph by Kalman Zabarsky.)

Curved directions and opposing planes are easily seen in this foreshortened view of the skull. Note the angles of the jaw, the arches of the teeth, and the curve through the cheekbones, eye cavities, and forehead. These curves are important in drawing the features. Observe their influence in illustrations 3-12, 3-13, and 3-14.

3-12 <u>Sketch of Girl's Head, Looking Up</u> by the author. (Photograph by Kalman Zabarsky.)

This study can profitably be compared with the Cloquet skull [3-11]. Curves through the features are clearly dependent on the underlying skull structure. Related axes may be conceived on the principle of an archer's bow and string. (This principle is seen in the foreshortened full figure by Mantegna [1-4].)

AXES OF THE FACE

Axes running through the features from one side of the head to the other are too frequently reduced to a straight direction. Forms, like the eyes, aligned on such a rigid straight axis, look stiff and mechanical because such an analysis is incomplete. Movements across the head are generally curved [3-11, 3-12].

The confusion that exists between the perspective of a straight axis and the arched structural relationship of certain forms can be easily clarified by noting the connection between the archer's crossbow and its string. This string and bow principle

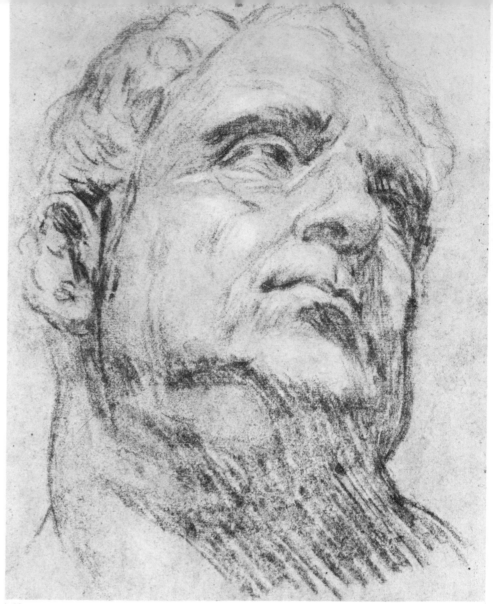

3-13

3-13 <u>Head of the Emperor Vitellius</u> (charcoal and white chalk) by Tintoretto. (Courtesy: The Pierpont Morgan Library.)

The two previous plates may be viewed as an introductory analysis to arched movements through the face, seen here in the musculature of the eyes and around the mouth (orbicularis oris). Observe the strong marking-out of vertical guidelines from both jaws to the temple plane and the converging limits of the almost peaked, foreshortened forehead.

3-14 Detail from <u>Vari Studi di Figura</u> (chalk), Scuola Emiliana. (Biblioteca Reale, Turin.)

An extreme view looking up and under the head. The bony, arched structure of the jaw is stressed. The curve of the foreshortened eye describes the bulge of the round eyeball beneath. Structural divisions in the planes of the face are lightly drawn from the chin through the corner of the mouth into the cheekbone. The side of the face resembles a slightly distorted diamond-shaped plane.

3-14

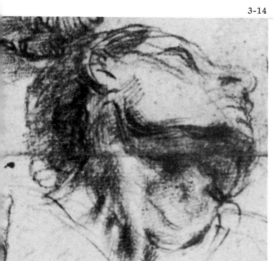

is particularly useful in understanding the curved perspectives that occur across the face [3-12]. In the archer's bow, both string and bow have common points of origin. It is the "straight string" axis that may be held in mind and left unstated, while the bow (archlike) curve of the lips or the curvature through the eyes is projected in a related perspective sequence across the face [3-13].

This same principle should be noted in detailing smaller relationships along the vertical median axis of the head [3-14]. This vertical axis has to be identified through the sequence of steplike, sharply opposed angles that make up the profile. These planes are foreshortened in a three-quarter view [3-15, 3-16] of the head.

Additional bone and muscle relationships are important to the form of the head. The zygomatic arch, a process of the temporal bone, behind the cheekbone is a clear and obvious organic limit between the temple plane and the plane enclosed by the angle of the jaw (masseter muscle). Auxiliary muscles fill out the plane beneath the eye cavity and are enclosed by the zygomaticus major muscle and the nose. A number of small muscles activate various facial expressions (frowns, smiles, etc.) [3-17].

3-15

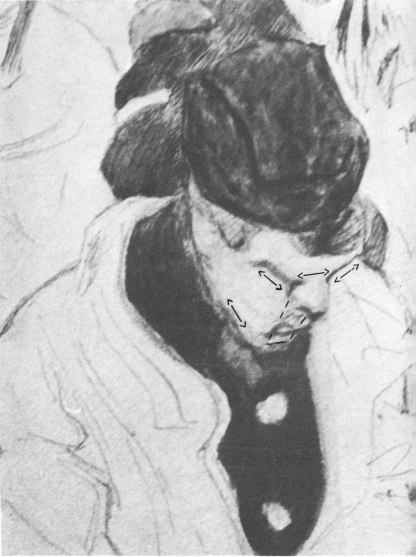

3-16

3-17

3-15 <u>How Sweet It Is To Do Nothing</u> (mixed media) by Jacques Villon. (R. M. Light and Company, Inc., Boston. Photograph by Kalman Zabarsky.)

3-16 Detail from <u>How Sweet It Is To Do Nothing</u> by Jacques Villon.

This detail is of the head and shoulders of the figure in the far-right foreground. When the head is bent forward, the curved perspective and axes across the skull are still influential and not to be overlooked.

3-17 Detail from <u>Self-Portrait</u> (etching) by Henri Matisse. (Fogg Art Museum, Harvard University; Gift of Norbert Schimmel.)

Matisse, in this early, intense, carefully observed self-portrait, demonstrates clearly the angular change of direction in the cheekbone, showing the sharply compressed, foreshortened zygomatic arch moving to the ear away from the front plane of the face. The angles from front to side are clear.

59

3-19

3-18 <u>Skull with Eyeball</u> (engraving), from <u>Tables of the Skeleton and Muscles of the Human Body</u> by Bernhard Albinus. (Courtesy: Boston Medical Library in the Francis A. Countway Library of Medicine. Photograph by Kalman Zabarsky.)

The eye is a spherical volume within the eye cavity. The upper and lower eyelids are curved planes of a distinct thickness, draped over this round form. (See the delineation of the eyelids in illustration 3-19.)(In this engraving, note the formation of the orbicularis oris muscle enclosing the lip structure.)

3-18

3-19 <u>Portrait of Guido Reni</u> by Simone Cantarini. (Pinacoteca Nazionale, Bologna.)

In this portrait by Cantarini, the tense, sensitive, and distinct features of the painter Guido Reni are acutely observed. The eyelids follow the form of the eyeball, clearly reflecting its spherical volume. Skeletal structure at the cheek and jaw is revealed beneath tightly strained skin and muscle.

3-20 <u>Muscles of the Head</u>, from <u>Anatomy of Bones and Muscles Applicable to the Fine Arts</u> by Jean Galbert Salvage. (Courtesy: Boston Medical Library in the Francis A. Countway Library of Medicine. Photograph by Kalman Zabarsky.)

The eyelids have solidity and thickness and follow the curved volume of the spherical eyeball. Compare the eye in this diagram drawing with the eyes in the Matisse lithograph [3-22], the Cantarini portrait [3-19], and the Schiele head [3-21].

THE EYE

The eye has a wide range of very subtle movements. These remarks on the eye are suggestive rather than exhaustive but represent important observations in drawing, once the overall direction and axial curve of the eye are set.

The eyeball [3-18] is not quite a perfect sphere. The added fullness of the iris alters the curvature of the lids in its movement from side to side. The upper lid projects forward over the eyeball—the lower lid moves backward and is generally set deeper in the cavity [3-19]. The lids join into the elliptical orbicularis oculi muscle enclosing the

ORBICULARIS OCULI
ZYGOMATICUS MINOR
ZYGOMATICUS MAJOR
MASSETER
ORBICULARIS ORIS
TRIANGULARIS
MENTALIS

MUSCLES DE LA TÊTE ET DU COL

A — Muscle Frontal.
A 4 — Pyramidal.
B e — Temporal.
C — Orbiculaire.
C D — Grand et Petit Zigomatique.
D — Labial.
D — Releveur commun de l'aile du Nez et de la Levre Sup.re
d — Releveur propre de la Levre Supérieure.
d — Canin.
4 D — Transversal du Nez. (Voyez Pl. 2.)
D E — Buccinateur.
E — Carré du Menton.
e — Triangulaire.
e c — Masseter.
b e — Digastrique.
b 4 — Sterno-Cléido-Mastoïdien.
f 4 — Sterno-Hyoidien.
f 4 — Sterno-Thyroïdien.
f 4 — Omoplat-Hyoïdien.
V 4 — Angulaire de l'Omoplate.
V 3 — Trapeze.
9 V — Grand Pectoral.
V 6 — Deltoïde.

3-21

eyeball in the socket [3-20]. In general, along the vertical dimension of the eye the iris is set on a diagonal axis [3-21].

It is most important, in drawing the eye, not to limit one's observations to the "linear" opening of the lids. To establish convincingly the position of the eye, surfaces surrounding the eyelids should be carefully studied [3-22]. The eye cavity presents clues on the outer skin surface that are helpful in locating the eye form. The structure of bone beneath the eyebrow, the orbital process and depressions just above the cheekbone (malar) and below the lower lid, the temple plane and the process beside the nasal bone may be noted as an enclosing frame for the eye. The inner tear duct of the eye is frequently misplaced forward on the nasal bone. This projects the eye out of the cavity. A considerable plane exists deep on each side of the bridge of the nose, and noting its dimension will keep the eye in its place, behind the forehead plane. This inner surface of the eye cavity is the nasal process of the maxilla bone.

3-22 Detail from <u>The White Boa</u> (lithograph) by Henri Matisse. (Fogg Art Museum, Harvard University; Hyatt Fund.)

Below the lower lid of the left eye, three clearly defined planes follow the form of the eyeball. In this lithograph the enclosing planes of the cheeks have also been closely studied in relation to the eyeball.

3-23 <u>Head of a Man</u> (metalpoint on toned paper, heightened with white) by Filippino Lippi. (Windsor Collection. Copyright reserved.)

The cartilage structure of the lower end of the nose thickens this part of the form. In order to understand the volumes and planes, it may be helpful to see this form in terms of the accompanying diagram.

3-24 Conical Analysis of the Nasal Cartilage.

This analysis is based on the detail of the nose from the portrait by Filippino Lippi. The lower alar cartilage may be likened to two conical units resting one over the other and in opposing directions.

3-24

THE NOSE

The three major planes of the nose (two sides and front) are subject to wide and subtle variation, from small, compact forms to large prominences, occasionally accentuated to the point of caricature. In some individuals the forms of the nose are a small and tightly integrated unit—so much so that details to be discussed here may not seem apparent or even to exist. Close study, however, will reveal the clues to the anatomy of the nose.

It is important to understand the lower alar cartilage and its conical structure. Its relation to the lobe of the nostril may be compared to two half-cones pointing in opposite directions and locked, one above the other, on each side of the nose [3-23, 3-24]. The joining of this alar cartilage at the tip of the nose is sometimes marked by a thin furrow.

64

3-25 Jean, le Musicien (pencil) by Juan Gris. (Private collection, Boston. Photography by Kalman Zabarsky.)

The planes of the nose are clearly explained in this line drawing

3-26 Detail from Jean, le Musicien by Juan Gris.

The projecting underplanes of the nose are clearly defined. The opening of the nostril is contained within a larger, enclosing diagonal plane (note arrow analysis). The front planes from the bridge of the nose are implied by a sequence of related angular changes in the two enclosing contours.

3-25

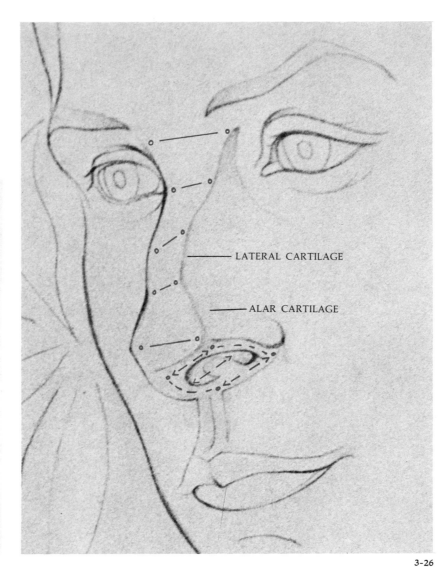

LATERAL CARTILAGE

ALAR CARTILAGE

3-26

The underneath planes that contain the nostrils are obscured by the nostril opening. The dividing septum forms a center horizontal plane between two slightly angled directions. The nostrils lie within these planes, rising diagonally on either side [3-25, 3-26]. To achieve a convincing projection of this form, it is important to observe the surface just outside the nostril opening. This is clearly illustrated in the Gris drawing.

Schematically, the planes seen from the front are three in number. The attachment of the septum and lobes of the nostrils on the head can be observed dimensionally in the profile. The lobes extend into the face, within the profile contour. The septum is shorter, and from a front or three-quarter view this relationship should not be ignored, or the nose may appear false, like a party mask, with no attachment onto the head. The nose fits the curvature of the maxilla bone above the archlike turn of the teeth (and the curve of the orbicularis oris muscle).

3-27

THE MOUTH AND LIPS

The arch structure of the teeth influences the curve of the lips and the fullness of the muscle surrounding the lips (orbicularis oris). In an eye-level, three-quarter view of the head, this arched curve causes a sharp foreshortening of the far side of the lips.

The curvature can be seen easily in a view from below, and this curve can be held consistent with the general axis of the head by noting related axes in the eyes, cheeks, and chin [3-12]. The bow-and-string principle is applicable here. The axis of the lips from one end to the other may be structured on a straight line, within the mouth, like a horse's bridle bit. The lip departs from this axis into an arch following the form of the teeth.

In drawing the refinements of lip form, the steplike opposition between the upper and lower lip and their curved perspective are important [3-26, 3-27].

The chin is a relatively simple blocklike form determined largely by the structure of the mandible and angled forward in opposition to the lower front teeth. It is padded by the mentalis, the quadratus labii inferioris, and the triangularis [3-3].

THE EAR

The complicated form of the ear, if not carefully studied, may easily be distorted into a flat, linear, decorative fixture on the side of the head. Its attachment to the head, surrounding the inner ear, appears sinuously convoluted, disguising major directions and significant structural groupings [3-3, 3-19].

The overall axis of its attachment is generally on a diagonal, continuing the direction of the ramus of the mandible (rear vertical jawline). To further locate the ear, its inner opening in the skull may be noted below the end of the zygomatic arch [3-4].

The ear may be separated into two, not easily distinguishable units: an inner basin and a complex outer frame. Enclosing the large inner basin (concha) is the flaring curvature of complex cartilage that should be understood as lifting away from the head. From the lobe below, this outer surface forms an ever-widening curved frame as it extends upward. The variable corrugations of cartilage that compose this form may be

66

3-28

seen in illustrations 3-19 and 3-28. Important to note are the external rim (the helix) and an inner parallel rim (the antihelix) which surrounds the concha (inner bowl). The tragus is a small projecting baffle partially covering the concha. The lobus (lobe), an extension of softer tissue, is below.

To fully appreciate the relationships of the many forms in the head, it should be studied and drawn in all possible views—from above, from below, from the side, and partially turned from the back, etc. When no model is available, the student may draw self-portraits, using two mirrors angled against each other to reflect a wide range of views (including the profile). Lighting the head for study is important. A single source of overhead light will help reveal large planes and the eye cavities. A movable light fixture with a clamp will permit experimentation to reveal and emphasize different aspects of the form.

3-28 Head of a Negro (charcoal) by Albrecht Dürer. (Graphische Sammlung Albertina, Vienna.)

The strong planes on the side of the head may be compared with those in the work by Degas [3-8].

67

CHAPTER 4
THE NECK

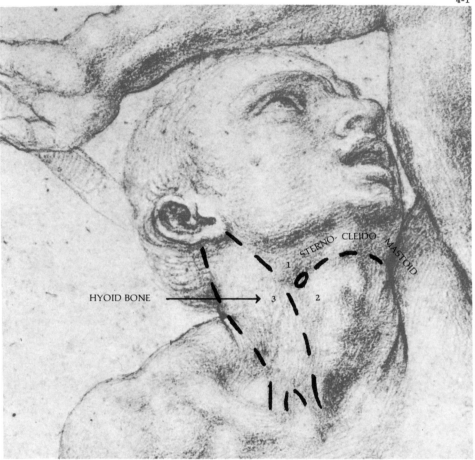

The general axis of the neck in profile is determined in back by the cervical curve of the vertebral column, paralleled in front by a visible axis running through the larynx. It begins above the larynx at the hyoid bone and ends, below it, at the pit of the neck. The cylindrical character of the neck is sharply modified in its form by three major anatomic structures. They are (1) the larynx and hyoid bone in front; (2) the sterno-cleido-mastoid muscle on the side and front (and back); (3) the trapezius muscle (and spinal column) at the back of the neck (from the spinous process of the seventh cervical vertebra to the base of the skull). The deeper musculature, especially at the back of the neck, is important to the fullness of volume, but the framework of spatiality is determined primarily by the three form units listed above.

From the front, the link between the planes of the head and neck [4-1] is the hyoid bone, the pivotal connection between three surface areas [4-2]. These areas are (1) the plane, behind and under the chin and enclosed by the mandible (and the muscles of this region, the digastric and the mylo-hyoid); (2) the form of the larynx (dominated by the thyroid cartilage and its notched prominence, the Adam's apple); (3) the sterno-cleido-mastoid muscle (running diagonally across the neck from the base of the skull, behind the ear, to the pit of the neck).

The key position of the U-shaped hyoid bone in the relationship of forms, seen from the front [4-3], is well illustrated in the accompanying drawings by Bronzino and

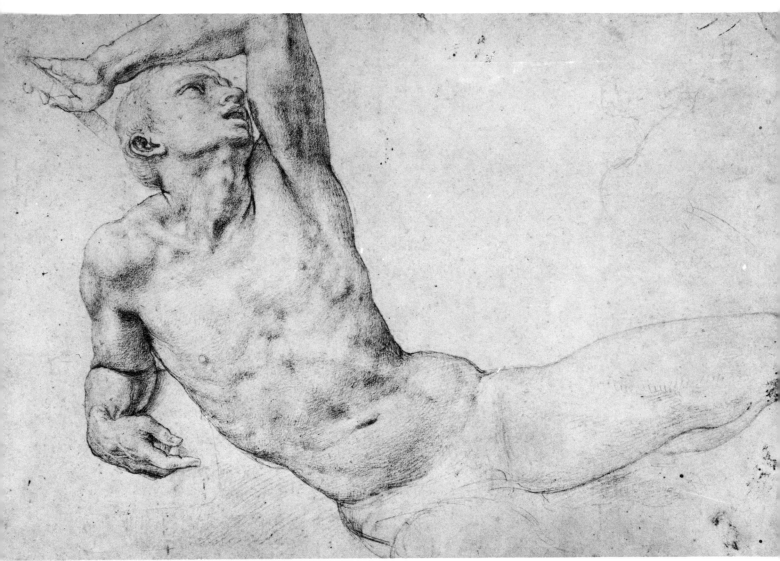

4-2

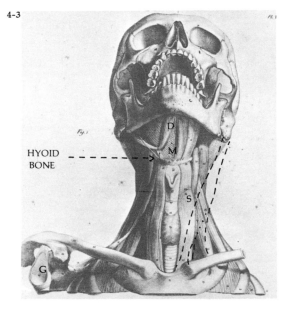

4-3

4-1 Detail from <u>Study for a Figure</u> by Bronzino.

The hyoid bone is a pivotal connection between three surface areas: (*1*) the plane composed of small muscles between the jaw and hyoid bone;(*2*) the thyroid cartilage and larynx; (*3*) the sterno-cleido-mastoid muscle.

4-2 <u>Study for a Figure</u> in the Resurrection Altarpiece, Church of the Annunziata, Florence (black chalk on white paper), by Bronzino. (Isabella Stewart Gardner Museum, Boston.)

The head, neck, and shoulder girdle have been clearly articulated in this drawing.

4-3 <u>Raised Skull with Muscles of the Neck</u> (lithograph), from <u>Anatomie de L'Homme</u> by Jules Cloquet. (Courtesy: Boston Medical Library in the Francis A. Countway Library of Medicine. Photograph by Kalman Zabarsky.)

The important units in the neck that influence its surface and volume from the front are: the hyoid bone (arrow); the larynx and its notched thyroid cartilage (Adam's apple); the thyroid gland below; and the sterno-cleido-mastoid muscle (dotted line). The following muscles are also superficially influential and should be noted: the digastric (*D*); the mylo-hyoid (*M*); and the sterno-hyoid (*S*). The glenoid cavity of the scapula (*G*) is shown below.

4-4 L'Annegato (pencil, 1907) by Umberto Boccioni. (Collection: Gianni Mattioli, Milan.)

Beneath the jaw line, the three forms meeting at the hyoid bone are clearly structured. They are the sterno-cleido-mastoid, the larynx, and the plane between hyoid and mandible containing the elevator muscles of the hyoid bone. (This drawing contains a carefully ordered, consistent overall perspective across the knees, the hips, and the shoulders. The near thigh is worth careful study for the curving guidelines running through the length of the form as well as the clear identification of three long planes enclosing the form from knee to hip.)

Boccioni [4-2, 4-4]. The inner contour of the sterno-cleido-mastoid muscle forms the rear limit of the plane under the chin and the larynx [4-3].

Shaped like a horseshoe, the hyoid bone has no direct attachment to other bones of the skeleton. Its position is maintained by a network of supporting muscles and by the tongue. The hyoid bone rests within the larger framework of the mandible (jawbone), slightly below, and repeats the arched form of the mandible on a smaller scale. It forms the angle of the plane enclosing the surface beneath the jaw and behind the chin. The muscles that fill out this space and elevate the hyoid are: the mylo-hyoid, the digastric, the stylo-hyoid, and the genio-hyoid.

In the profile [4-5], the plane filled out by these muscles is frequently confused with the lower edge of the jawbone (mandible). This plane, behind and under the chin and jaw, should be carefully identified. The direction of the jawbone and the muscle

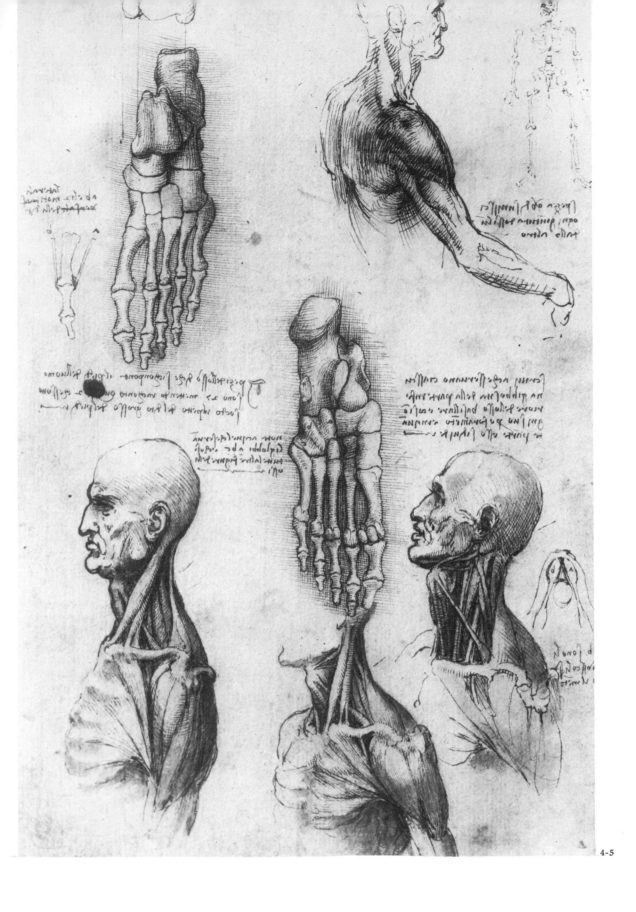

4-5

4-5 Anatomical Studies by Leonardo da Vinci. (Windsor Collection. Copyright reserved.)

Several of the drawings on this page from one of Leonardo's notebooks show his study of the muscles of the neck and shoulder. The major directional thrust of the neck is set by the cervical vertebrae (in back) and the larynx (in front). The opposing movement of the sterno-cleido-mastoid muscle (from the pit of the neck to the mastoid process behind the ear) should not obscure the main forward thrust. In some views (usually three-quarter front or three-quarter back), the fullness of the sterno-cleido-mastoid suggests a backward thrust to the neck. This may give a stiff appearance to the relationship between head, neck, and torso.

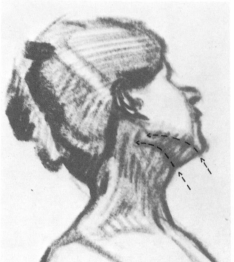

4-6

contour formed below it by the digastric muscle form a foreshortened, thin, wedgelike plane bending in toward the neck [4-6].

The muscles below the hyoid bone that depress it and enclose the larynx are the sterno-thyroid, the thyro-hyoid, the sterno-hyoid, and the omo-hyoid. When the head is raised and the neck is in a tensed, strained attitude, the sterno-hyoid muscle may stand forward, tendon-like, from the larynx form.

A number of deeper muscles contribute to the fullness of the back of the neck [4-5]. The deepest are the upper fibers of the erector spinae, overlaid by the complexus and the splenius. More to the side are the levator scapulae and the scalene. These are partially visible between the trapezius and the sterno-cleido-mastoid muscle.

The origin of the trapezius muscle at the base of the cranium (occipital protuberance) creates a clear change of plane direction between the curve of the skull and the flatter surface of this muscle [4-8]. The trapezius muscle covers an extensive area of the upper back, spreading out to the shoulders and covering part of the scapulae. The part

4-7

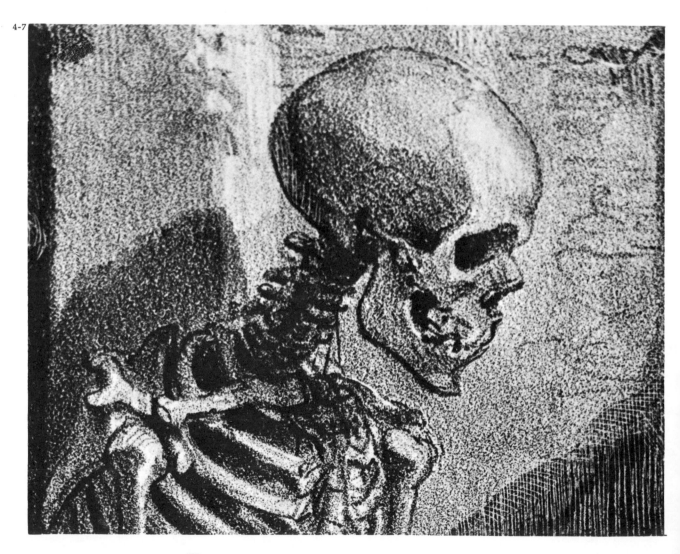

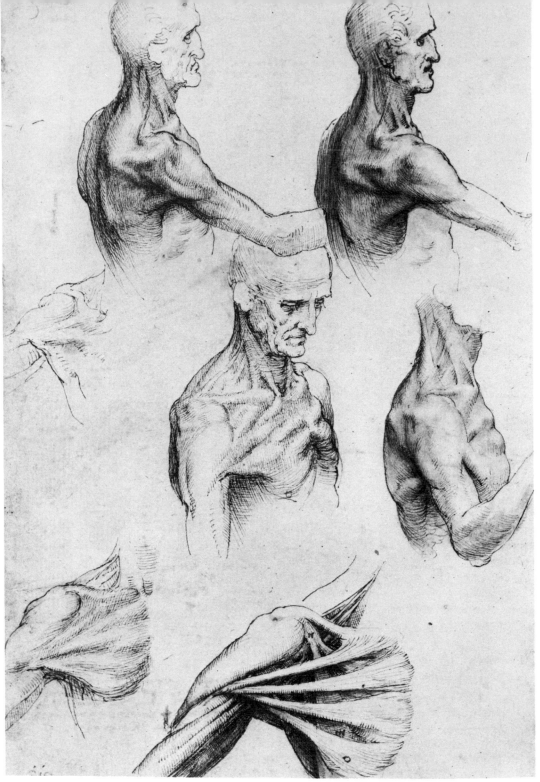

4-8

4-6 Detail from <u>Study of a Figure</u> by the author. (Photograph by Kalman Zabarsky.)

In this study, the head and neck are seen from below and the side. The plane enclosed between the jawbone (mandible) and the neck (hyoid bone) is seen from the side. This surface is frequently ignored or misunderstood in joining the head and neck. The lower arrow indicates the angle created by the hyoid bone.

4-7 Detail from <u>Vous etes bien long, jeune homme</u> (lithograph) by Auguste Raffet. (Collection: the author. Photograph by Kalman Zabarsky.)

The relationship of skeletal structure in the head, neck, and shoulders as seen in this lithograph may be compared with the musculature in the center figure in the anatomical sketches by Leonardo [4-8].

4-8 <u>Anatomical Studies</u> by Leonardo da Vinci. (Windsor Collection. Copyright reserved.)

The muscles of the neck and shoulder are seen from various angles in this series of sketches by Leonardo. The angle of the trapezius muscle sets the relationship between the neck and shoulder planes. The distance from the trapezius, the large, high muscle extending from the shoulder to the back of the neck and the clavicle bone in front, indicates a major part of the thickness of the upper torso.

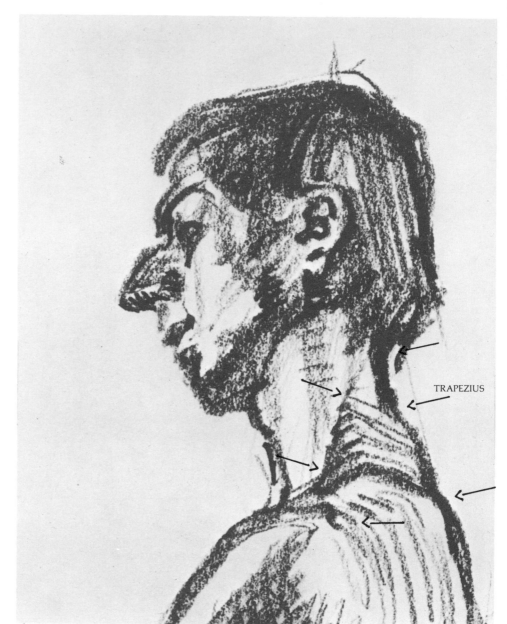

TRAPEZIUS

4-9

4-9 <u>Study of the Head and Neck</u> by the author. (Photograph by Kalman Zabarsky.)

The thickness of the trapezius muscle is indicated as it proceeds from the shoulder to the base of the skull in the back of the neck. Observe also jaw and neck relationships and the plane enclosing the jaw.

4-10 <u>Portrait of an Italian Boy</u> (crayon and water-color) by Oskar Kokoschka. (Courtesy: Worcester Art Museum.)

Careful study of this drawing will reveal a beautiful order of space supporting an intensely moving, expressive figure. The neck structure and the plane behind the chin and under the jaw are clearly and economically stated. From the pit of the neck, the larynx stretches diagonally upward, and a clear line defines the hyoid bone. Parallel guidelines have been inventively employed to define planes and muscular form: the strong diagonal hairline on the side of the head at the ear, and the line from the corner of the near eye; the line over the near cheek to the jaw (masseter muscle), and the line in the neck (limiting the sterno-cleido-mastoid).

relevant to the neck forms a modified triangular plane with its apex at the back (occipital ridge) of the skull and spreads to a broad base ending at each shoulder. The distance from the angle of the trapezius, between the neck and shoulder running forward to the sternal attachment of the clavicle, indicates part of the thickness of the upper torso [4-8, 4-9].

Two prominent strands of muscle embrace the neck on each side, running diagonally across the form. This muscle, the sterno-cleido-mastoid, can confuse the direction of the neck, especially when seen from a three-quarter back view. Since it runs diagonally across the neck from an upper attachment (insertion) at the mastoid process (behind and under the ear) to its two lower points of origin at the sternal end of the clavicle and the manubrium, it should be carefully observed in relation to the overall axis of the neck (4-5, 4-8).

74

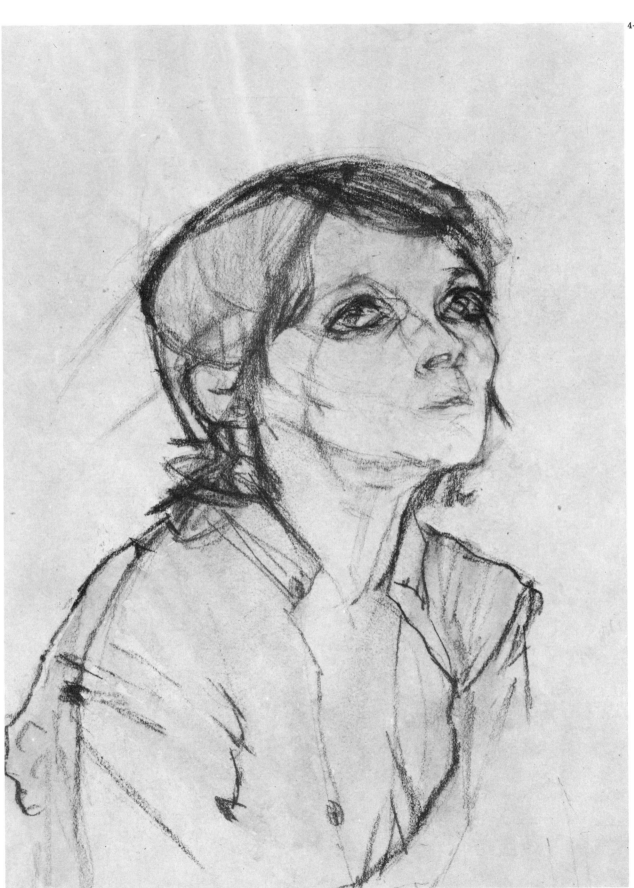

CHAPTER 5
THE TORSO

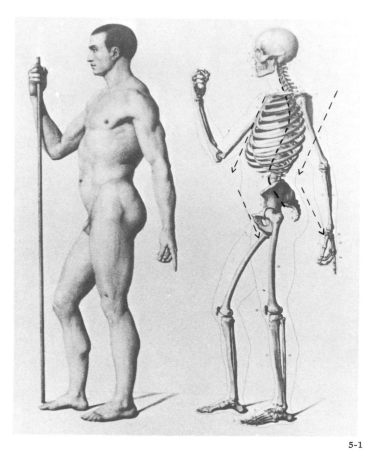

5-1

5-1 Skeleton and Figure (lithograph), from <u>Anatomie of the External Forms of Man</u> by Julian Fau. (Courtesy: Boston Medical Library in the Francis A. Countway Library of Medicine. Photograph by Kalman Zabarsky.)

The curvature of the spine governs the axis and location of the pelvis, rib cage, and skull. In the standing figure, this curve controls the opposing directions between the pelvis and the rib cage and contributes to the overall curve of the torso. The understanding of this opposing relationship is well demonstrated in the drawing by Raphael [5-2].

5-2 Two Male Nudes (study for The Battle of Ostia) by Raphael. (Graphische Sammlung Albertina, Vienna.)

The two major skeletal forms of the torso, the rib cage and the pelvis, are united by the spine. It is the curve of the spinal column that determines their relationship. In the mature figure, in a normal erect posture, the rib cage is angled forward toward its wide base, and the pelvic structure is set in an opposing backward direction, giving an arched form to the trunk [5-1, 5-2].

THE SPINE

The vertebral column, made up of twenty-four bones, has a considerable range of movement. Roughly drum-shaped, the bodies of these twenty-four vertebrae are stacked, one upon the other, forming a strong pillar for the support of the cranium and trunk [5-3]. Movement is permitted by flexible intervertebral disks (cartilage) wedged between the vertebrae. The long, deep muscles of the back act on three short levers (processes) of bone arranged radially on each vertebral unit. In the region of the rib cage (dorsal vertebrae), two of the levers (transverse processes) provide added support for the vertebral attachment of the ribs. There are seven (cervical) vertebrae in the neck, twelve (dorsal) vertebrae for the attachment of ribs, and five (lumbar) vertebrae in the space between the rib cage and the pelvis.

1515

Zerfrakel Er Seligr der so Hoff von
Poht gwoht ist gwest hot die sa-
shist norkene Bild gemacht vnd
vr Herr albrecht Düre von Nornte
geshikt in seim sand Herweisl

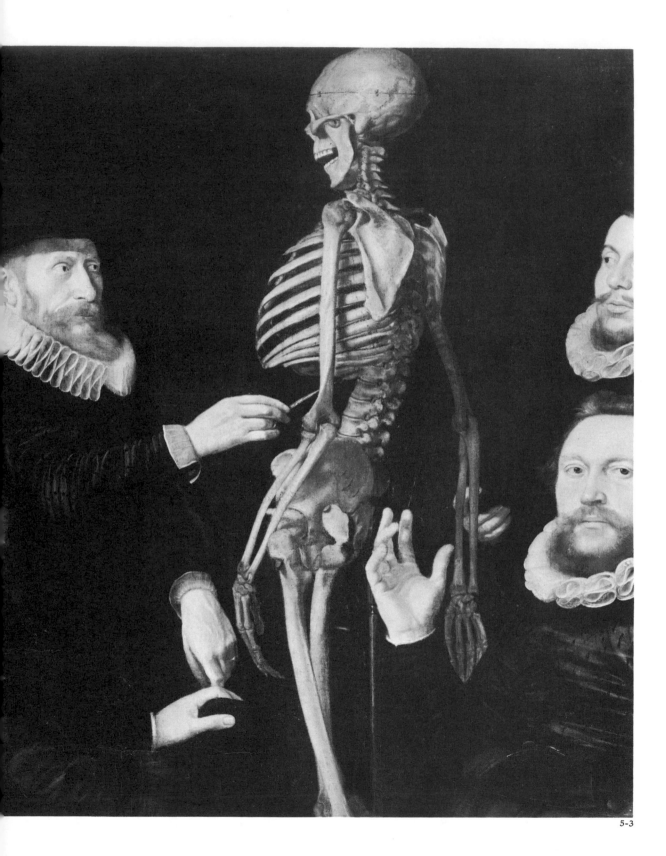

5-3

5-3 Detail from <u>The Anatomy Lesson of Dr. Egbertsz</u> (oil on canvas) by Thomas de Kayser. (Rijksmuseum, Amsterdam.)

The rib cage, similar to a rounded keg, is the dominant volume in the torso. It is enclosed by the scapula in the upper back. (Compare this with the sketch by Pontormo [5-4] and with the skeleton in the lithograph by Raffet in the next chapter [6-1].) The anatomist, in this detail, is pointing to the disklike body of a vertebra.

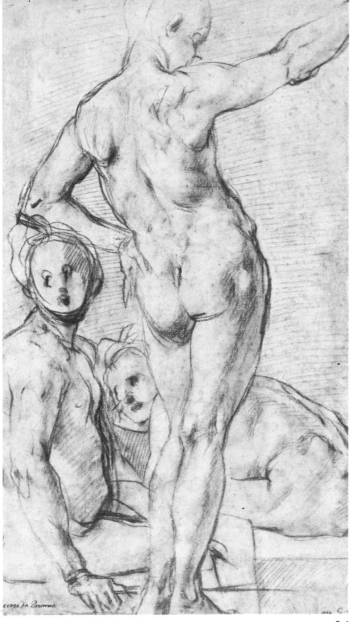

5-4

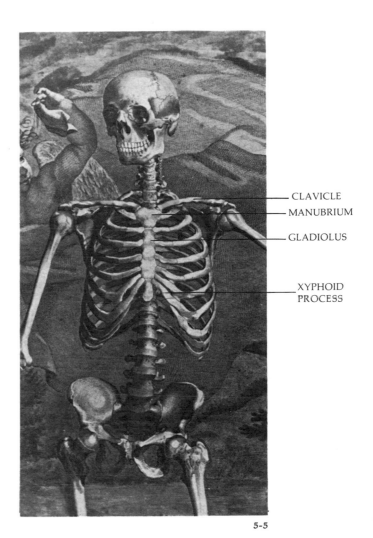

CLAVICLE
MANUBRIUM
GLADIOLUS
XYPHOID
PROCESS

5-5

THE RIB CAGE

The rib cage [5-3], the major skeletal frame for the volume of the upper torso, is to an extent hidden within the shoulder girdle and the strong musculature of the back and chest. This intimate overlapping of the ribs by the shoulder girdle makes it difficult to separate and identify the individual forms.

 The form of the thorax (rib cage) from the rear is expressed indirectly through the scapula overlaying the volume beneath. The full form—the space-filling, three-dimensional capacity of the torso—is primarily fixed by this ribbed, egglike or keg-shaped framework [5-3, 5-4]. Some idea of the dimension of the rib cage may be inferred from external facts. The diameter of the base of the neck behind the clavicle approximates the size of the opening of the first rib. Comparing this dimension with the enclosing curves of the ribs on each side of the upper torso beneath the chest will offer some understanding of the shape of this form [5-1, 5-3].

 In the rib cage, the relationship of the sternum (breastbone) to the lower dorsal section of the spinal column is important to the axis of the torso. They are roughly parallel. The breastbone is like a bony necktie on the chest into which the cartilages of the ribs insert [5-5]. The sternum is formed of three firmly joined units. The top unit, the manubrium, is like the knot of the tie, and its upper surface locates the pit of the neck. The gladiolus is the blade-shaped body below this form. The small lower extension is called the xyphoid process.

5-4 **Standing Male Nude Seen from the Back, and Two Seated Nudes** (red chalk) by Jacopo da Pontormo. (Courtesy: The Pierpont Morgan Library.)

The egglike form of the rib cage and the triangular frame of the scapula may be clearly distinguished in this drawing. (Compare this with the drawing by Raphael [5-2].) When the arm is raised, the scapula swings away from the spine. Guidelines mark its location. (Compare the position of the scapula here with the illustration by Julian Fau in the next chapter [6-7].)

5-5 **Detail of the Rib Cage and Pelvis, from The Skeleton: Front View, from Tables of the Skeleton and Muscles of the Human Body** by Bernhard Albinus. (Courtesy: Boston Medical Library in the Francis A. Countway Library of Medicine. Photograph by Kalman Zabarsky.)

In this illustration, the breastbone (sternum) and its three parts can be seen. The topmost unit, the manubrium, forms the pit of the neck and is triangular in shape. The middle unit, the gladiolus, has a long, wedgelike shape. The xyphoid process, the third unit, is suspended below like a small, rounded pendant.

THE SHOULDER GIRDLE

The shoulder girdle is a loose framework of two bones, the clavicle (collarbone) and the scapula (shoulder blade) joined at the outer shoulder. These two bones enclose the upper part of the rib cage, front and back. The scapula glides smoothly over the ribs in the upper back, pivoting at its acromion process (shoulder articulation) against the outer extremity of the clavicle. This is its only direct contact with another bone. The clavicles, in turn, articulate in front with the upper unit of the sternum (the manubrium) [5-5]. From this single articular connection at the pit of the neck, the shoulder girdle enjoys wide movement.

Since the bone of the upper arm (humerus) articulates with the glenoid cavity of the scapula, this added shoulder flexibility contributes to the great range of movement in the arm. (This relationship should be reviewed when studying the arm.)

PLANES OF THE UPPER TORSO

While most body forms exhibit a challenge by their complexity, some present a problem by their apparent simplicity. The chest plane within the torso is a case in point [5-6, 5-7]. It is formed largely by the pectoralis major muscle spreading out on both sides of the breastbone (sternum) and the inner part of the clavicle. It inserts into the bicipital ridge of the humerus bone at the shoulder, stretching uniformly over the ribs. The unseasoned draftsman may be disarmed by the unadorned chest expanse. The chest plane is frequently ignored—treated as a non-existent surface area—probably because it is framed by a number of visually more intriguing forms. Seen from the front, the chest plane has no obvious outer contour limit. It is enclosed: (1) on top by the clavicle and neck (and above and behind by the trapezius, upper back); (2) on each side by the shoulders; (3) below by the rib cage (in the female, by the breasts).

This relationship often leaves the mistaken impression that the chest plane has no clear identity. It is therefore incumbent on the observant student to measure the frame of the chest with great care, to momentarily isolate its shape and clearly note its distinctive form. Failure to consider this surface area carefully will result in a cottony, flaccid, unsupported structure and an unconvincing central surface contact for the more obvious and easily seen adjacent forms.

The chest plane is markedly altered when the arms are raised, the pectoral (chest) muscle being pulled into the form of the deltoid (shoulder), and the two seeming to become one muscle form. This can be seen in the Leonardo drawing in the preceding chapter [4-8].

When the arms are relaxed and hanging, the outer third of the curve of the clavicle marks a surface change that corresponds with the origin of the deltoid (shoulder). In this position, the chest plane in relation to the shoulders is like the center panel of a three-paneled screen with the shoulders as the outer projecting panels [5-7]. The thickness of the pectoral muscle and its insertion beyond the ribs into the humerus bone of the arm somewhat flattens the plane of the chest over the curvature of the upper ribs, but the larger egglike fullness of the rib cage should not be forgotten or ignored.

In the female form, the breast is divided by the pectoral muscle at its outer limit, part attaching into the side of the rib cage below the armpit, and the major portion forming an appendage over the lower chest [1-19]. Again the curvature of the ribs cannot be overlooked. In a reclining pose [2-10] the breasts are flattened and fall to

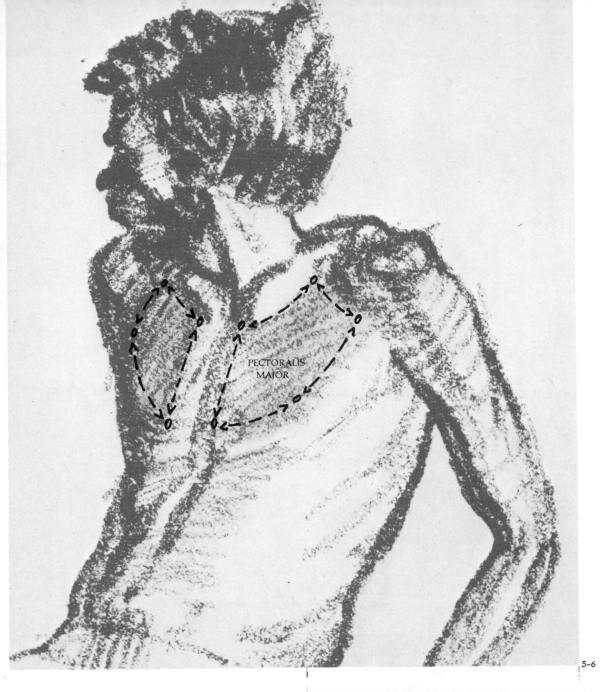

PECTORALIS
MAJOR

5-6

5-7

5-6 Shoulders and Chest (crayon) by the author. (Photograph by Kalman Zabarsky.)

The chest plane, a relatively simple area, is frequently ignored in favor of more interesting adjacent forms. It should be carefully measured to hold in place the prominent forms joining into it. (See illustration 4-8, the studies by Leonardo, for the muscles of the chest.)

5-7 Detail of Shoulders and Chest from Figure Study (crayon) by the author. (Photograph by Kalman Zabarsky.)

In the upper torso, the chest plane is like the center panel of a three-paneled screen. When the arms hang limp beside a relaxed torso, the shoulders project forward like two outer panels.

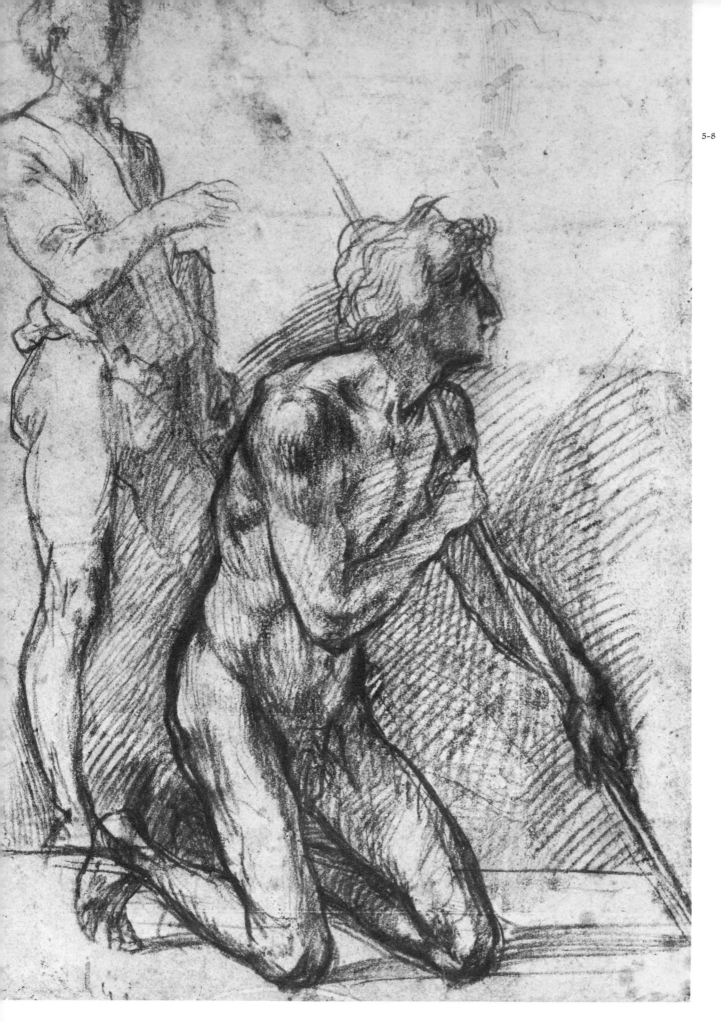

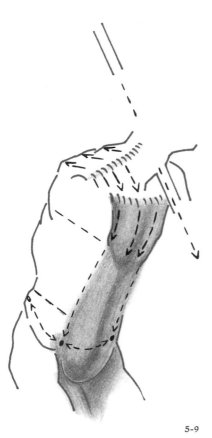

5-9

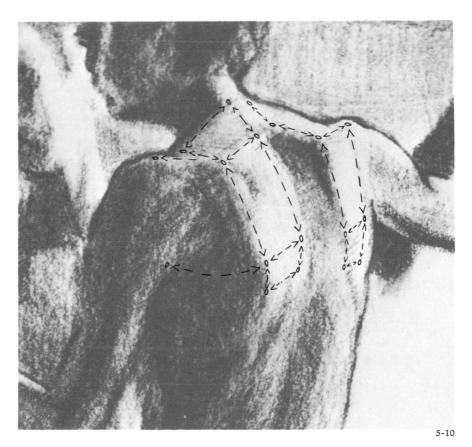

5-10

each side of the arched rib form. This opposing movement of the breasts, down on each side and away from the sternum, is a far more subtle relationship in the standing figure.

The pit of the neck (manubrium), bordering above the chest, is a very useful point of reference [4-8]. It is the hub for forms radiating out in many directions: (1) from the larynx to the hyoid bone vertically above; (2) from the sterno-cleido-mastoid muscles moving diagonally upward to behind the ears (inserting at the mastoid process); (3) from the clavicles moving outward, right and left, to the shoulders; (4) from the sternum projecting down to the high point of the thoracic arch.

The Del Sarto study [5-8] a figure seen from a three-quarter view, reveals the thickness and dimension of the upper torso from the upper back over the shoulder blade, and the space between trapezius and clavicle. The two planes are pitched to an apex at the height of the trapezius. From the spine of the scapula in the back, up to the limit of the trapezius, down to the clavicle in front, two inclined planes "roof over" the top of the torso and convey its thickness, front to back [5-9]. (Note how the staff, in contact with the clavicle, emphasizes the forward top plane.)

The shoulder blades are two thin, triangular frames clearly visible on each side of the upper back. Each has a strong projecting ridge called the spine of the scapula. Seen from the back, the spine of the scapula comes more directly into play as a significant limit to the top surface of the shoulder [5-2, 5-10]. The two opposing angles (created by the two scapula spines) establish strong directions which enclose the volume of the upper torso.

The torso seen from the side or three-quarter view requires special care in its organization. The individual rib, set in place, has a diagonal direction down from its vertebral attachment around to the front of the figure [5-1]. Its curve and its

5-8 Study of a Kneeling Figure by Andrea Del Sarto. (Courtesy: Trustees of the British Museum.)

The relationship of the collarbone to the shoulder blade identifies the thickness of the torso—front to back. The pressure of the staff against the shoulder emphasizes the diagonal direction of the top front plane from the clavicle to the trapezius muscle. The plane from the trapezius to the spine of the scapula completes the thickness of the torso. (Compare this illustration with the sketches by Leonardo in the previous chapter [4-8].)

5-9 Diagram of the Planes in Study of a Kneeling Figure.

This diagram is based on the study by Andrea Del Sarto [5-8]. The two planes of the shoulder and the upper back, from the collarbone to the spine of the scapula, "roof over" the top of the torso and convey its thickness. Both planes meet at the height of the trapezius muscle. These planes are related to the architecture of the side and front of the figure and extend downward into the hip structure.

5-10 Detail from Model and Mirror by the author. (Photograph by Kalman Zabarsky.)

The bony triangular frame of the scapula (and the spine of the scapula) encloses the top shoulder plane, identifying the thickness of the upper torso from the back. The planes over the upper rib cage are primarily formed by the scapula in relation to the spine. Compare this with illustration 5-2. (See illustration 5-18 for the complete drawing.)

83

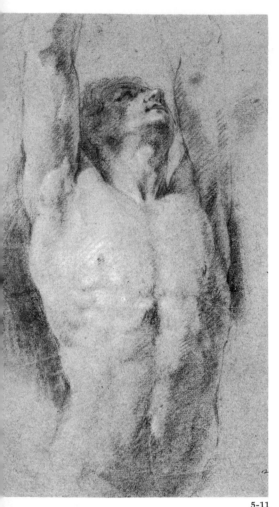

5-11

5-11 <u>Study of a Man with Upraised Arms</u>, seventeenth century. (National Gallery of Scotland.)

The interlocking of the serratus magnus and the external oblique muscles against the rib cage creates an often confusing zigzag pattern of shadow that should be seen in a larger context. This braided effect should be carefully organized in direction and tone so that it will tie into the larger planes of the torso.

5-12 Detail from <u>Muscle Analysis of the Laocoon</u>, from <u>Anatomie of the External Forms of Man</u> by Julian Fau. (Courtesy: Boston Medical Library in the Francis A. Countway Library of Medicine. Photograph by Kalman Zabarsky.)

The relationship of the rectus abdominus (A), the external oblique (B), the serratus magnus (C), the latissimus dorsi (D), the pectoralis major (E), the deltoid (F), and the inguinal (Poupart's) ligament (G) is clearly illustrated in this figure. The tendinous transverse lines running across the abdomen should not be overstressed, or they will destroy the long vertical planes. (See the drawing by Prud'hon [5-13].) The serpent is biting the tensor fasciae latae and gluteus medius muscles.

pronounced marking on the slender model can confuse and hide the overall order of planes on the front and side of the body. On a muscular individual this is further complicated by the obvious plaited effect of the serratus magnus muscle with the external oblique, creating an interlocking zigzag pattern that offers an irresistible temptation to lovers of detail [5-11]. Drawn without understanding and out of context, this area can obliterate all sense of form and unity in the torso.

The serratus magnus is a broad, flat (segmented) muscle originating on the side of the rib cage from the eight upper ribs and converging up and under the scapula to its inner border (near the backbone) [5-11, 5-12].

The external oblique originates from the lower border of the eight lower ribs joining against the five lower segments of the serratus magnus. The larger curving plane of the rib cage on the side of the torso must be preserved while these muscle segments are drawn and integrated. The external oblique at its insertion on the outer crest of the pelvis forms the overhanging fullness of the flank pad.

THE PELVIS AND ABDOMEN

The composite form of three bones known as the pelvis is puzzling in its apparent irregularity. Although the two flaring sides, joining the sacrum, are called the "nameless bone" (os innominatum), having no similarity to any known object, the form as a whole may be given some order and description. The lower portion, made up of the triangular sacrum, the ischial tuberosities, and the pubic arch, forms a small, perforated basket-like enclosure (the true pelvis). Above are the two fan-shaped wings with a thick, curving ridge (iliac crest) flaring out from an inner rim (pectineal line) and forming the back part of a larger basin (the false pelvis) [5-5]. Behind the pubic arch are located the cuplike sockets for the articular head of the femur. The thickened lower ischial tuberosities support the body when it is in a seated posture.

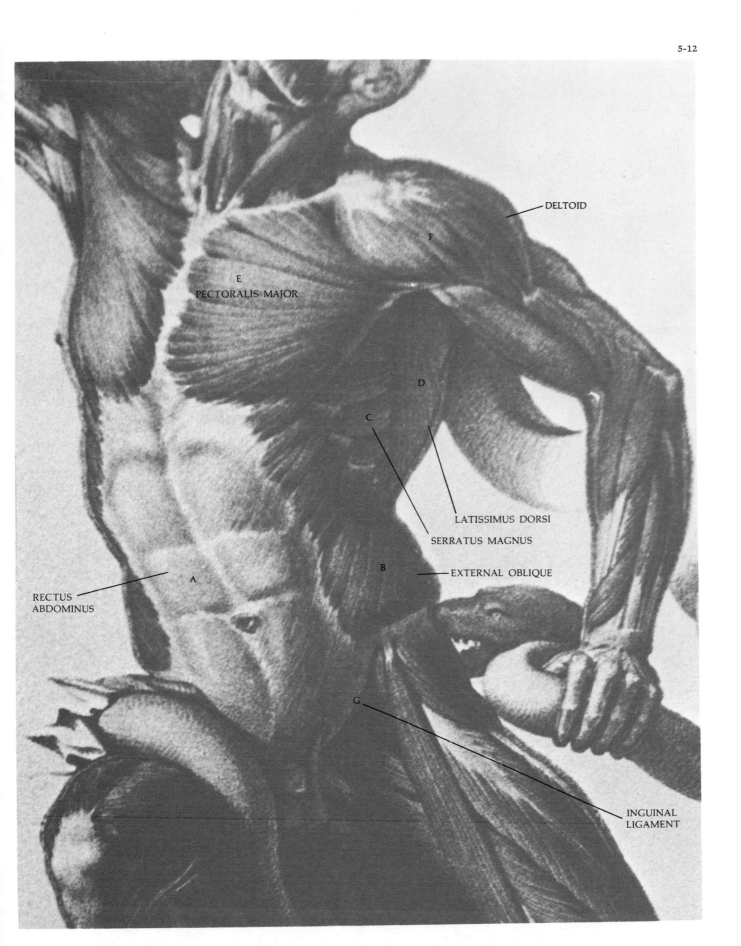

DELTOID

F

E
PECTORALIS MAJOR

D

C

LATISSIMUS DORSI

SERRATUS MAGNUS

B EXTERNAL OBLIQUE

A

RECTUS
ABDOMINUS

G

INGUINAL
LIGAMENT

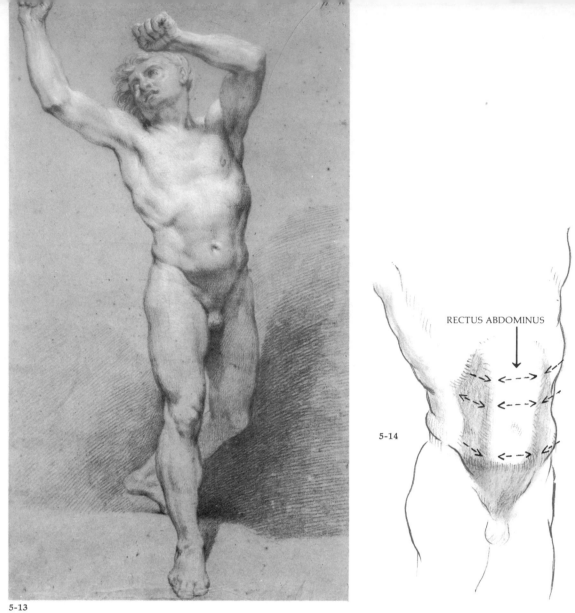

5-13

RECTUS ABDOMINUS

5-14

5-13 <u>Study of a Male Nude with Arms Raised</u> (drawing on toned paper, heightened with white) by Pierre-Paul Prud'hon. (Fogg Art Museum, Harvard University; Gift of Mr. and Mrs. Philip Hofer.)

The form of the abdomen is a variable mass of subtle curvature. The broad planes flow easily, one into the other. In the standing figure, the volume is made up of three planes forming a front and two sides enclosed below by the pelvic arch. This lower fullness, attaching into the pubic bone, completes the basin-like volume of the pelvis. In this drawing the form bulges forward. Compare it with illustrations 5-14 and 5-15.

5-14 Analysis of the Planes of the Abdomen.

This analysis is based on the drawing by Prud'hon [5-13]. Three broad, vertical planes make up the abdominal form. They bend around the abdomen like a three-paneled screen.

The pelvis initially may be conceived as two joined basins, the larger above, with much of its enclosing surface removed. Above the iliac crest of the pelvis is the muscular fullness of the lower portion of the external oblique muscle forming the flank pad [5-12]. Fleshing out the form of the flank pad are the transversalis and internal oblique muscles beneath the external oblique. The upper, curved bony ridge of the pelvis (iliac crest) is set in and under, and should not be confused with this fleshy form above. Below the iliac crest, on the side, are the tensor fasciae latae and gluteus medius. Originating from the rear iliac crest and sacrum is the large, padded gluteus maximus muscle.

The abdominal muscle (rectus abdominus) [5-12, 5-13] stretches like a tent over the lower front of the torso, attached to bone at the arch of the ribs above, and the reverse pelvic arch below (emphasized by Poupart's ligament). Its mid-area, as a volume, is formed by the pressure of internal organs (intestines, bladder, etc.). As a consequence of this limited peripheral contact with bone, it too can be radically altered in form by the movement of the spine (and ribs and pelvis).

On either side of the median line (linea alba and navel) the abdominal mass contains a frontal plane parallel to the frontality of the figure. This plane turns diagonally back on both sides of the torso into the external oblique, like a three-sided screen angled away from the viewer [5-13, 5-14]. The form is somewhat rounded below and joins at the pubes. The rectus abdominus is segmented by tendons known as transverse lines. Care should be taken not to overemphasize these transverse divisions. They can obscure the three enclosing vertical planes of this form [5-15, 5-16].

86

5-15 A Skeleton with One Leg Kneeling on a Rock by Rosso Fiorentino. (National Gallery of Scotland.)

This figure may be used as a partial dissection for the Michelangelo *Study for Haman* [5-16]. The rectus abdominus is pulled in under the ribs by the external oblique. (Contrast this with the drawing by Prud'hon [5-13].) This region, below the thoracic arch and above the pelvic girdle, occupied by abdominal muscle and flank pad, is an area free of bony support and therefore capable of wide modification as a volume. On either side of the median division are two parallel limits which join the abdominal mass to the external oblique, projection above the crest of the hip bone. (Under the raised arm are segments of the serratus magnus.)

5-15

5-16

5-16 Study for the Figure of Haman by Michelangelo. (Courtesy: Trustees of the British Museum.)

In this extraordinary drawing the complicated tension of muscles and bones has been brilliantly integrated into fluent, powerful action functionally animating even the smallest forms, yet preserving structure and volume. The sharply foreshortened axial thrust through the raised arms and shoulders is opposed by the direct front view of the pelvis, giving a powerful twist to the torso. Within this spiral movement, contour and tonal complexity are organized to preserve large masses. The chest plane is confined by the tightened parallel shoulder and pectoral muscles, visible as a contour on the left and a shadow on the right. The front plane of the torso is framed by a long S-curved shadow running from the armpit at the right shoulder down to the hip. This long, interrupted shadow is repeated by the contour on the left side of the rib cage, and the movement continues within the torso, breaking into the pelvic cavity above the flank pad.

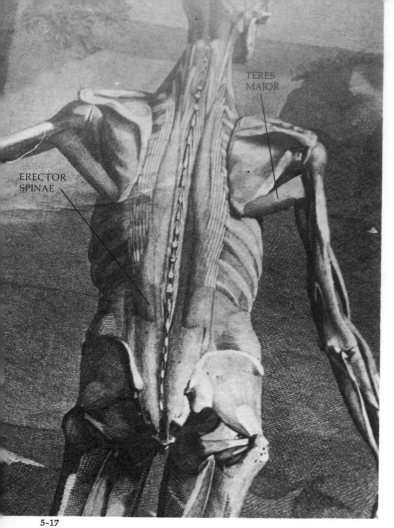

TERES
MAJOR

ERECTOR
SPINAE

5-17

5-17 Detail from <u>Skeleton with the Deep Muscles of the Back</u>, from <u>Tables of the Skeleton and Muscles of the Human Body</u> by Bernhard Albinus. (Courtesy: Boston Medical Library in the Francis A. Countway Library of Medicine. Photograph by Kalman Zabarsky.)

The erector spinae, the deep supporting muscles of the spine and back, extend from the pelvis to the base of the skull and fill out like two semicylindrical fullnesses on each side of the spinous processes of the vertebrae. (See illustration 5-18.) Shown also free of other muscles are the two teres major muscles extending from the lower border of each shoulder blade to the humerus bone. The teres major is visible above the latissimus dorsi.

5-18 <u>Model and Mirror</u> by the author. (Photograph by Kalman Zabarsky.)

On the slender model, the two columnar fullnesses rising from the sacrum on each side of the spine show the influence of the erector spinae muscles on the form of the lower back. (Compare this with illustration 5-17.) The spinal column in the back and the median line in the front of the torso are useful guides to foreshortening in the three-quarter view of the figure. The distance from the spine to the far contour of the torso should be very carefully noted and compared with the larger dimension from the spine to the near contour. This simple judgment, so frequently ignored or carelessly observed, holds the smaller form convincingly behind and away from the viewer. (An enlarged far form unit competes with the near volume and confuses the space.)

THE BACK

The muscles of the back are numerous but are covered almost completely by two large, broad muscles. These two muscles are strongly influenced by the deeper skeletal and muscular structure beneath [5-17].

The latissimus dorsi is a wide, flat muscle enclosing the lower back [5-20]. From an extensive attachment at the rear of the pelvis, it spreads and encloses the lower part and midsection of the rib cage on the back and side. Moving out from the torso, the muscle fibers converge and twist inserting into the bicipital groove of the humerus.

Above the latissimus dorsi the somewhat triangular-shaped trapezius muscle [5-19] spreads from its vertebral origin to the ridgelike spine of the scapula out to the shoulder. Its upper portion forms the high, forward-thrusting plane of the back, and it narrows to form the back of the neck inserting into the base of the skull (occipital bone). Beneath these two muscles is an extensive network of smaller muscles that play an important part in filling out the form of the back.

The erector spinae form two long complex muscular and tendinous masses that fill out the groove on either side of the spinous process of the vertebrae extending the full length of the back from the pelvis to the base of the skull [5-17, 5-18].

Two additional muscle groups in the upper back should be studied and observed with care. They are: (1) the three muscles that spread between the spine and the inner border of the scapula (shoulder blade), and draw the shoulder blade in toward the spine—the rhomboid major, the rhomboid minor, and the levator anguli scapulae; (2) the four muscles [5-19] that extend from the scapula to the upper humerus bone and act to rotate and to lower the raised arm—the supraspinatus, the infraspinatus, the teres minor, and the teres major.

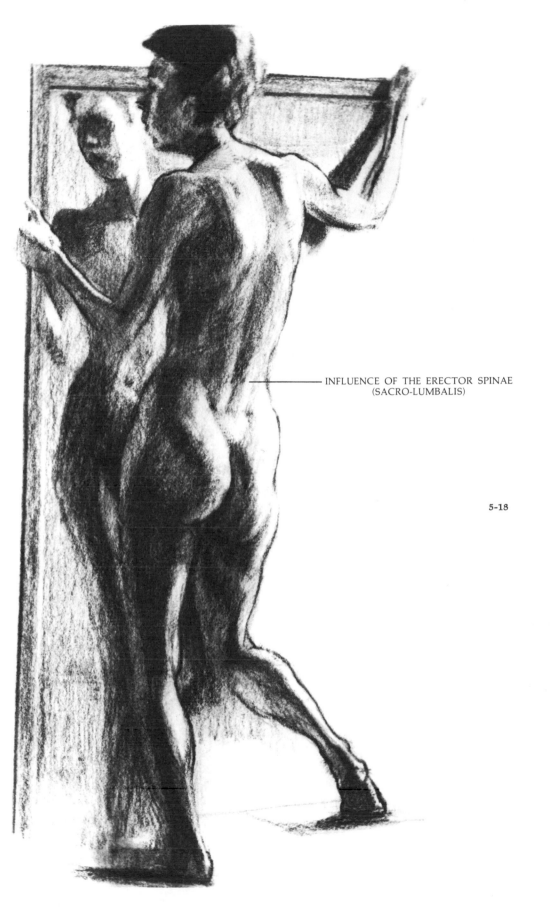

INFLUENCE OF THE ERECTOR SPINAE
(SACRO-LUMBALIS)

5-18

5-19

5-19 Detail from <u>The Muscles of the Side and Back of the Torso</u>, from <u>Tables of the Skeleton and Muscles of the Human Body</u> by Bernhard Albinus. (Courtesy: Boston Medical Library in the Francis A. Countway Library of Medicine. Photograph by Kalman Zabarsky.)

Beneath the shoulder and back muscles, the bony triangular frame of the scapula and the larger volume of the rib cage are visible. The transition of muscles over the side of the torso may be seen here and in illustration 5-20.

5-20 <u>Bending Figure</u> by the author. (Photograph by Jonathan Goell.)

On this muscular model the turn of the latissimus dorsi envelops the rounded rib cage within. Other muscles of the back are clearly visible and are labeled.

TERES MAJOR INFRASPINATUS

LATISSIMUS DORSI

DELTOID

TRICEPS

5-20

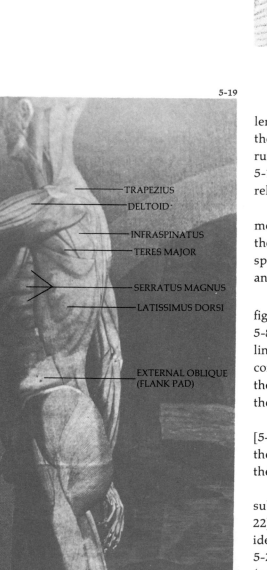

TRAPEZIUS

DELTOID·

INFRASPINATUS

TERES MAJOR

SERRATUS MAGNUS

LATISSIMUS DORSI

EXTERNAL OBLIQUE (FLANK PAD)

The trunk, seen front and back, is marked by a median division running the full length of the form in both views. In the back, this is the spinal column [5-17, 5-18]. In the front, the median division extends from the pit of the neck to the pubic symphysis, running through the sternum and the linea alba (dividing the rectus abdominus) [5-11, 5-12]. One of the problems of foreshortening the torso can be profitably discussed in relation to this central division.

Three-quarter-view drawings of the torso are invariably given too wide a dimension from the median line to the far contour in the drawing. When this happens, the distant part of the form competes with the near (dominant) form and confuses the space. Then, the overextended dimension of the far surface does not keep its position and distance behind the nearer parts of the figure.

In a front three-quarter view, both side and front are seen on the near part of the figure, while only part of the front is seen on the distant side of the median line [5-2, 5-8]. This should be noted and measured with a vigilant eye. The distance from midline to far contour, carefully observed as to dimension, quite simply can set the space convincingly back. The same consideration should be made for the back, comparing the distance from the spine to far contour with the near section of the back and side of the figure [5-10, 5-18].

The lean of the hips, when the weight of the figure has been shifted to one leg [5-22], can be quickly traced on the back surface of the body in the dimpled triangle of the sacrum bone set between and slightly above the buttocks. (In the skeleton [5-21], the sacrum bone joins the two units of the pelvis, the os innominatum.)

Though they appear gradually rounded, the form of the buttocks often has a subtly converging movement, following the converging sides of the sacral triangle [5-22]. The location of the sacrum (visible by its dimples) is, therefore, essential. It also identifies a broad, steplike plane opposing the direction of the mid and lower back [5-2, 5-22]. Dominating the muscular form in this area is the large, strong gluteus maximus (padded below by additional fatty tissue.)

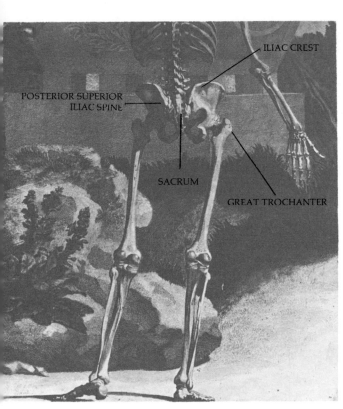

5-21 Detail from <u>The Skeleton: Back View</u>, from <u>Tables of the Skeleton</u> and <u>Muscles of the Human Body</u> by Bernhard Albinus. (Courtesy: Boston Medical Library in the Francis A. Countway Library of Medicine. Photograph by Kalman Zabarsky.)

The triangle at the back of the pelvis is emphasized by the rear portion of the crest of the ilium and the posterior superior iliac spine above the triangular sacrum bone.

ILIAC CREST

POSTERIOR SUPERIOR
ILIAC SPINE

SACRUM

GREAT TROCHANTER

5-21

5-22 Detail from <u>Model and Mirror</u>.

The sacral triangle is a wedgelike plane above and between the buttocks. The fleshy, rounded form of the buttocks has a thrust and direction that reiterates the converging frame of the sacrum. The two upper depressions are aligned horizontally. When the weight of the figure is shifted to one supporting leg, this upper border of the sacrum tilts diagonally down toward the relaxed limb. The angle of the sacrum provides a useful clue to the lean and angle of the overall hip structure. (See 5-18 for the complete drawing.)

5-22

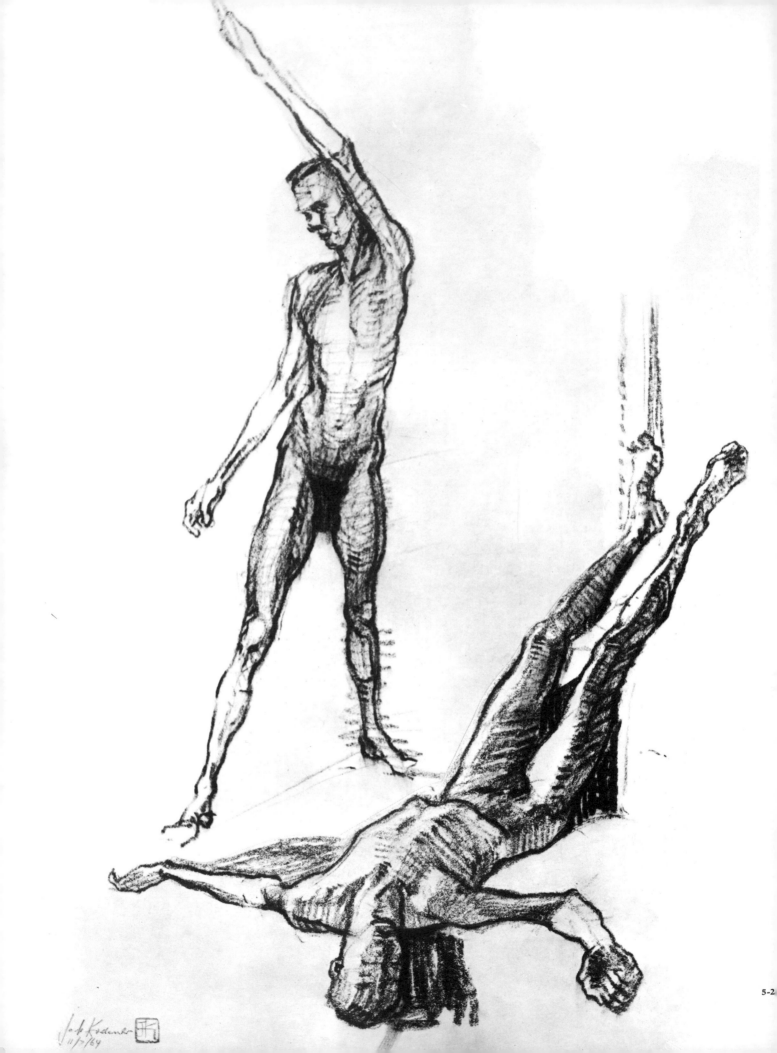

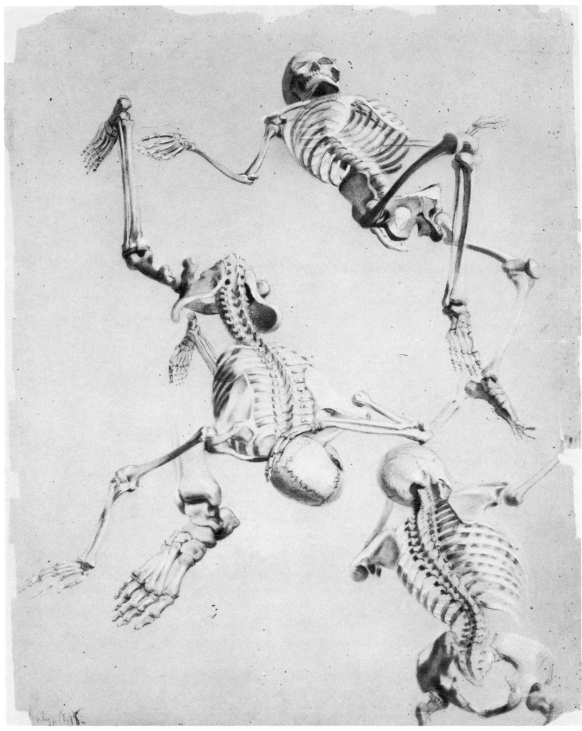

5-23 <u>Figure Studies</u> by the author. (Photograph by Kalman Zabarsky.)

Extensive drawing from a lean, muscular model and an articulated skeleton (as in the examples by Huntington [5-24]) in a wide range of views will contribute enormously to an understanding of the structure of the torso. The planes of the rib cage are sharply defined in the reclining figure.

5-24 <u>Flying Skeletons</u> (crayon and white chalk) by Daniel Huntington (1816–1906). (In The Brooklyn Museum Collection; Gift of the Roebling Society.)

Studies of the skeleton in perspective. To gain a better understanding of the figure in space, the skeleton should be drawn in many foreshortened positions. This will also provide greater insight into the structure of the pelvis and rib cage.

CHAPTER 6
THE UPPER EXTREMITY: ARM,WRIST & HAND

The arm, with its remarkably accommodating range of articulation, presents a challenging exercise in understanding. A ball-and-socket joint at the shoulder and the arm's two-way articulation at the elbow (both hinge and rotary action), extending to the intricate action at the wrist, allow for involved and subtle changes of form [6-1]. Add to this the articulation of the fingers controlled by muscles in the forearm, plus the important muscles of the upper arm, and one can discover a multitude of possible relationships within this appendage. A selective examination of the influential anatomy may be a helpful guide to understanding this form and its variability of shape and movement.

THE UPPER ARM

The acromion process of the scapula (the flat outer extension of its spine) forms the limit that joins the top plane of the torso to the side plane of the shoulder mass. Below is the projecting fullness of the head of the humerus. The acromion process extends the plane and direction of the clavicle. This connection, usually marked on the skin surface, is not always easy to identify. (See the section on the shoulder girdle, Chapter 5, page 80.)

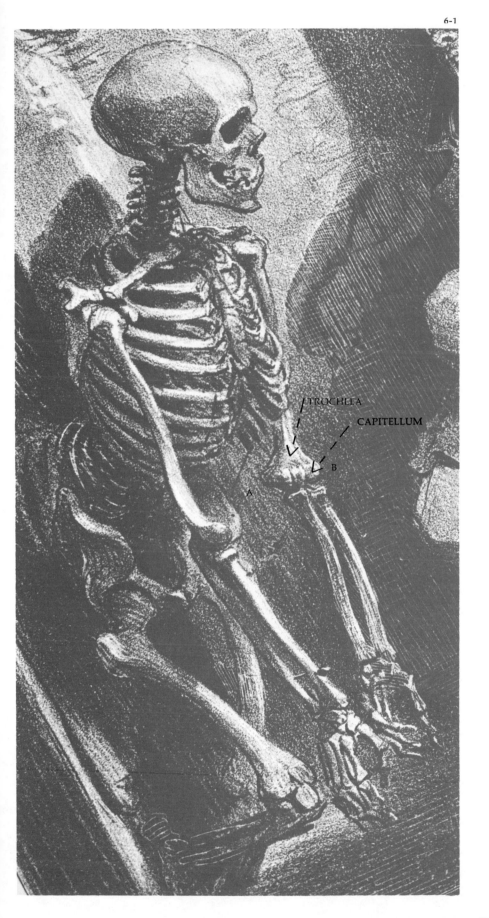

6-1 Detail from <u>Vous etes bien long, jeune homme</u> by Auguste Raffet. (Collection: the author. Photograph by Kalman Zabarsky.)

The two epicondyles of the humerus are the internal epicondyle (*A*) and the external epicondyle (*B*). The arrow indicates the trochlea, the spool-like articular surface of the humerus bone. (Refer also to illustration 1-14 .)

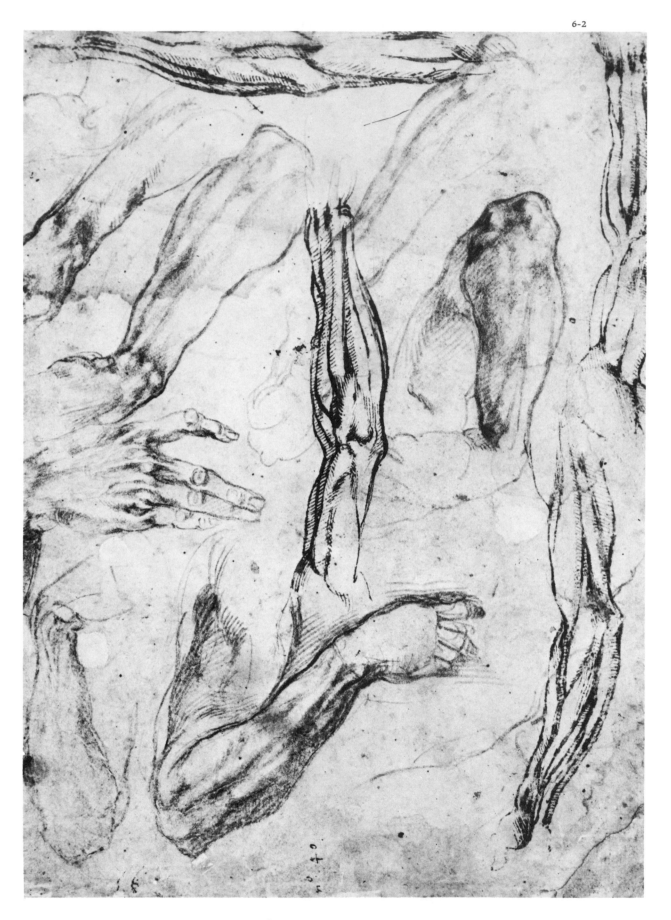

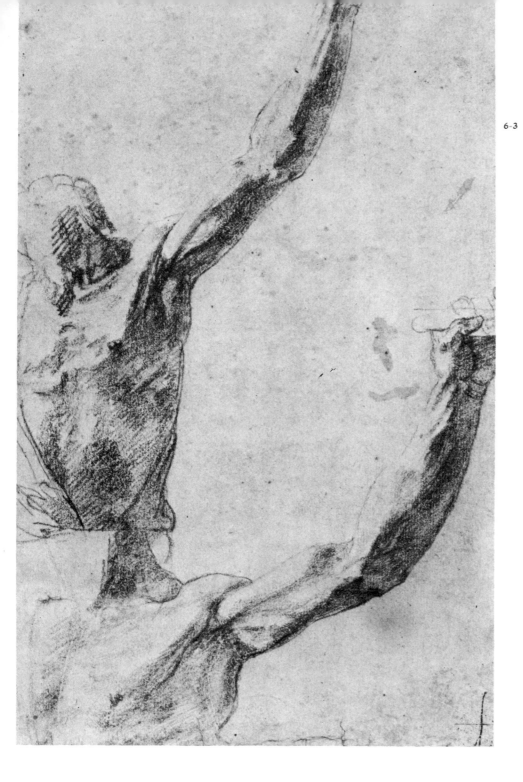

The upper arm, made up of one long bone (the humerus) and relatively few muscles, has large and apparent volumes. Surrounding the ball-and-socket joint of the shoulder is the strong, well-padded deltoid muscle attached in front to the outer third of the clavicle along the outer edge of the acromion process and in back, extending the full length of the spine of the scapula. The fibers converge to an insertion almost half the length of the cylindrical shaft of the humerus on the outer side of the arm.

The shaft of the humerus is thickly padded through its length. At the elbow, the two bony epicondyles of the humerus are clearly exposed at this hinge articulation [6-1, 6-2].

The biceps, the best known and most obvious muscle in the arm, by its prominence gives the arm a great deal of its character [6-3]. Beneath the biceps and largely hidden is the deep but influential brachialis anticus. This muscle causes much of the projecting volume of the biceps.

6-2 Studies of Arms and Hands by Michelangelo. (Teylers Stichting, Haarlem.)

This valuable page of studies reveals the artist's careful study of bone, muscle, and tendon. The raised forearm at the lower left shows the two epicondyles of the humerus on each side of the point of the elbow (the olecranon process of the ulna). The articulation of the wrist-space for its existence between hand and forearm is clear in other studies.

6-3 Two Studies of a Raised Arm by Polidoro da Caravaggio. (Courtesy: Trustees of the British Museum).

The lower study of the extended raised arm shows the spatial architecture of this form with a consistent perspective of related parallels running through the length of the forms, and across the form at right angles. Observe the parallel movements of tone across the biceps at either end of this muscle.

6-4 Study of an Arm (crayon) by the author. (Photograph by Kalman Zabarsky.)

In the raised arm, the biceps muscle departs from the overall axis from the shoulder to the elbow. A cross-tension from the tendon of the short head (A) at the coracoid process of the scapula to the radial insertion (B) bicipital tuberosity causes this movement. It should be carefully noted.

6-5 Studies of a Raised Arm by Michelangelo. (Musée Atger, Montpellier. Photograph by Charles O'Sughrue.)

In this informative drawing Michelangelo has carefully identified important surface anatomy. Beginning at his signature on the left and reading up are the following muscles: (A) latissimus dorsi; (B) teres major; (T) triceps (long head); (V) triceps (medial head); (Z) inner epicondyle of the humerus; (8) olecranon process of the ulna. Unidentified, but found between the deltoid and the teres major, is the coraco brachialis. In the upper left corner is another view showing the teres major (B).

6-6 Muscles in the Raised Arm, from **Anatomie of the External Forms of Man** by Julian Fau. (Courtesy: Boston Medical Library in the Francis A. Countway Library of Medicine. Photograph by Kalman Zabarsky.)

Compare this muscle drawing with the studies by Michelangelo [6-5].

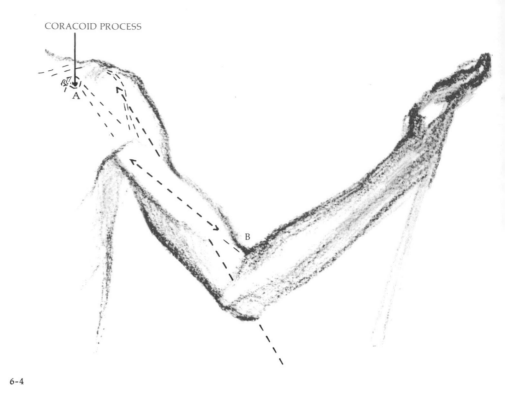

CORACOID PROCESS

6-4

6-6

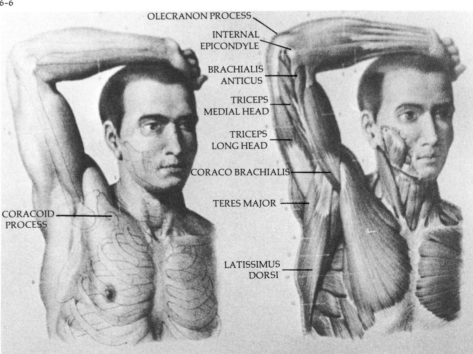

OLECRANON PROCESS
INTERNAL EPICONDYLE
BRACHIALIS ANTICUS
TRICEPS MEDIAL HEAD
TRICEPS LONG HEAD
CORACO BRACHIALIS
TERES MAJOR
LATISSIMUS DORSI
CORACOID PROCESS

In the partially extended arm (palm up), the biceps muscle does not follow the humeral axis precisely. The origin of the long head of the biceps above the glenoid cavity of the scapula passes over the head of the humerus. The origin of the short head at the coracoid process of the scapula and its insertion at the bicipital tuberosity of the radius induces a diagonal tension from the armpit to the outer side of the elbow and gives a distinctive thrust to the biceps [6-4, 6-5, 6-6].

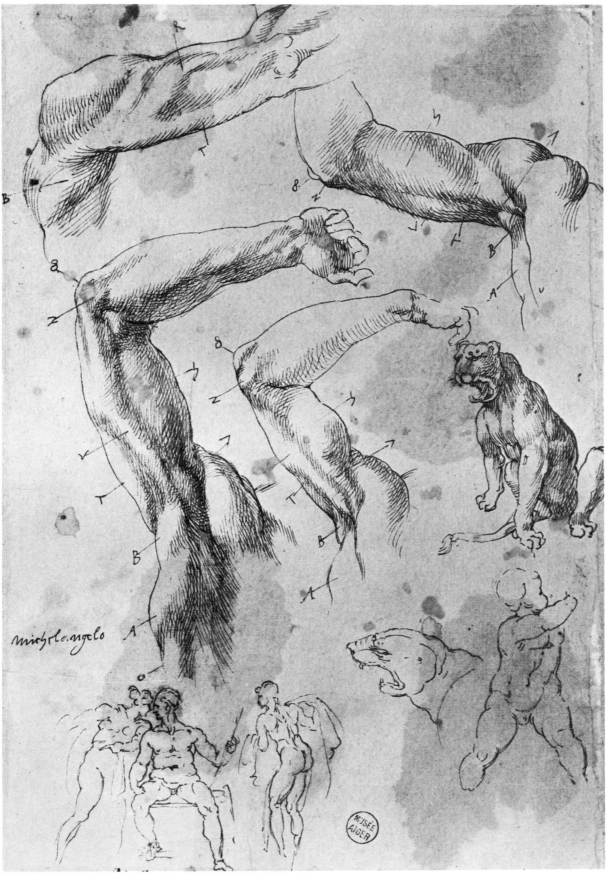

michelangelo

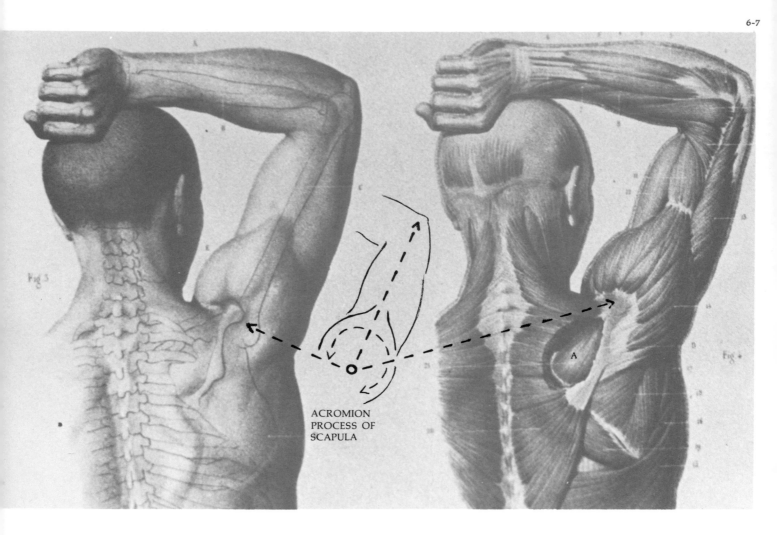

ACROMION
PROCESS OF
SCAPULA

6-8

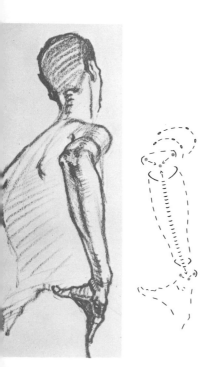

6-7 Muscles of the Raised Arm: Back View, from Anatomie of the External Forms of Man by Julian Fau. (Courtesy: Boston Medical Library in the Francis A. Countway Library of Medicine. Photograph by Kalman Zabarsky.)

A visible point for the axis of the volume in the raised upper arm is the acromion process of the spine of the scapula. The deltoid muscle encircles the shoulder articulation from front to back and forms a curved volume around this depressed pivotal attachment. A portion of the triceps has been removed to reveal the supraspinatus muscle (A) above the spine of the scapula.

6-8 Analysis of the Structure of the Forearm. (Photograph by Jonathan Goell).

The V-shaped alignment of bones at the elbow is repeated by muscle and bone at the wrist to provide the basis of form structure. (See illustration 6-9.)

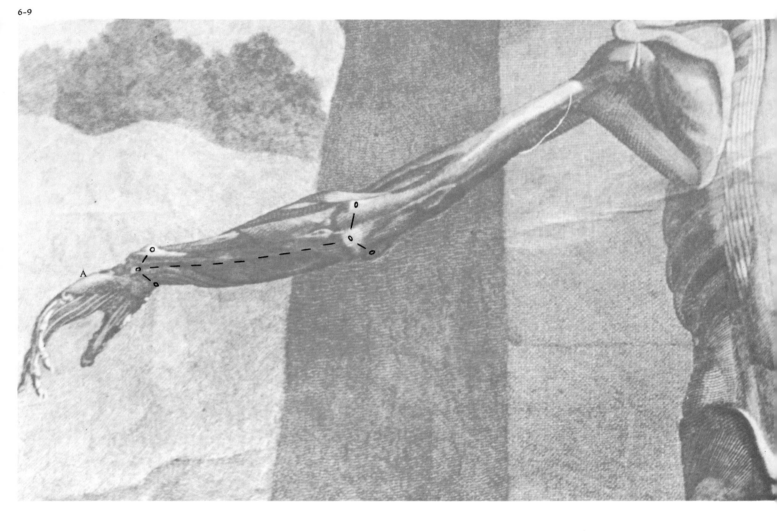

From the back [6-7], the tendon of the triceps presents an unbroken, rather flat plane that passes over the elbow joint and inserts into the olecranon process of the ulna. The three padded heads of the triceps have the following points of origin: (1) the scapular (middle) head below the glenoid cavity of the scapula; (2) the external head at the rear of the humerus above the deltoid eminence; (3) the internal head at the lower rear surface of the humerus beneath the tendon [6-6, 6-16].

The hanging, relaxed arm presents directions and contour relationships that should be carefully noted. The vertically suspended upper arm changes at the elbow [P.44] to an outward diagonal thrust of the forearm away from the torso, most apparent when the palm faces forward. The spool-like diagonal trochlea (at the lower end of the humerus) sets the diagonal angle of the ulna bone at this articulation [6-1].

At the elbow, when the arm is bent (i.e., when the hand rests on the hip), a triangular relationship of bony eminences occurs. This V-shaped alignment [6-8, 6-9] is formed by the two epicondyles of the humerus and the olecranon process of the ulna

6-9 Detail of the Arm, from <u>Tables of the Skeleton and Muscles of the Human Body</u> by Bernhard Albinus. (Courtesy: Boston Medical Library in the Francis A. Countway Library of Medicine. Photograph by Kalman Zabarsky.)

The structure of the forearm in pronation (palm down) is shown. The position of the epicondyles and olecranon process at the elbow provides the basis for a structure of surfaces ending in a related sequence at the wrist. The flexor brevis minimi digiti (A) of the hand is shown in relation to the wrist.

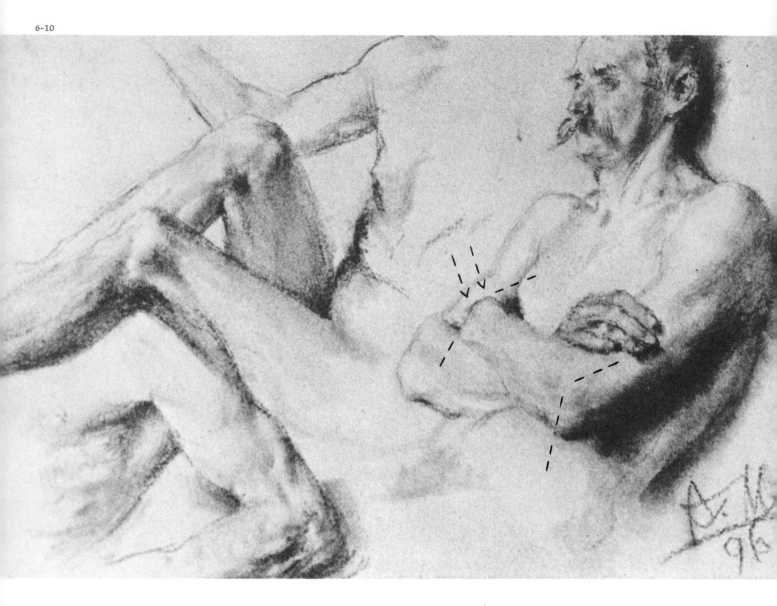

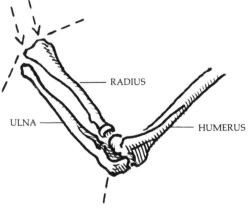

RADIUS

ULNA

HUMERUS

6-10 Anatomical Figure Studies by Adolph Menzel. (Collection: Mr. and Mrs. Irving M. Sobin, Boston. Photograph by Kalman Zabarsky.)

The change of planes just above the wrist in the forearm is set by the dimension of the radius (arrows) opposed to the lower position of the head of the ulna bone. This surface relationship is echoed at the elbow.

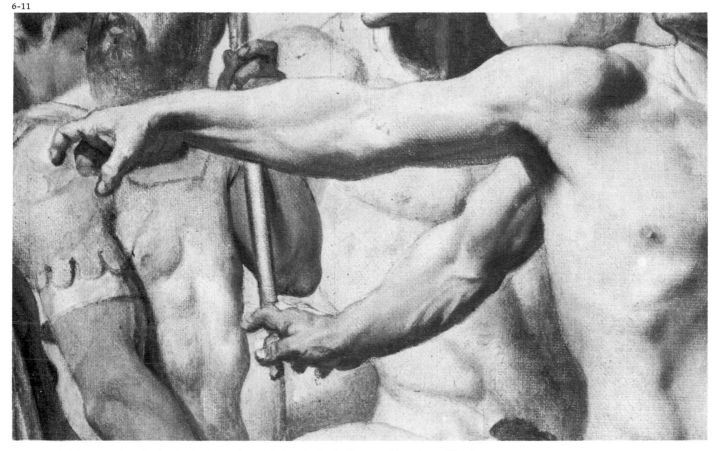

6-11 Detail of Two Arms from <u>Studies for the Martyrdom of St. Symphorien</u> by Jean Dominique Ingres. (Courtesy: Fogg Art Museum, Harvard University; Grenville L. Winthrop Bequest.)

The continuity of interconnected forms is well understood by Ingres.

bone. The arrangement is the origin of opposing planes that undergo considerable modification as they extend toward the wrist [6-10]. The muscular, rounded, upper forearm gives way to a bony and tendinous length, more blocklike in structure as it approaches the wrist and hand [6-21].

In drawing, the interconnectedness of muscles between the upper arm and the forearm is often compromised by overemphasizing linear creases at the inner side of the arm at the elbow. These creases can mistakenly be accepted as the end of a muscle, and may interrupt the continuity of the fleshy extensor muscles (dominated by the supinator longus) as they insert between the brachialis anticus and triceps above the elbow. Linear creases and folds of flesh in many parts of the figure distort the organic continuity of muscle structure and demand careful scrutiny. In general, it is advisable not to stress these folds and creases of flesh [6-11].

The tension and interconnectedness of muscles in action is difficult to combine with the spatial existence of forms. No artist resolved this complex interdependence more successfully than Michelangelo. His mastery of straining muscle movement, synthesized into foreshortened spatial figure structures in every conceivable attitude, is unique in its understanding, authority, and expressive power [6-2, 6-5, 6-13, 6-18, 6-19, 6-21].

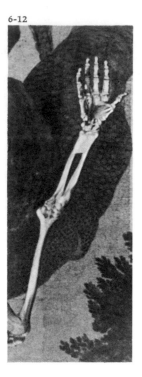

6-12 Detail of Bones of the Arm, from <u>Tables of the Skeleton and Muscles of the Human Body</u> by Bernhard Albinus. (Courtesy: Boston Medical Library in the Francis A. Countway Library of Medicine. Photograph by Kalman Zabarsky.)

6-13 Forearm Detail from <u>Studies of Arms and Hands</u> by Michelangelo. (Teylers Stichting, Haarlem.)

Running vertically through the center of the arm is the shaft of the ulna bone. It is clearly visible from the prominent elbow (olecranon process) to the rounded head of the ulna at the wrist. To the left of this bone is the long extensor carpi ulnaris (and related extensors). To the right of this shaft is the flexor carpi ulnaris (and related flexors). These two groups of muscles (flexors and extensors) are separated by the ulna.

6-13

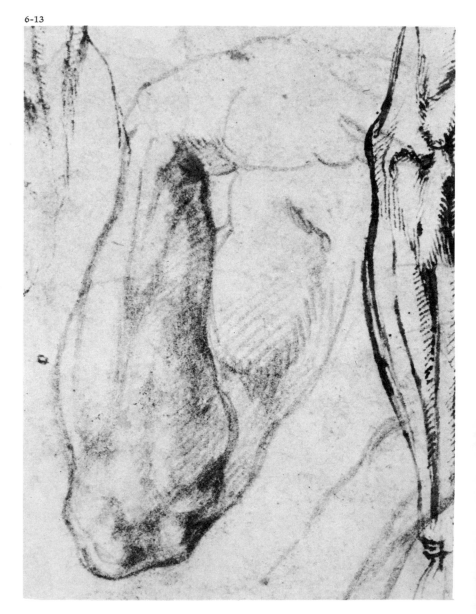

THE FOREARM

The muscles of the forearm are numerous and difficult to visualize. They have a variety of functions—extending and flexing the arm, turning the radius bone on its ulna axis, bending the hand at the wrist, and controlling the movement of the fingers and their individual digits. These are frequently combined actions and employ many muscles, continually transforming the shape of this extremity. The forearm presents itself conveniently for direct examination. The reader may wish to make immediate reference to his own arm as he studies this section of the text. It has been developed with this intention, using the right forearm (to be compared with illustrations 6-12, 6-13, and 6-14).

The muscles will be considered in three major groups as form, but they are functionally either flexors or extensors. (The flexors of the forearm bend the fingers into the palm in a gripping action; the extensors straighten the fingers. Related flexors bend the arm at the elbow and wrist.)

First, note the location of the two bones of the forearm. (Observe your own right arm as you read. Compare it with illustration 6-12, and then touch each point referred to—tactually and visually "X-ray" the form.) Viewing the forearm, palm up, the radius and ulna bones lie parallel from elbow to wrist. (The turning action of the radius and the movement of related muscles will be discussed later in this chapter in the section, "The Rotation of the Radius.") The radius is on the thumb side; the ulna aligns with the little finger. The ulna bone can be felt along its entire length by running the fingers of the left hand from the point of the elbow (the olecranon process of the ulna) along the exposed shaft to the knob of bone just above the wrist (above the styloid process of the ulna). This clearly identifiable shaft of bone divides two important groups of muscles [6-13]. Above the ulna, on the palmar side of the forearm, are the flexor muscles fanning out across the inner arm from a common origin at the internal epicondyle of the humerus. The condylar prominence can be felt on the inner side just above the point of the elbow.

The flexor muscles [6-14]—all with a common origin at the internal epicondyle of the humerus—are: (1) the flexor carpi ulnaris (lies directly along the shaft of the ulna bone and inserts by tendon into the pisiform bone of the wrist or carpus); (2) the palmaris longus (fans out from its tendon into the surface of the palm of the hand); (3) the flexor carpi radialis (inserts into the base of the metacarpal bone of the index finger); (4) the pronator radii teres (a short muscle that inserts into the outer margin at mid-shaft of the radius). The deeper muscles of this group are the flexor digitorum sublimus and the flexor pollicis longus.

Continuing the direct examination of the right forearm, palm up, with the forearm slightly bent and tensed, place the left index finger in the slight depression at the inner side of the arm at the elbow articulation. Firm pressure at this point, while tensing the arm, will identify the biceps tendon (inserting at the bicipital tuberosity of radius).

6-14 Detail of Muscles of the Inner Arm, from <u>Tables of the Skeleton and Muscles of the Human Body</u> by Bernhard Albinus. (Courtesy: Boston Medical Library in the Francis A. Countway Library of Medicine. Photograph by Jonathan Goell.)

The flexor muscles of the forearm in supination are shown.

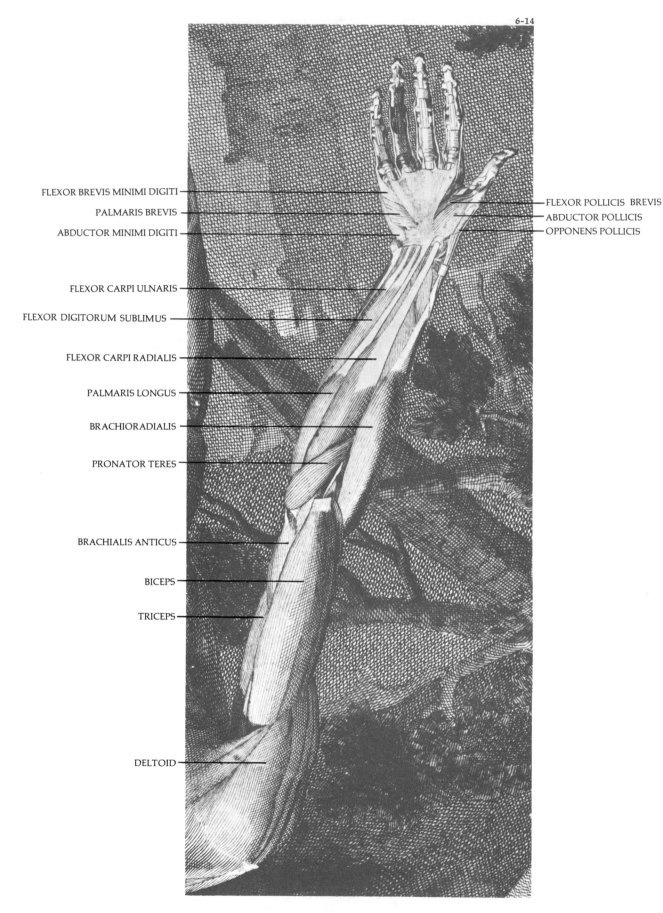

FLEXOR BREVIS MINIMI DIGITI

PALMARIS BREVIS

ABDUCTOR MINIMI DIGITI

FLEXOR POLLICIS BREVIS

ABDUCTOR POLLICIS

OPPONENS POLLICIS

FLEXOR CARPI ULNARIS

FLEXOR DIGITORUM SUBLIMUS

FLEXOR CARPI RADIALIS

PALMARIS LONGUS

BRACHIORADIALIS

PRONATOR TERES

BRACHIALIS ANTICUS

BICEPS

TRICEPS

DELTOID

6-15 Bones and Muscles of the Arm.

The diagram on the left shows the position of the radius in pronation and supination. On the right, the muscles of the forearm are shown in pronation.

6-15

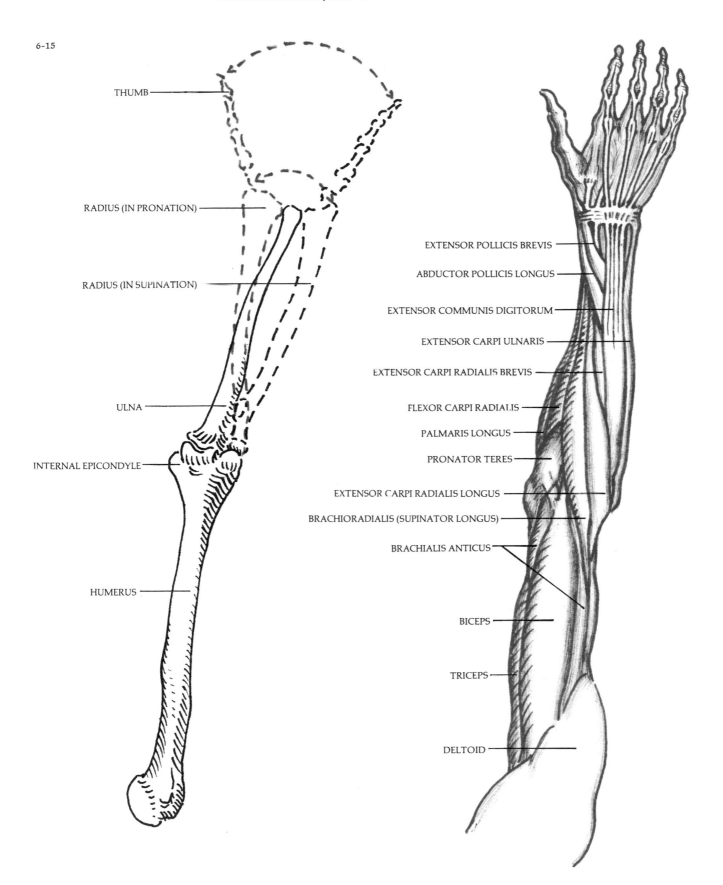

THUMB

RADIUS (IN PRONATION)

RADIUS (IN SUPINATION)

ULNA

INTERNAL EPICONDYLE

HUMERUS

EXTENSOR POLLICIS BREVIS

ABDUCTOR POLLICIS LONGUS

EXTENSOR COMMUNIS DIGITORUM

EXTENSOR CARPI ULNARIS

EXTENSOR CARPI RADIALIS BREVIS

FLEXOR CARPI RADIALIS

PALMARIS LONGUS

PRONATOR TERES

EXTENSOR CARPI RADIALIS LONGUS

BRACHIORADIALIS (SUPINATOR LONGUS)

BRACHIALIS ANTICUS

BICEPS

TRICEPS

DELTOID

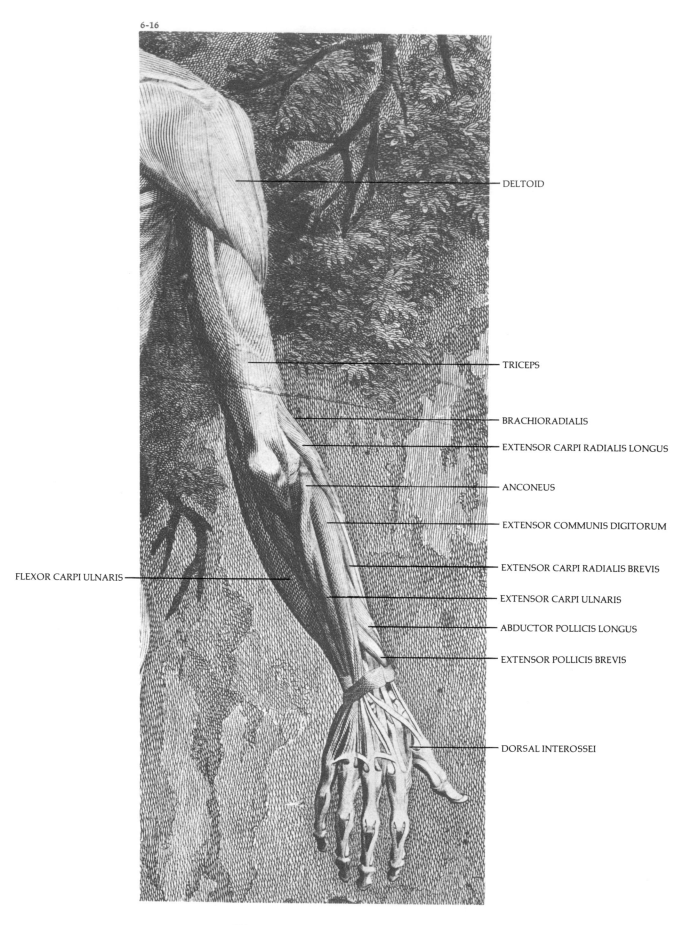

DELTOID

TRICEPS

BRACHIORADIALIS

EXTENSOR CARPI RADIALIS LONGUS

ANCONEUS

EXTENSOR COMMUNIS DIGITORUM

EXTENSOR CARPI RADIALIS BREVIS

FLEXOR CARPI ULNARIS

EXTENSOR CARPI ULNARIS

ABDUCTOR POLLICIS LONGUS

EXTENSOR POLLICIS BREVIS

DORSAL INTEROSSEI

The extensor muscles of the forearm are shown in this illustration.

To the right of the biceps tendon (the radial region), two strong and visually significant extensor muscles are located [6-15, 6-16]. Both originate from the outer ridge of the humerus bone, one above the other (at the lower third of the humerus, just above the external condyle). Above is the supinator longus (brachioradialis), inserting at the wrist into the styloid process of radius. Below is the extensor carpi radialis longus, inserting into the base of the metacarpal bone of the index finger. These two prominent muscles round out the upper forearm as they pass over the elbow articulation, and they extend the wrist and supinate the forearm, turning the palm of the hand forward.

The remaining group of five extensor muscles lie on the back side of the forearm and have a common origin at the external condyle of the humerus bone. (Two additional extensors will be covered separately.) Again with the palm up and returning to the shaft of the ulna, the first muscle encountered on its underside is the anconeus, a short superficial muscle inserting at the olecranon process (elbow) of the ulna [6-16]. (The anconeus should be mentioned but may be difficult to locate.) Emerging beneath this muscle and extending the length of the shaft of the ulna (from a common origin at the external epicondyle) is the extensor carpi ulnaris (which inserts at the outer side of the metacarpal of the little finger).

The following muscles proceed in sequence to the radial (thumb) side of the arm: the extensor minimi digiti (inserts into the last two digits of little finger); the extensor communis digitorum (each of its four separate tendons inserts into the last two digits of the four fingers); the extensor carpi radialis brevis (inserts at the base of the third metacarpal of the middle finger). This last muscle lies under the previously mentioned extensor carpi radialis longus [6-16].

The pollicis (thumb) muscles are exposed as a group above the wrist on the radial (thumb) side of the lower forearm and activate the bones of the thumb [6-17]. The abductor pollicis longus has its origin at the mid-rear surface of the shaft of the ulna and diagonally across the lower third of the radius. It inserts at the base of the metacarpal of the thumb. The extensor pollicis brevis (which lies under the abductor pollicis longus) has its origin at the rear lower third of the radius, and its insertion is at the base of first digit of the thumb. (An additional muscle articulates the last digit of the thumb and is visible only as a tendon—the fibers of this muscle, the extensor pollicis longus, lie deep against the ulna).

SUPINATOR LONGUS

ABDUCTOR POLLICIS LONGUS

EXTENSOR POLLICIS BREVIS

ABDUCTOR INDICIS

ABDUCTOR POLLICIS

PRONATOR TERES

FLEXOR CARPI RADIALIS

DORSAL INTEROSSEI

ABDUCTOR MINIMI DIGITI

6-17 Muscles of the Inner Forearm and Hand, from <u>Anatomy of Bones and Muscles Applicable to the Fine Arts</u> by Jean Galbert Salvage. (Courtesy: Boston Medical Library in the Francis A. Countway Library of Medicine. Photograph by Kalman Zabarsky.)

Seen in the illustration, the muscles of the hand are: abductor indicis (first dorsal interossei) (*A*); abductor minimi digiti (*B*); dorsal interossei (*C*); abductor pollicis (*D*). The muscles of the forearm in pronation (palm down) are: supinator longus, (brachioradialis) (*E*); pronator teres (*F*); flexor carpi radialis (*G*); abductor pollicis longus (*H*); extensor pollicis brevis (*I*).

THE ROTATION OF THE RADIUS

The radius bone, pivoting against the lower end of the humerus at the round radial head (capitellum), turns over the unmoving shaft of the ulna [6-15]. This is a combined action of a number of flexor and extensor muscles. With the elbow stationary, the hand may be turned palm down. The radius is the active bone. In this act of rotation, the forearm muscles make an elongated spiral twist diagonally around the ulna bone [6-17, 6-18]. It is this action that can cause great confusion, and the forearm should be carefully studied and drawn in the supine position (palm up) and the prone position (palm down) [6-18].

6-18 <u>Studies of the Arm</u> by Michelangelo. (Teylers Stichting, Haarlem.)

The muscles as drawn by Michelangelo in these studies may be compared with those in the anatomical illustration by Salvage [6-17].

6-19 Detail from <u>Studies of the Arm</u> by Michelangelo. (Teylers Stichting, Haarlem.)

6-20 <u>Study for the Martyrdom of St. Symphorien</u> by Jean Dominique Ingres. (Fogg Art Museum, Harvard University; Grenville L. Winthrop Bequest.)

The arms and hands have been carefully observed in a number of views.

THE WRIST

The wrist, the link between the forearm and the hand, is frequently bypassed as a distinct unit of form. If it is not carefully taken into account in drawing, the result is a stiff or broken appearance between the hand and the forearm. When the carpal structure (the eight bones of the wrist) is recognized as an entity and an important transitional connection, this articulation will contribute to a fluid and organically convincing sequence of forms [6-20, 6-21].

The carpal (wrist) ends of the ulna and radius are prominent and offer identifiable clues to the movement into the wrist articulation. Ample length should be given the wrist area to fully account for the wrist, plus the hand. Careful study of illustrations 6-21, 6-22, and 6-25 is recommended, as they present this articulation clearly.

6-21 Forearm detail from <u>Studies of the Arm</u> by Michelangelo. (Teylers Stichting, Haarlem.)

A superbly articulated, fluent drawing of the joined units of the hand, wrist, and forearm. Note especially the length and blocklike form of the wrist.

6-21

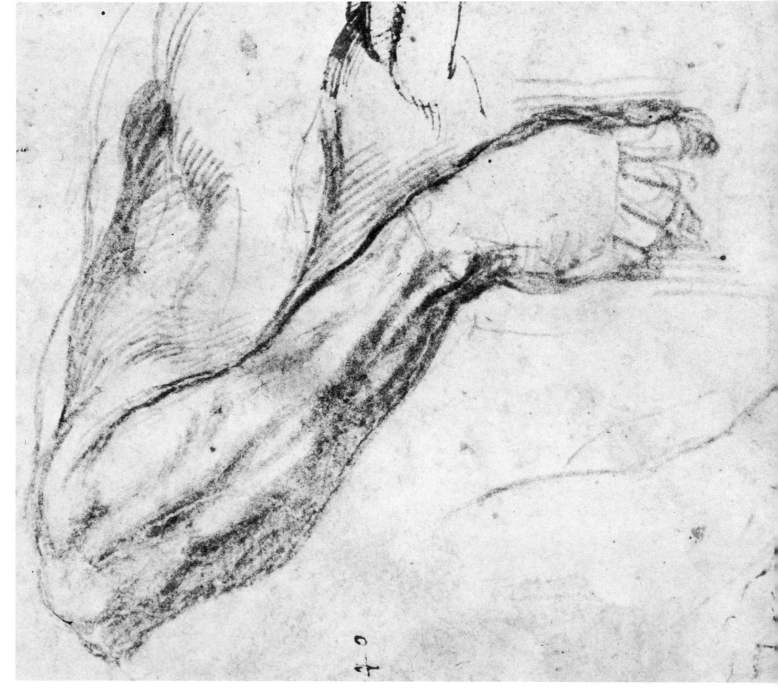

THE HAND

One obvious structural difference between the palm and the back of the hand should be immediately apparent. The palm is fleshy and muscular; the back of the hand is bony and tendinous. The five metacarpal bones make up the body of this form from the wrist to the knuckle. On the back of the hand, each metacarpal can be felt, and when the fingers are tightened into a fist, the phalangeal ends (knuckles) are thrust into prominence. The unique articulation of the metacarpal of the thumb permits it to bend in opposition to the fingers (as in grasping). The plane formed by the metacarpals of the thumb and index finger (roughly triangular) rests at right angles to the back of the hand but may be flattened to align with it [6-22, 6-26, 6-27].

6-22

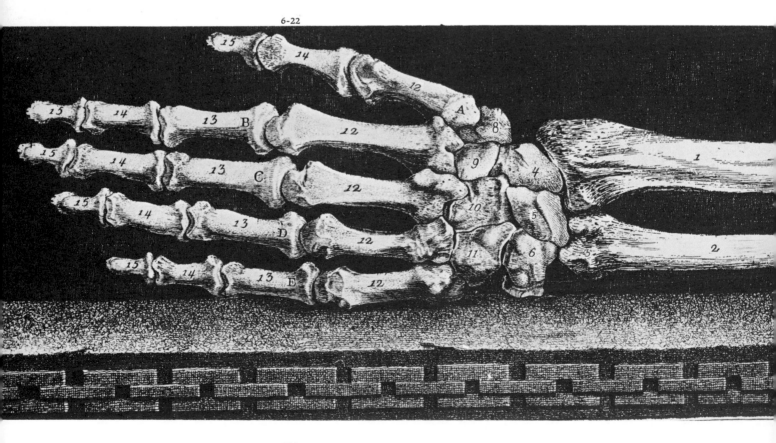

6-23

6-22 Bones of the Hand, Dorsal View, from <u>Twenty Plates of the Osteology and Myology of the Hand, Foot, and Head</u> by Antonio Cattani. (Courtesy: Boston Medical Library in the Francis A. Countway Library of Medicine. Photograph by Jonathan Goell.)

In the view of the back of the hand, the forearm bones, the radius (*1*) and the ulna (*2*), join with the eight carpal bones of the wrist. The bones of the carpus are as follows: scaphoid (*4*); lunate (*5*); cuneiform (*6*); pisiform (*7*); trapezium (*8*); trapezoid (*9*); os magnum (*10*); unciform (*11*). The body of the hand, from the wrist to the knuckles, is made up of the metacarpals (*12*). The phalanges (*13, 14,* and *15*) are the bones of the thumb and fingers. In drawing the hand, sufficient space between the forearm (radius and ulna) and the back of the hand (metacarpals) should be allowed for the eight bones of the wrist (carpus).

6-23 Detail from <u>Allegory of Fidelity</u> by Tintoretto. (Fogg Art Museum, Harvard University; Gift of Mrs. Samuel Sachs in memory of Mr. Samuel Sachs.)

The broad impasto brushwork (apparently easy and spontaneous) is precise in length and dimension to accommodate the wrist and the back of the hand. The curvature through the knuckles and the thinning of the brushstroke above the index finger turn the form. (The painting is reproduced in full in illustration 1-8.)

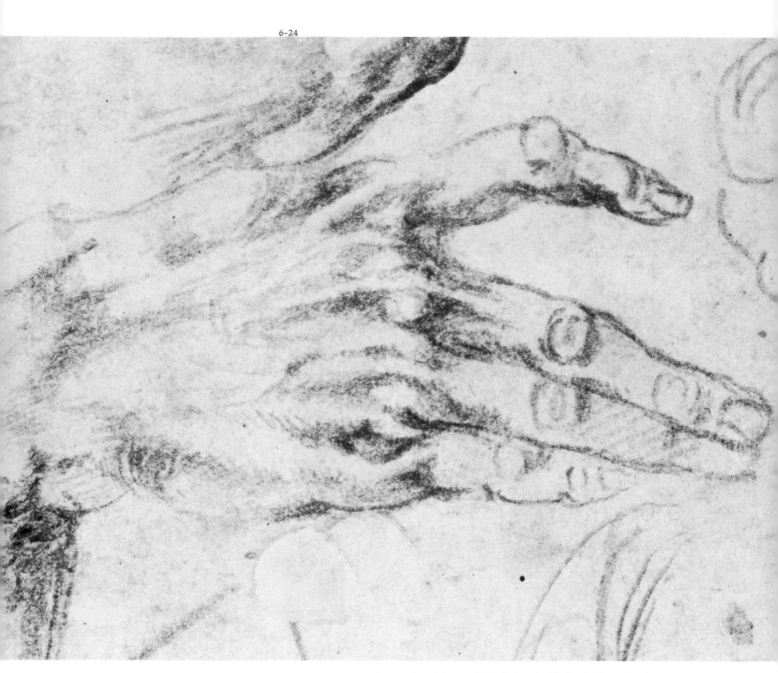

6-24 Detail of a Hand from <u>Studies of the Arm</u> by Michelangelo. (Teylers Stichting, Haarlem.)

Muscle tendons are visible extending over the knuckles into the fingers. The blocklike structure of the fingers (in this illustration, the index finger) should not be confused by wrinkles at the articulation of the digits.

Contributing to the prominence of the knuckles are the tendons of the extensor communis digitorum muscle stretched over the end of the form [6-24, 6-25]. The deeper muscles between the metacarpal bones fill out the body of the hand and act on the fingers, drawing them together when extended or separating them in fan-shape. These are the interossei dorsales and the interossei palmares. When the fingers are extended, they may appear shorter on the palmar side. This is caused by the fleshy "webbing" between the fingers which extends forward between the knuckles.

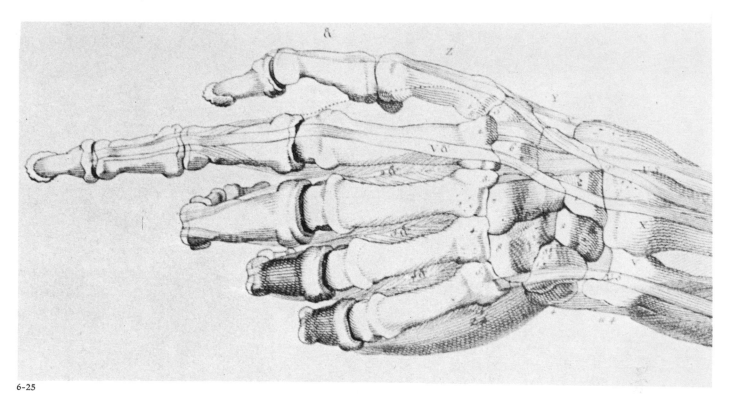

6-25

6-26

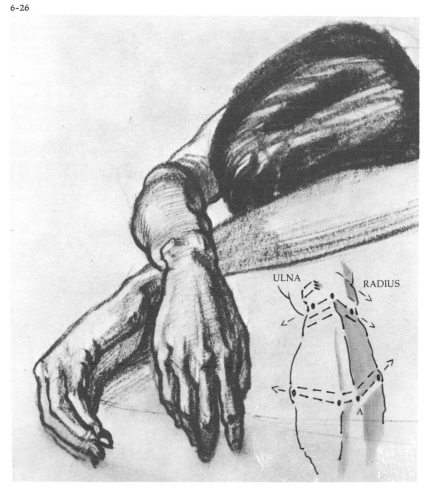

6-25 The Hand, from <u>Anatomy of Bones and Muscles Applicable to the Fine Arts</u> by Jean Galbert Salvage. (Courtesy: Boston Medical Library in the Francis A. Countway Library of Medicine. Photograph by Kalman Zabarsky.)

The tendons extending from the muscles in the forearm articulate the fingers and are visible as ridge-like strands in the tensed hand. The obvious complication of the hand by tendons and veins requires care and selectivity on the part of the artist to retain the unity of underlying broad surfaces. (Compare this with the drawing by Michelangelo [6-24].)

6-26 Detail from Study and Analysis of Planes of the Hand by the author. (Photograph by Kalman Zabarsky.)

In the relaxed, unsupported hand, the metacarpal bone of the thumb rests almost at right angles to the four metacarpals of the fingers. This division of planes occurs along the axis of the index finger (A). As a plane it can continue into the wrist and forearm.

117

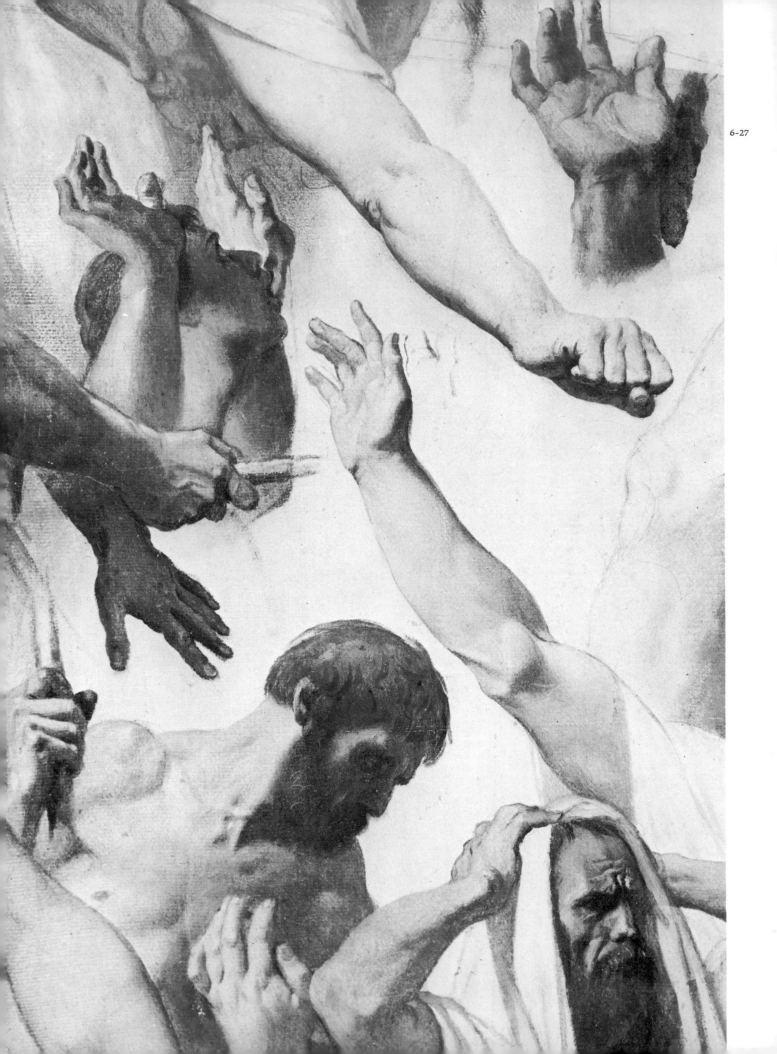

The palm of the hand is thickly padded with short muscles. This is in sharp contrast to the back of the hand which is bony and tendinous.

The palm of the hand is padded by an arrangement of muscles that frame a basin-like depression at its center. Short, thick muscles filling out the heel of the hand from the wrist to thumb create an egglike fullness. Unified in appearance, the muscles that build up this form are the opponens pollicis, the flexor pollicis brevis, and the abductor pollicis brevis [6-14, 6-27].

The muscles framing the side of the palm over the metacarpal of the little finger are thinner and about the length of this bone. They are the opponens digiti quinti, the flexor digiti quinti brevis, and the abductor digiti quinti (and the palmaris brevis) [6-14, 6-27].

The digits (phalanges), though small, have a thin shaft and enlarged extremities. The expanded forms of the articular heads create the structure for the four long planes enclosing the fingers [6-24]. When the fingers are extended, wrinkles gather at the articulation of each digit. This is a distraction that should not obscure the longer top and side planes which run the full length from knuckle to fingertip.

CHAPTER 7
THE LOWER EXTREMITY: THIGH, LEG & FOOT

The leg is composed of a strong and obvious interrelationship of muscles. The bones of the leg are long, with enlarged articulations (hip and knee) developed for the major functions of support, balance, and movement [7-1, 7-2].

The longest bone, the femur, articulates with the outer framework of the pelvis known as the os innominatum by a ball-and-socket joint. The round head of the femur is joined to its lengthy shaft by a short diagonal neck of bone [7-2]. At this juncture, a blocklike tuberosity—the great trochanter—is influential on the form of the figure. When the weight of a figure is on one leg, this prominence on the supporting limb provides a clear angle of opposing directions between the thigh and the torso and is the peak for the regional planes of hip and upper thigh [7-1, 7-2].

The blocklike volume at the lower end of the femur (thigh bone) is set on the equally wide head of the tibia below to form the knee, and demonstrates the weight-bearing function of the leg [7-2]. It is a frequent occurrence that the only representation in drawing given to this large knee articulation is the patella (kneecap). Small, but

7-1 Detail of <u>Skeleton with Deep Muscles: Front View,</u> from <u>Tables of the Skeleton and Muscles of the Human Body</u> by Bernhard Albinus. (Courtesy: Boston Medical Library in the Francis A. Countway Library of Medicine. Photograph by Kalman Zabarsky.)

The influence of the great trochanter (arrow) of the femur bone, prominent at the hip in the weight-bearing leg, may be seen. Two enlarged extremities of bone, the tuberosities of the femur and tibia, join to form a long, blocklike unit at the knee. This is often ignored, minimized, or eliminated in drawing the leg, causing a stiff, incomplete, and unarticulated limb. Its dimension is enclosed between arrows at the knee. The relationship of deep muscles to bones is worth noting.

7-2 <u>Bones of the Leg</u> by Raphael da Montelupo. (Courtesy: Ashmolean Museum.)

This drawing indicates the influence of the bones of the leg on surface form at the hip (great trochanter), at the knee (encompassing the tuberosities of femur and tibia), and at the ankle. A comparison with the drawing by Tintoretto [7-9] reveals a close parallel of bone and muscle projection in this form.

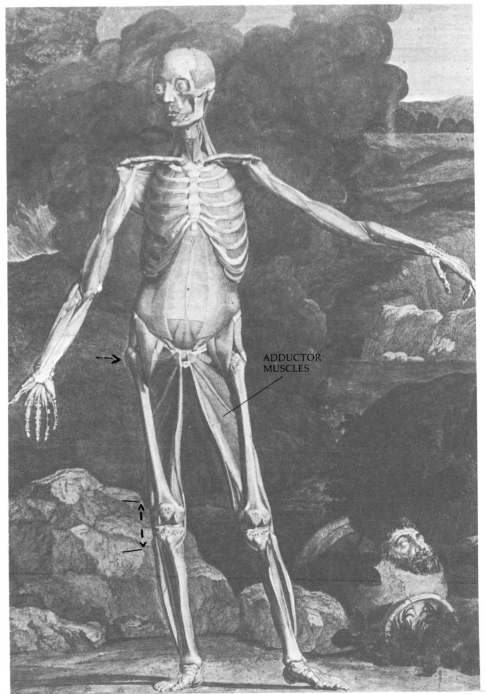

ADDUCTOR MUSCLES

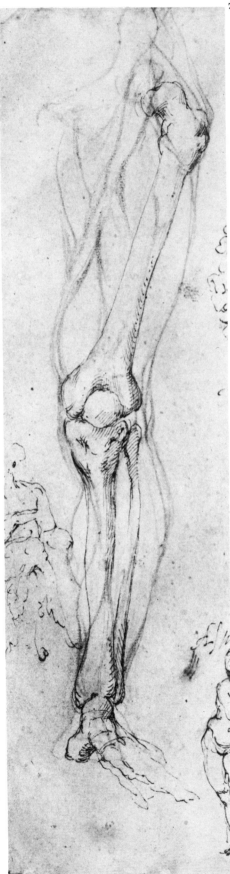

7-1

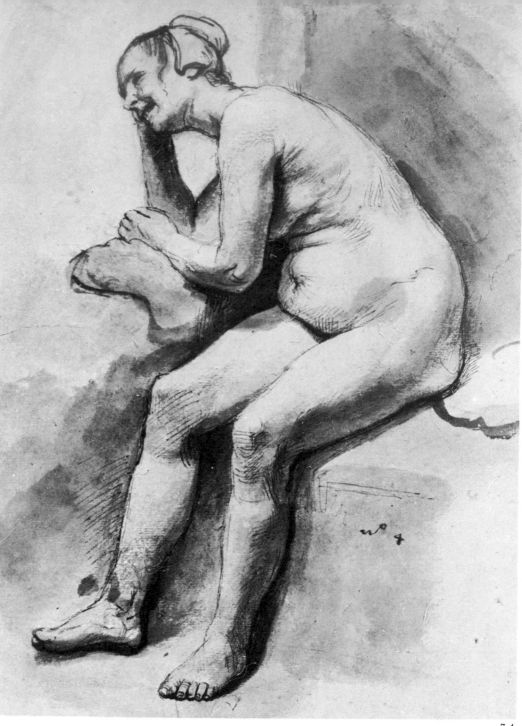

7-3 <u>Studies of the Knee</u> by Michelangelo. (Teylers Stichting, Haarlem.)

The blocklike volume of the femur and the tibia as well as the patella and its ligament have been carefully studied by the artist.

7-4 <u>Seated Nude</u> by Rembrandt van Rijn. (Cabinet des Dessins, Musée du Louvre.)

In the leg, when bent, the large bone relationships at the knee set the frame of space for the full volume of the thigh and lower leg. Locations at the top of the kneecap and just behind it establish the origin of the top horizontal light plane moving to its insertion at the hip.

obvious as a unit, the function of the patella is not support, but protection. Behind it is the substantial formation of two joined units—a structure that is repeatedly minimized or ignored as a lengthy extension of volume, clearly identified between the calf and the thigh. This large-scale bony framework is visible whether the leg is extended or bent [7-3, 7-4]. The reader may refer again to Chapter 1, page 18, for an analysis of this relationship. Also in Chapter 1, observe in the works by Michelangelo [1-26] or Tintoretto [1-8, 1-25] the position of the kneecap to the underside of the leg. A sense of the full third dimension is projected by location alone (reinforced by modeling).

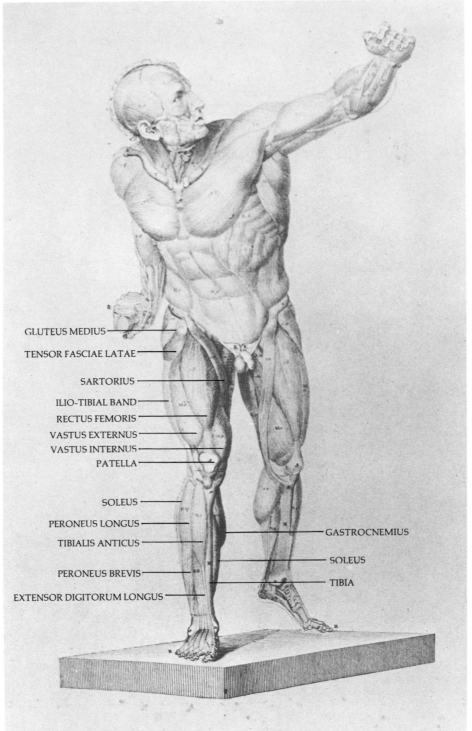

GLUTEUS MEDIUS

TENSOR FASCIAE LATAE

SARTORIUS

ILIO-TIBIAL BAND

RECTUS FEMORIS

VASTUS EXTERNUS

VASTUS INTERNUS

PATELLA

SOLEUS

PERONEUS LONGUS

TIBIALIS ANTICUS

PERONEUS BREVIS

EXTENSOR DIGITORUM LONGUS

GASTROCNEMIUS

SOLEUS

TIBIA

7-5 <u>Front View of the Borghese Fighter</u>, from <u>Anatomy of Bones and Muscles Applicable to the Fine Arts</u> by Jean Galbert Salvage. (Courtesy: Boston Medical Library in the Francis A. Countway Library of Medicine. Photograph by Kalman Zabarsky.)

In this illustration the muscles of the leg are labeled for study.

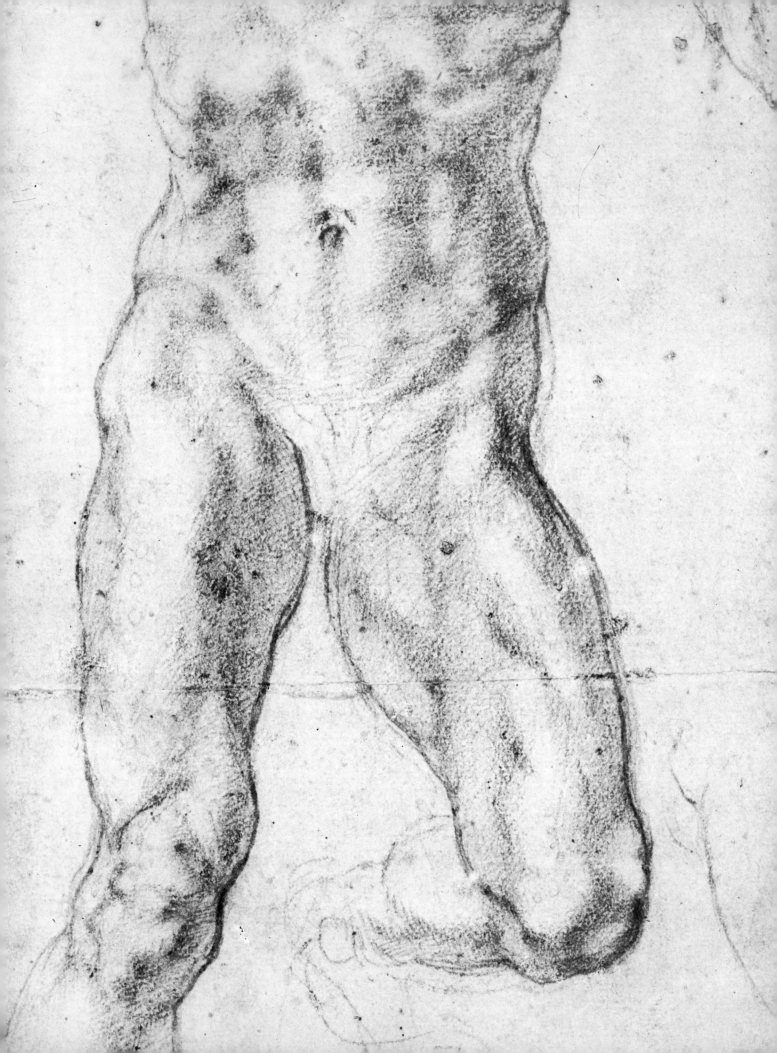

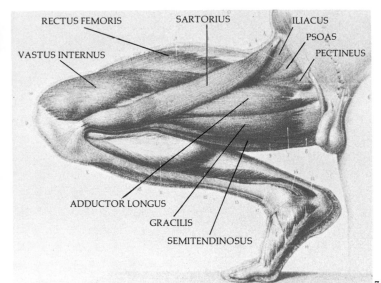

RECTUS FEMORIS SARTORIUS ILIACUS
PSOAS
VASTUS INTERNUS PECTINEUS

ADDUCTOR LONGUS
GRACILIS
SEMITENDINOSUS

7-6 Detail of the Thigh and Hip from <u>The Figure of Haman</u> by Michelangelo. (Courtesy: Trustees of the British Museum.)

Observe the diagonal attachment of the thigh into the hip from the pubic symphesis to the crest of the ilium. The long, tense sartorius muscle is clearly visible in the right leg, running from the hip to the inner knee and separating two groups of muscle: the adductors of the inner thigh from the quadriceps femoris. (See 5-16 for a reproduction of the entire drawing.)

7-7 <u>Muscles of the Inner Thigh</u>, from <u>Anatomie of the External Forms of Man</u> by Julian Fau. (Courtesy: Boston Medical Library in the Francis A. Countway Library of Medicine. Photograph by Kalman Zabarsky.)

In this admirably clear lithograph, the influence of the sartorius muscle may be seen as the diagonal division between the quadriceps femoris and the adductors of the inner thigh. Compare this anatomical study with the drawing by Michelangelo [7-8].

7-8 <u>Study of the Inner Side of the Thigh and Leg</u> by Michelangelo. (Teylers Stichting, Haarlem.)

Compare this study with the preceding illustration to note the parts of the quadriceps femoris, the sartorius, and the adductors, as well as the clear forms of the calf.

7-7

7-8

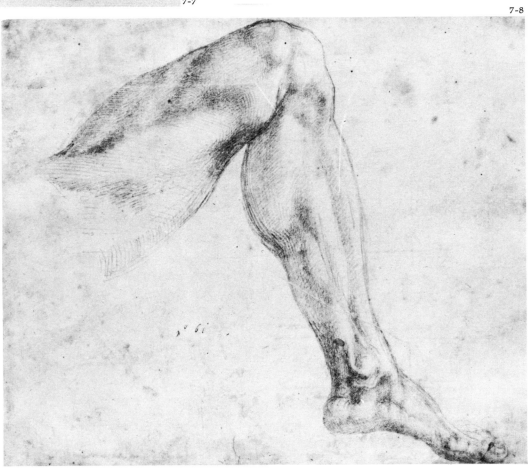

THE THIGH

The muscles of the thigh fill out its volume in a dimensionally significant manner above the knee and into the hip. On all sides, the shaft of the femur is enclosed. This bone is only visible and directly influential on the surface form at the hip (great trochanter) and knee. (The shaft of the femur has, of course, an important influence as a hidden inner axis on the overall length of this form.)

7-9 Figure Bending Forward by Domenico Tintoretto (National Gallery of Scotland.)

Compare this study with the drawing by Raphael da Montelupo [7-2].

7-10 Study of Two Youths by Jacopo da Pontormo. (Fogg Art Museum, Harvard University; Bequest of Charles Alexander Loeser.)

See the analysis of the planes of the thigh in illustration 7-11.

7-11 Detail of Study of Two Youths by Jacopo da Pontormo.

In this study, essentially a line drawing, a few pertinent indications of tone and line within the form identify key structural relationships. The dotted line running the length of the thigh identifies the height of the mid-form joining the two broad surfaces of the front and inner volume.

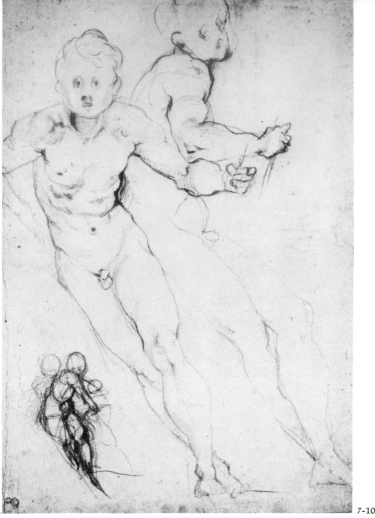

7-10

7-9

The thigh has a diagonal attachment into the pelvic structure of the torso, low at its inner pubic connection and rising to the iliac crest at the outer side of the figure. This may be traced from the obvious marking of the inguinal ligament (Poupart's ligament [5-12]) below the abdomen from the crest of the ilium to the pubic symphesis [7-5, 7-6]. This ligament overlaps the adductor muscles and sets an oblique direction of importance in describing the wedgelike surface below. The adductors form a somewhat conical unit interrupted by the sartorius [7-6, 7-7]. From a common origin in the pubic region of the pelvis, the adductors fan out along the shaft of the femur and, with the gracilis, shape the inner form and contour of the thigh.

The ribbon-like sartorius, the longest muscle, effects a sharp division through the length of the thigh [7-7, 7-8]. Running diagonally from the front crest of the ilium to the internal tuberosity of the tibia, it clearly separates two important groups of muscles: the adductor group (filling out the inner and upper thigh) and the powerful extensors (quadriceps femoris) of the front plane [7-6].

The front plane of the thigh is dominated by a four-part muscle, the quadriceps femoris. Three parts are clearly marked in a well-developed limb [7-8]. The fourth (crureus) is a deep, indirect influence on the front surface of the thigh. The quadriceps femoris is visible the full length of the form, and its influence is paramount in giving character to the thigh [7-6]. The rectus femoris portion [7-5] from its origin above at the front of the pelvis emerges between two muscles, the tensor fasciae latae and the sartorius, and follows closely the diagonal axis of the femur bone. It is flanked on the outer side of the thigh by the vastus externus (high) and on the inner thigh by the vastus internus, the latter filling out lower, just above the knee. Both originate on the rear femur shaft. All three parts insert into a common tendon flowing into and over the patella. The key structural relationships of the thigh are seen in the Pontormo drawing [7-10] and the accompanying diagram [7-11].

126

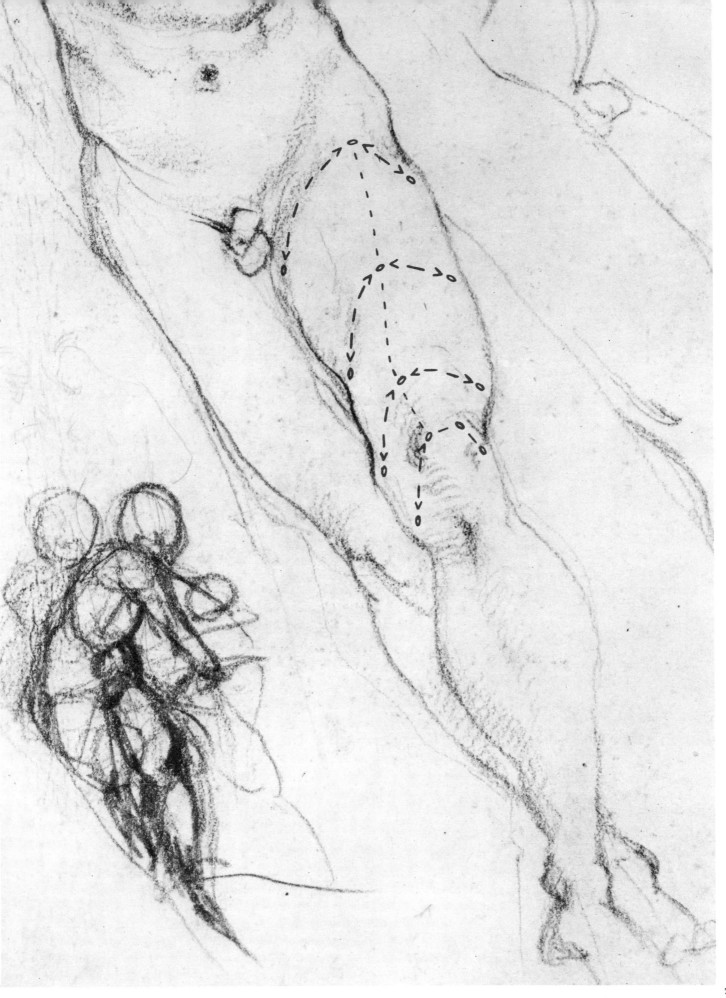

7-12 Skeleton Study (chalk and pencil, 1848) by Daniel Huntington. (In The Brooklyn Museum Collection; Gift of the Roebling Society.)

7-13 Detail of the Legs, from Muscles of the Back from Tables of the Skeleton and Muscles of the Human Body by Bernhard Albinus. (Courtesy: Boston Medical Library in the Francis A. Countway Library of Medicine. Photograph by Kalman Zabarsky.)

The continuity of form over an articulation is well illustrated in the back of the leg. The tendons of the hamstring muscles slip outside to the head of the fibula and the internal tuberosity of the tibia. The two enlarged bellies of the gastrocnemius originate between, at the rear condyles of the femur. This interlocking relationship should not be compromised by the creases at the back of the leg behind the knee. Compare this with the drawing by Pontormo [5-4].

7-14 Back view of the Borghese Fighter, from Anatomy of Bones and Muscles Applicable to the Fine Arts by Jean Galbert Salvage. (Courtesy: Boston Medical Library in the Francis A. Countway Library of Medicine. Photograph by Kalman Zabarsky.)

In this illustration the muscles of the thigh and leg as seen from the back are labeled for study.

7-13

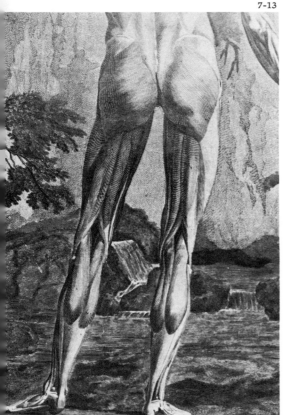

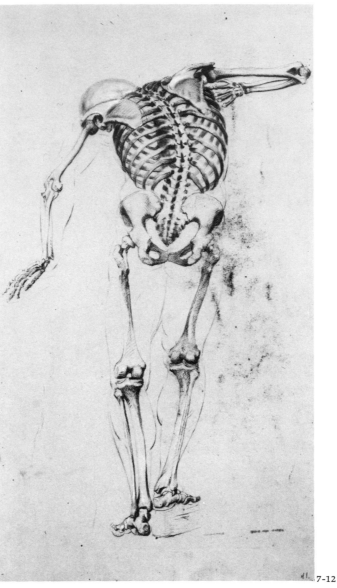

7-12

The back of the thigh [7-12, 7-13, 7-14] is formed by the three hamstring muscles: the semitendinosus (above), the semimembranosus (below) at the inner form, and the biceps femoris, with a long and a short head on the outer side. As a group these muscles extend the full length of the form, originating from the ischial tuberosity of the pelvis. They are distinguished at their lower insertion (tibia-fibula) by sharply evident, stringlike tendons that frame both sides of the rear knee articulation.

The two heads of the gastrocnemius (calf muscle) fill out part of the space between the hamstring tendons. Their connection into the back of the femur is disguised and slightly interrupted by a crease at this articulation, but they should be understood as continuing through this superficial marking.

The remaining smaller superficial muscles of the thigh to be carefully studied are the tensor fasciae latae (plus the important ilio-tibial band) on the outer side of the hip and thigh [7-5, 7-14] and the partly visible pectineus and ilio-psoas below the inguinal ligament.

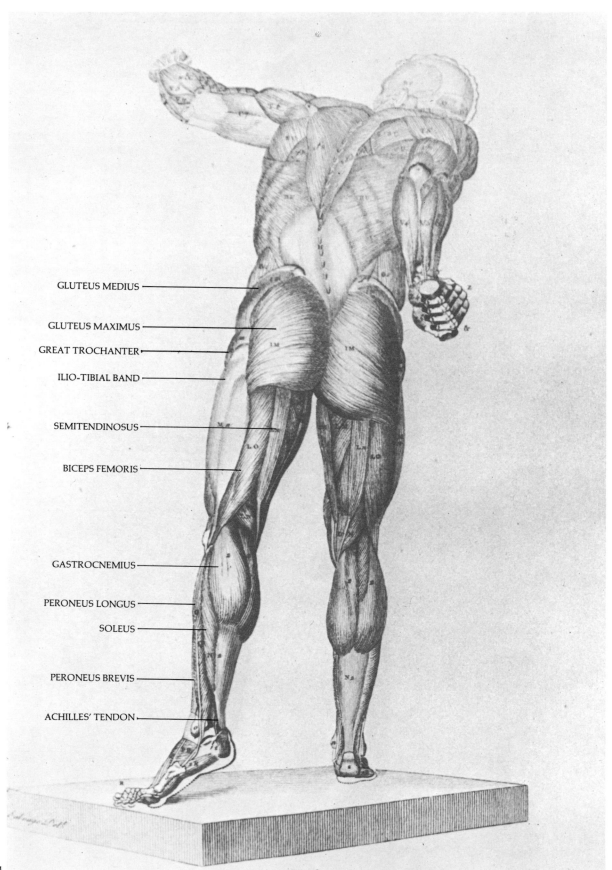

GLUTEUS MEDIUS

GLUTEUS MAXIMUS

GREAT TROCHANTER

ILIO-TIBIAL BAND

SEMITENDINOSUS

BICEPS FEMORIS

GASTROCNEMIUS

PERONEUS LONGUS

SOLEUS

PERONEUS BREVIS

ACHILLES' TENDON

7-14

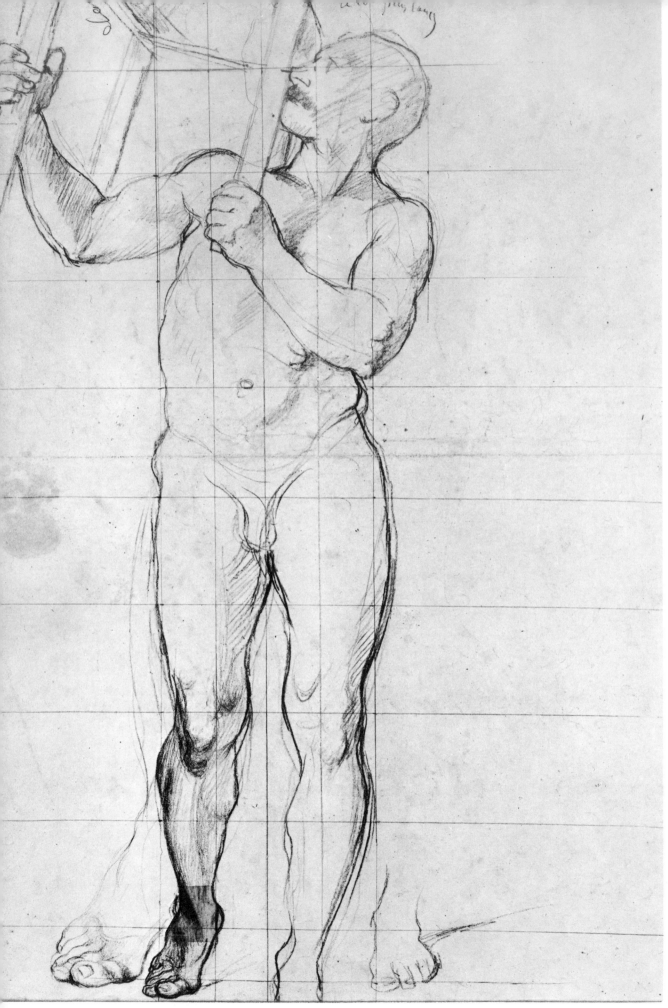

7-15

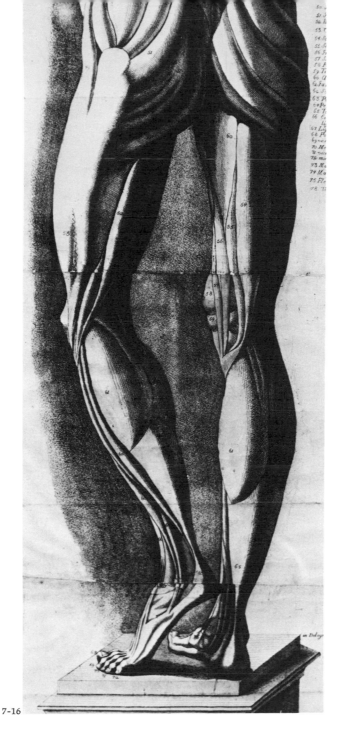

7-16

THE CALF

In contrast to the muscles of the thigh and the well-padded shaft of the femur bone, the musculature of the lower leg is situated largely behind and to the side of the bones [7-15]. The crest of the tibia (shinbone) is exposed in front for its entire length. Here a sharp angular surface change is directly related to a bone from the knee to the inner ankle. This can be easily felt by running the fingers along the front of the lower leg. The fibula bone, long and thin, is exposed primarily at its lower end as the outer ankle (outer malleolus). Its thin shaft is buried in muscle, but at the outer side of the knee it surfaces again as a small, knoblike eminence. This can be easily identified with the finger.

The most characteristic forms in the calf are the two parts of the gastrocnemius muscle (filled out and supported by the flat, elliptical soleus muscle visible beneath) [7-14]. The outer portion of the calf is higher; the inner unit, somewhat lower. This relationship dominates the broad upper form of the lower leg. Both units join the strong, wedgelike Achilles' tendon which attaches to the os calcis bone (heel bone). The thin dimension of this tendon just above the bone should be noted [7-16].

7-15 Study of Nude Man Holding a Chair (black chalk) by Jean Dominique Ingres. (Courtesy: Nelson Gallery-Atkins Museum, Nelson Fund, Kansas City, Missouri.)

The lower leg, from the front, is dominated by the curved axial thrust of the shinbone (tibia) from the knee to the inner ankle. The muscles are to the side and behind the full length of this exposed shaft of bone.

7-16 Detail from Muscles of the Back, from Muscles of the Human Body by Hercules Lelli, engraved on copper by Antonio Cattani. (Courtesy: Boston Medical Library in the Francis A. Countway Library of Medicine. Photograph by Kalman Zabarsky.)

The wedgelike structure of the Achilles' tendon and its thin, stringlike dimensions just above the heel bone (os calcis) will help to emphasize the tension to which this tendon is continuously exposed.

7-18

The lower leg tapers rapidly to a quite narrow dimension just above the ankle. This is repeatedly ignored as a development and results in a stiff, awkward transition into the ankle. The ankle forms a wider, archlike structure over the foot—the inner ankle higher, the outer ankle lower—a relationship that is the reverse of the two parts of the gastrocnemius. This gives a somewhat shorter appearance to the inner contour of the lower leg [7-17].

The remaining muscles of the lower leg, like those in the forearm, are generally slender and numerous [7-5, 7-14]. On the outer front side of the tibia, the dominant muscle is the tibialis anticus which runs parallel with the bone from its outer tuberosity and inserts by a long tendon into the base of the metatarsal of the big toe. Moving back in sequence on the outer side are the long extensor of the toes (extensor digitorum longus) and the peroneus longus (adjoining the soleus). Less evident are the extensor hallucis longus and flexor hallucis longus (both acting on the big toe), the peroneus brevis, and the flexor digitorum longus (deep). All of these muscles should be examined for their exposed tendons and their function.

7-17

THE FOOT

The tarsus, forming the arch and heel of the foot, is composed of seven bones. Two, the astragalus and the os calcis, deserve special comment. The thick, archlike upper segment of the astragalus (talus) articulates with the underside of the tibia bone. The lower portion of the astragalus fits snugly into the saddle-shaped depression of the os calcis. The full weight of the figure is transmitted to these two rugged bones. Ample thrust, behind the ankles, should be given to the blocklike os calcis. The five remaining tarsus bones form the high portion of the arch of the foot.

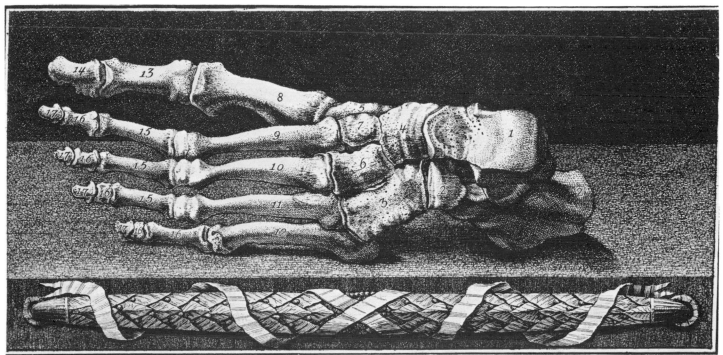

7-19 <u>Bones of the Foot</u>, from <u>Twenty Plates of the Osteology and Myology of the Hand, Foot, and Head</u> by Antonio Cattani. (Courtesy: Boston Medical Library in the Francis A. Countway Library of Medicine. Photograph by Jonathan Goell.)

The tarsus forms the arch and the heel of the foot and is composed of the following bones: astragalus (*1*); os calcis (heel bone) (*2*); cuboid (*3*); scaphoid (navicular) (*4*); internal cuneiform (*5*); external cuneiform (*6*); middle cuneiform (*7*). The metatarsals (*8, 9, 10, 11, 12*) flare into the phalanges (*13, 14, 15, 16, 17*). Compare this illustration with the drawings of the foot by Leonardo [4-5].

7-20 Bones, Tendons, and Muscles of the Foot, from <u>Twenty Plates of the Osteology and Myology of the Hand, Foot, and Head</u> by Antonio Cattani. (Courtesy: Boston Medical Library in the Francis A. Countway Library of Medicine. Photograph by Jonathan Goell.)

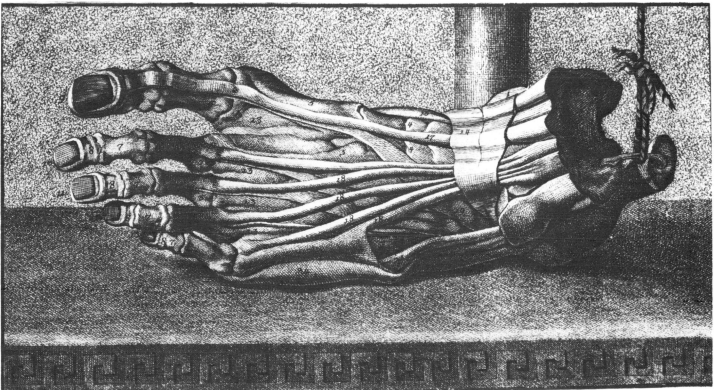

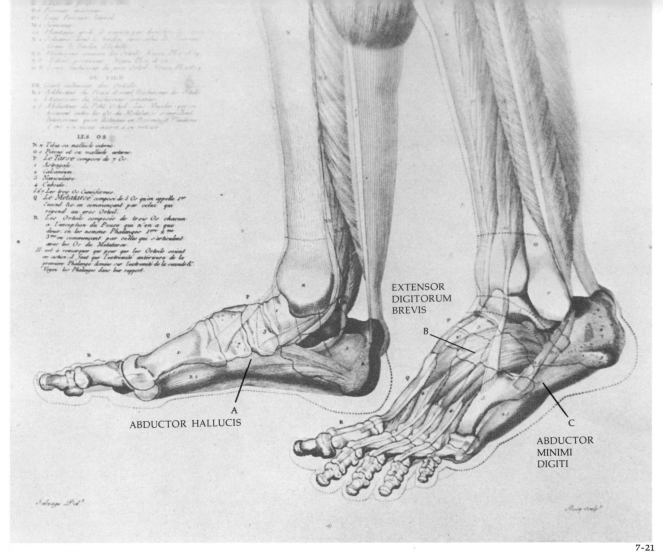

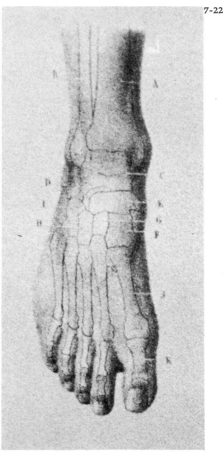

The five long metatarsals flare diagonally forward into the phalangeal units of the toes [7-19, 7-20]. The arched form of the foot is highest along a ridgelike axis extending into the big toe [7-21]. Below the ankle, the inner side plane of the foot is vertical [7-23]. The top plane fans out from the ankle diagonally down and forward, flattening just behind the toes. The toes, as a group, are often mistakenly drawn at a rigid right angle to the length of the foot; in fact, they form a wedgelike projection toward the big toe.

Like the hand, the foot is bony and tendinous on top and thickly padded below. The thin, flat extensor digitorum brevis muscle, from its origin on the outer side of the os calcis bone, fans out into four heads over the metatarsals and inserts into the phalanges of the toes (except the little toe). It extends the toes. This muscle does not hide the bony structure of the metatarsals.

The muscles underneath the foot are heavily padded with thickened skin at the heel and ball (beneath the first phalangeal articulation) and emphasize its archlike structure.

134

7-21 Bones and Muscles of the Foot, from <u>Anatomy of Bones and Muscles Applicable to the Fine Arts</u> by Jean Galbert Salvage. (Courtesy: Boston Medical Library in the Francis A. Countway Library of Medicine. Photograph by Kalman Zabarsky.)

In this side view, three of the major muscles of the foot are seen. They are: abductor hallucis (*A*); extensor digitorum brevis (*B*); abductor minimi digiti (*C*). Compare the abductor hallucis here with its articulation in the drawing by Michelangelo [7-8].

7-22 <u>The Foot</u>, from <u>Anatomie of the External Forms of Man</u> by Julian Fau. (Courtesy: Boston Medical Library in the Francis A. Countway Library of Medicine. Photograph by Kalman Zabarsky.)

In this top view of the foot, the bones of the ankle and the foot may be seen, as well as their influence on the contour. Compare this with the two studies of the bones of the foot by Leonardo [4-5].

7-23 <u>Study for the Feet of Homer</u>, from <u>Homere Deifié</u> by Jean Dominique Ingres. (Musée du Louvre.)

Compare the height of the inner ankle and the arch of the foot to the position of the heel in a foreshortened view.

7-23

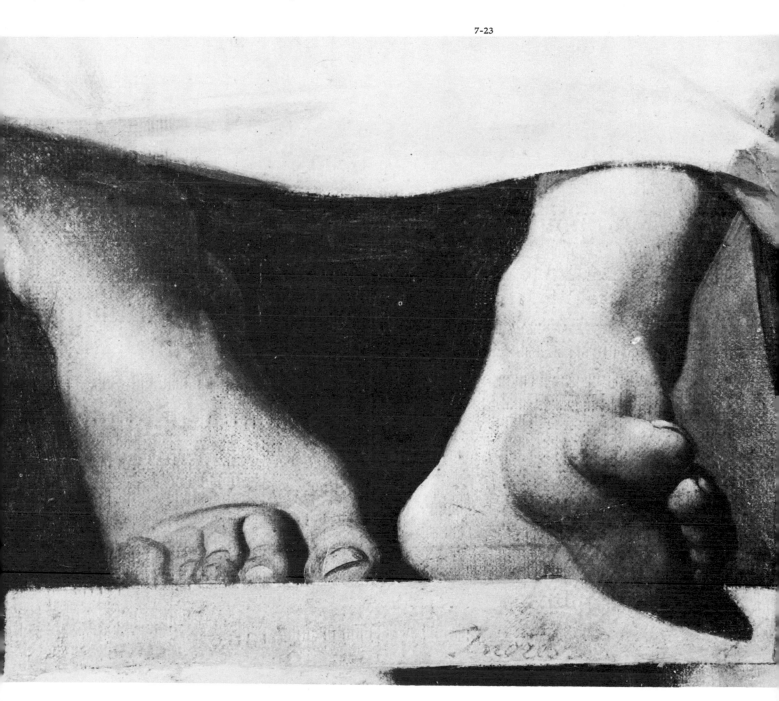

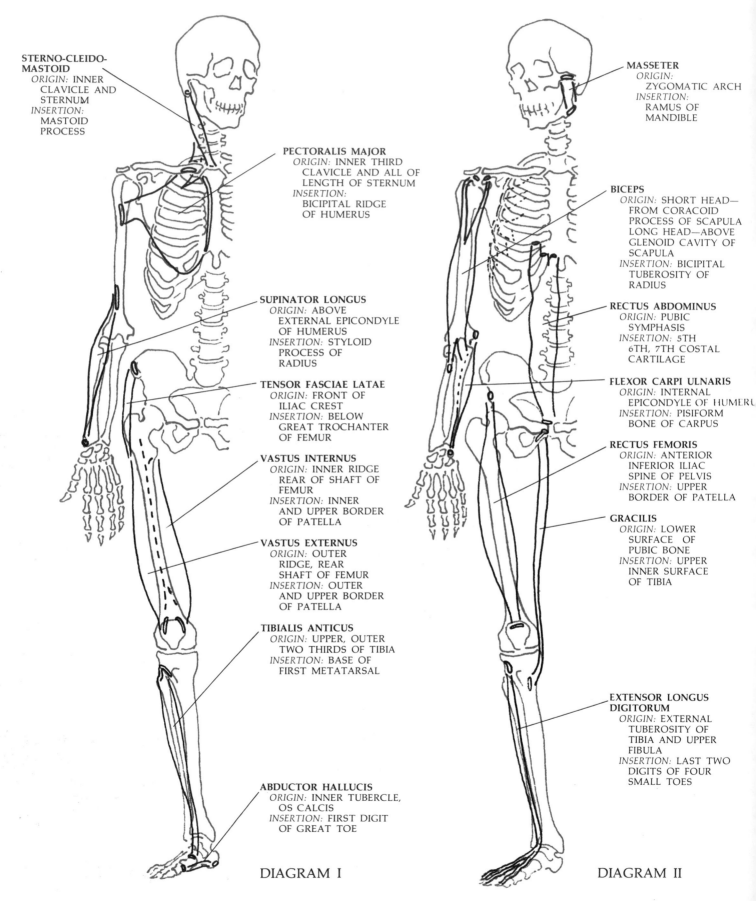

STERNO-CLEIDO-MASTOID
ORIGIN: INNER CLAVICLE AND STERNUM
INSERTION: MASTOID PROCESS

PECTORALIS MAJOR
ORIGIN: INNER THIRD CLAVICLE AND ALL OF LENGTH OF STERNUM
INSERTION: BICIPITAL RIDGE OF HUMERUS

SUPINATOR LONGUS
ORIGIN: ABOVE EXTERNAL EPICONDYLE OF HUMERUS
INSERTION: STYLOID PROCESS OF RADIUS

TENSOR FASCIAE LATAE
ORIGIN: FRONT OF ILIAC CREST
INSERTION: BELOW GREAT TROCHANTER OF FEMUR

VASTUS INTERNUS
ORIGIN: INNER RIDGE REAR OF SHAFT OF FEMUR
INSERTION: INNER AND UPPER BORDER OF PATELLA

VASTUS EXTERNUS
ORIGIN: OUTER RIDGE, REAR SHAFT OF FEMUR
INSERTION: OUTER AND UPPER BORDER OF PATELLA

TIBIALIS ANTICUS
ORIGIN: UPPER, OUTER TWO THIRDS OF TIBIA
INSERTION: BASE OF FIRST METATARSAL

ABDUCTOR HALLUCIS
ORIGIN: INNER TUBERCLE, OS CALCIS
INSERTION: FIRST DIGIT OF GREAT TOE

MASSETER
ORIGIN: ZYGOMATIC ARCH
INSERTION: RAMUS OF MANDIBLE

BICEPS
ORIGIN: SHORT HEAD—FROM CORACOID PROCESS OF SCAPULA LONG HEAD—ABOVE GLENOID CAVITY OF SCAPULA
INSERTION: BICIPITAL TUBEROSITY OF RADIUS

RECTUS ABDOMINUS
ORIGIN: PUBIC SYMPHASIS
INSERTION: 5TH 6TH, 7TH COSTAL CARTILAGE

FLEXOR CARPI ULNARIS
ORIGIN: INTERNAL EPICONDYLE OF HUMERU
INSERTION: PISIFORM BONE OF CARPUS

RECTUS FEMORIS
ORIGIN: ANTERIOR INFERIOR ILIAC SPINE OF PELVIS
INSERTION: UPPER BORDER OF PATELLA

GRACILIS
ORIGIN: LOWER SURFACE OF PUBIC BONE
INSERTION: UPPER INNER SURFACE OF TIBIA

EXTENSOR LONGUS DIGITORUM
ORIGIN: EXTERNAL TUBEROSITY OF TIBIA AND UPPER FIBULA
INSERTION: LAST TWO DIGITS OF FOUR SMALL TOES

DIAGRAM I

DIAGRAM II

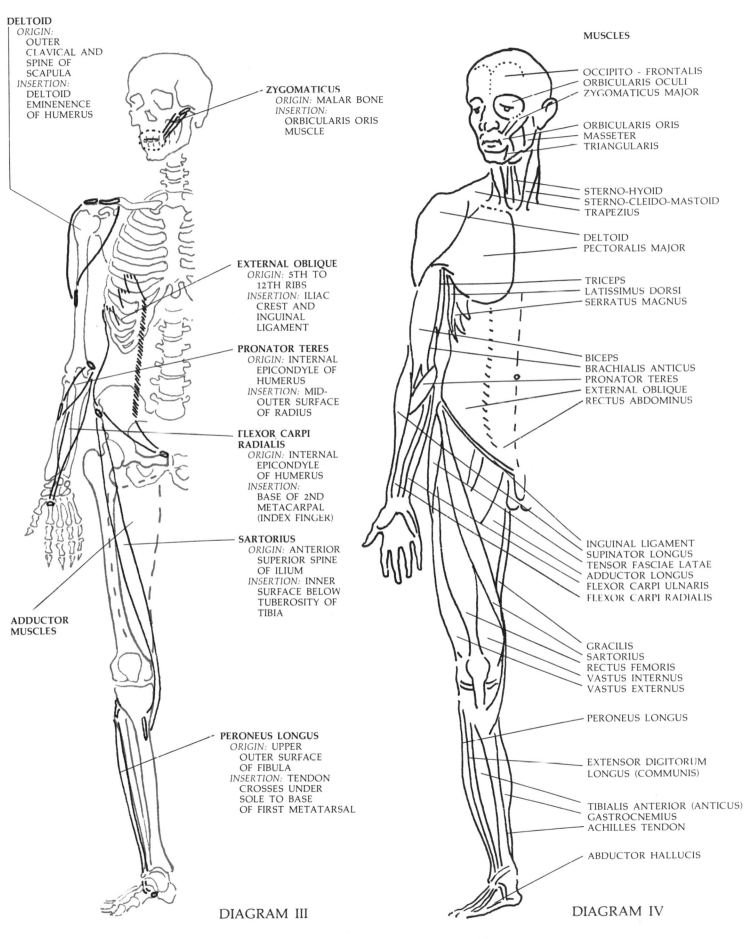

DELTOID
ORIGIN:
 OUTER
 CLAVICAL AND
 SPINE OF
 SCAPULA
INSERTION:
 DELTOID
 EMINENENCE
 OF HUMERUS

ZYGOMATICUS
 ORIGIN: MALAR BONE
 INSERTION:
 ORBICULARIS ORIS
 MUSCLE

EXTERNAL OBLIQUE
 ORIGIN: 5TH TO
 12TH RIBS
 INSERTION: ILIAC
 CREST AND
 INGUINAL
 LIGAMENT

PRONATOR TERES
 ORIGIN: INTERNAL
 EPICONDYLE OF
 HUMERUS
 INSERTION: MID-
 OUTER SURFACE
 OF RADIUS

**FLEXOR CARPI
RADIALIS**
 ORIGIN: INTERNAL
 EPICONDYLE
 OF HUMERUS
 INSERTION:
 BASE OF 2ND
 METACARPAL
 (INDEX FINGER)

SARTORIUS
 ORIGIN: ANTERIOR
 SUPERIOR SPINE
 OF ILIUM
 INSERTION: INNER
 SURFACE BELOW
 TUBEROSITY OF
 TIBIA

**ADDUCTOR
MUSCLES**

PERONEUS LONGUS
 ORIGIN: UPPER
 OUTER SURFACE
 OF FIBULA
 INSERTION: TENDON
 CROSSES UNDER
 SOLE TO BASE
 OF FIRST METATARSAL

MUSCLES

OCCIPITO - FRONTALIS
ORBICULARIS OCULI
ZYGOMATICUS MAJOR

ORBICULARIS ORIS
MASSETER
TRIANGULARIS

STERNO-HYOID
STERNO-CLEIDO-MASTOID
TRAPEZIUS

DELTOID
PECTORALIS MAJOR

TRICEPS
LATISSIMUS DORSI
SERRATUS MAGNUS

BICEPS
BRACHIALIS ANTICUS
PRONATOR TERES
EXTERNAL OBLIQUE
RECTUS ABDOMINUS

INGUINAL LIGAMENT
SUPINATOR LONGUS
TENSOR FASCIAE LATAE
ADDUCTOR LONGUS
FLEXOR CARPI ULNARIS
FLEXOR CARPI RADIALIS

GRACILIS
SARTORIUS
RECTUS FEMORIS
VASTUS INTERNUS
VASTUS EXTERNUS

PERONEUS LONGUS

EXTENSOR DIGITORUM
LONGUS (COMMUNIS)

TIBIALIS ANTERIOR (ANTICUS)
GASTROCNEMIUS
ACHILLES TENDON

ABDUCTOR HALLUCIS

DIAGRAM III

DIAGRAM IV

137

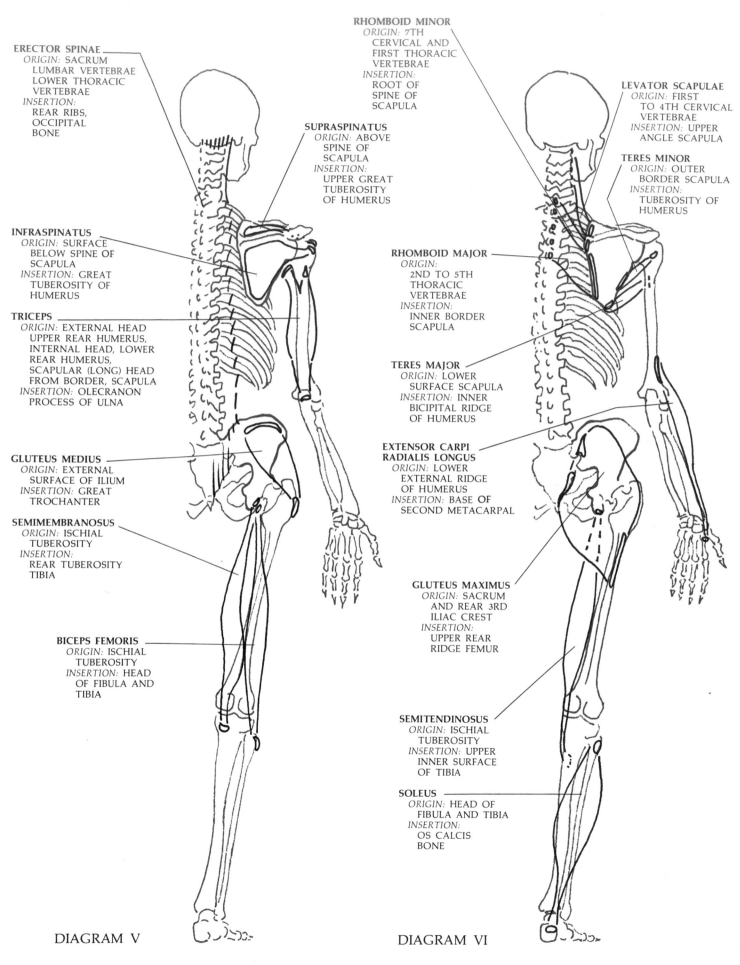

ERECTOR SPINAE
ORIGIN: SACRUM
LUMBAR VERTEBRAE
LOWER THORACIC
VERTEBRAE
INSERTION:
REAR RIBS,
OCCIPITAL
BONE

RHOMBOID MINOR
ORIGIN: 7TH
CERVICAL AND
FIRST THORACIC
VERTEBRAE
INSERTION:
ROOT OF
SPINE OF
SCAPULA

LEVATOR SCAPULAE
ORIGIN: FIRST
TO 4TH CERVICAL
VERTEBRAE
INSERTION: UPPER
ANGLE SCAPULA

SUPRASPINATUS
ORIGIN: ABOVE
SPINE OF
SCAPULA
INSERTION:
UPPER GREAT
TUBEROSITY
OF HUMERUS

TERES MINOR
ORIGIN: OUTER
BORDER SCAPULA
INSERTION:
TUBEROSITY OF
HUMERUS

INFRASPINATUS
ORIGIN: SURFACE
BELOW SPINE OF
SCAPULA
INSERTION: GREAT
TUBEROSITY OF
HUMERUS

RHOMBOID MAJOR
ORIGIN:
2ND TO 5TH
THORACIC
VERTEBRAE
INSERTION:
INNER BORDER
SCAPULA

TRICEPS
ORIGIN: EXTERNAL HEAD
UPPER REAR HUMERUS,
INTERNAL HEAD, LOWER
REAR HUMERUS,
SCAPULAR (LONG) HEAD
FROM BORDER, SCAPULA
INSERTION: OLECRANON
PROCESS OF ULNA

TERES MAJOR
ORIGIN: LOWER
SURFACE SCAPULA
INSERTION: INNER
BICIPITAL RIDGE
OF HUMERUS

**EXTENSOR CARPI
RADIALIS LONGUS**
ORIGIN: LOWER
EXTERNAL RIDGE
OF HUMERUS
INSERTION: BASE OF
SECOND METACARPAL

GLUTEUS MEDIUS
ORIGIN: EXTERNAL
SURFACE OF ILIUM
INSERTION: GREAT
TROCHANTER

SEMIMEMBRANOSUS
ORIGIN: ISCHIAL
TUBEROSITY
INSERTION:
REAR TUBEROSITY
TIBIA

GLUTEUS MAXIMUS
ORIGIN: SACRUM
AND REAR 3RD
ILIAC CREST
INSERTION:
UPPER REAR
RIDGE FEMUR

BICEPS FEMORIS
ORIGIN: ISCHIAL
TUBEROSITY
INSERTION: HEAD
OF FIBULA AND
TIBIA

SEMITENDINOSUS
ORIGIN: ISCHIAL
TUBEROSITY
INSERTION: UPPER
INNER SURFACE
OF TIBIA

SOLEUS
ORIGIN: HEAD OF
FIBULA AND TIBIA
INSERTION:
OS CALCIS
BONE

DIAGRAM V

DIAGRAM VI

138

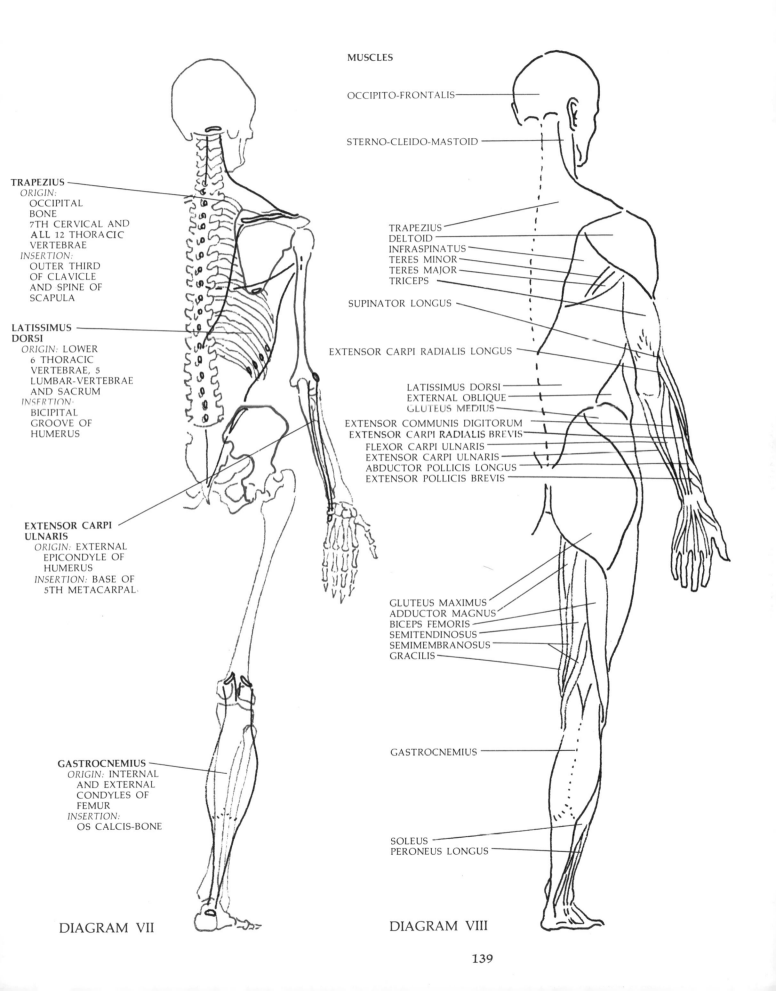

MUSCLES

OCCIPITO-FRONTALIS

STERNO-CLEIDO-MASTOID

TRAPEZIUS
ORIGIN:
 OCCIPITAL
 BONE
 7TH CERVICAL AND
 ALL 12 THORACIC
 VERTEBRAE
INSERTION:
 OUTER THIRD
 OF CLAVICLE
 AND SPINE OF
 SCAPULA

**LATISSIMUS
DORSI**
ORIGIN: LOWER
 6 THORACIC
 VERTEBRAE, 5
 LUMBAR-VERTEBRAE
 AND SACRUM
INSERTION:
 BICIPITAL
 GROOVE OF
 HUMERUS

**EXTENSOR CARPI
ULNARIS**
ORIGIN: EXTERNAL
 EPICONDYLE OF
 HUMERUS
INSERTION: BASE OF
 5TH METACARPAL

GASTROCNEMIUS
ORIGIN: INTERNAL
 AND EXTERNAL
 CONDYLES OF
 FEMUR
INSERTION:
 OS CALCIS-BONE

TRAPEZIUS
DELTOID
INFRASPINATUS
TERES MINOR
TERES MAJOR
TRICEPS

SUPINATOR LONGUS

EXTENSOR CARPI RADIALIS LONGUS

LATISSIMUS DORSI
EXTERNAL OBLIQUE
GLUTEUS MEDIUS
EXTENSOR COMMUNIS DIGITORUM
EXTENSOR CARPI RADIALIS BREVIS
FLEXOR CARPI ULNARIS
EXTENSOR CARPI ULNARIS
ABDUCTOR POLLICIS LONGUS
EXTENSOR POLLICIS BREVIS

GLUTEUS MAXIMUS
ADDUCTOR MAGNUS
BICEPS FEMORIS
SEMITENDINOSUS
SEMIMEMBRANOSUS
GRACILIS

GASTROCNEMIUS

SOLEUS
PERONEUS LONGUS

DIAGRAM VII

DIAGRAM VIII

BIBLIOGRAPHY

ANATOMY

Of the numerous works on human anatomy, this list contains only those that have been examined by the author, and he acknowledges his debt to them in the preparation of this book. They provide clear, descriptive information on human anatomy. The work by Ludwig Choulant contains the most extensive bibliography on early artistic anatomy.

Barcsay, Jeno. *Anatomy for the Artist.* London: Spring Books, 1955.

Briggs, C. W. *Anatomy for Figure Drawing.* Champaign, Ill.: Stipes Publishing Co., 1959.

Choulant, Ludwig. *History and Bibliography of Anatomic Illustration.* Translated by M. Frank. University of Chicago Press, 1920.

Duval, Mathias. *Artistic Anatomy.* Cassel and Co. Ltd., 1895.

Farris, Edmond J. *Art Students Anatomy.* New York: Dover Publications, Inc., 1961.

Gray, Henry. *Anatomy of the Human Body.* Philadelphia: Lea and Febiger, 1942.

Lockhart, R. D. *Living Anatomy.* London: Faber and Faber Ltd., 1948.

Muybridge, Eadweard. *The Human Figure in Motion.* New York: Dover Publications, Inc., 1955.

O'Malley, Charles D. and J. B. de C. M. Saunders. *Leonardo da Vinci on the Human Body.* New York: Henry Schuman, 1952.

O'Malley, Charles D. and J. B. de C. M. Saunders. *The Illustrations from the Works of Andreas Vesalius.* Cleveland: The World Publishing Co., 1950.

Peck, Stephen Rogers. *Atlas of Human Anatomy.* New York: Oxford University Press, 1951.

Richer, Paul Marie Louise Pierre. *Anatomie Artistique.* Paris, 1890.

Schider, Fritz. *An Atlas of Anatomy for Artists.* New York: Dover Publications, Inc., 1957.

Thomson, Arthur. *A Handbook of Anatomy for Art Students.* New York: Dover Publications, 1964.

FIGURE DRAWING

The following books contain valuable information on figure drawing. I can particularly recommend the work by Solomon J. Solomon dealing with the problem of foreshortening.

Blake, Vernon. *The Art and Craft of Drawing.* London: Oxford University Press, 1927.

Hale, Robert Beverly. *Drawing Lessons from the Great Masters.* New York: Watson-Guptill Publications, 1964.

Solomon, Solomon J. *The Practice of Oil Painting and Drawing.* London: Seeley, Service and Co. Ltd., 1919.

Vanderpoel, John H. *The Human Figure.* New York: Dover Publications, Inc., 1958.

PICTORIAL SPACE

The following works deal with important aspects of measurement and space in Western pictorial vision.

Ivins, William M., Jr. "On the Rationalization of Sight. (With an Examination of Three Renaissance Texts on Perspective.)". Metropolitan Museum of Art Papers No. 8, 1938.

Lecoq de Boisbaudran, Horace. *The Training of the Memory in Art.* London: Macmillan and Co. Ltd., 1911.

Meder, Joseph. *Drawing: Its Technique and Development.* Vienna: Schroll and Co., 1919.

Richter, Gisela M. A. *Perspective in Greek and Roman Art.* London and New York: Phaidon Press, 1970.

White, John. *The Birth and Rebirth of Pictorial Space.* London: Faber and Faber, 1957.

INDEX